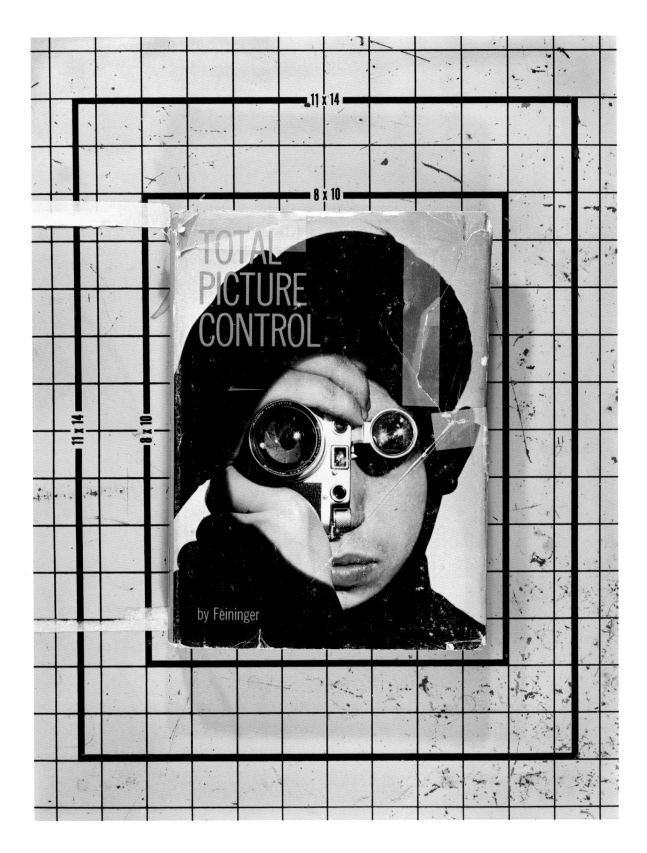

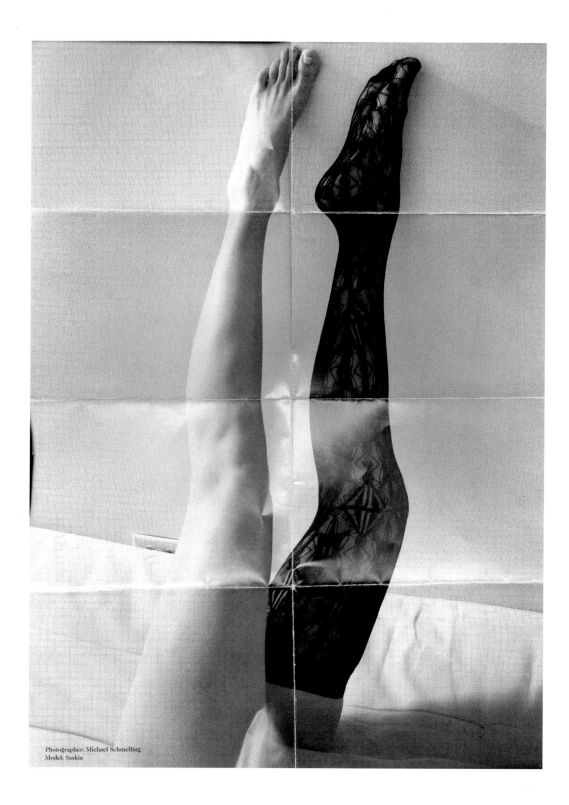

Photographer: Michael Schmelling
Model: Saskia

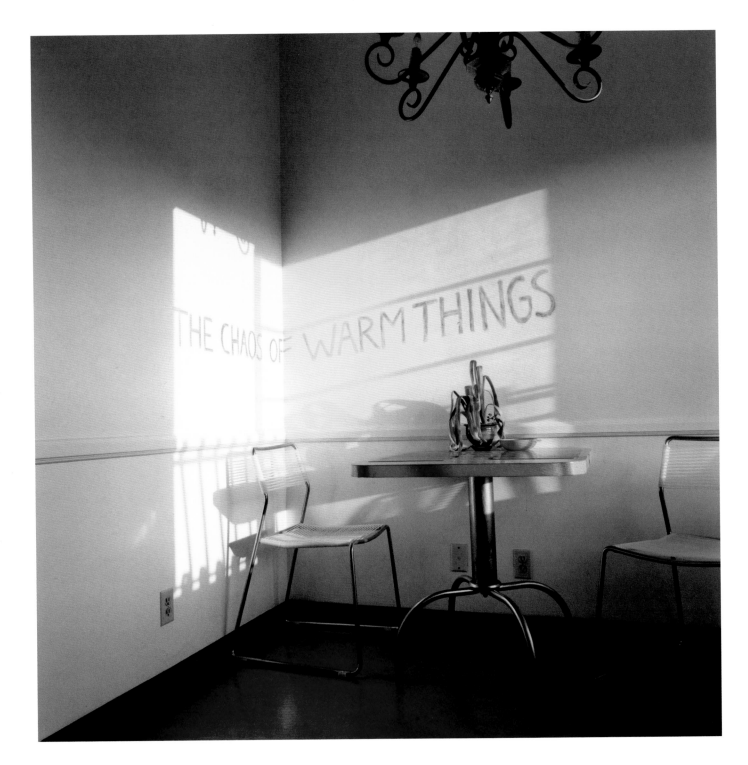

Augusta Wood

the chaos of warm things, 2006

From *text series*

Chromogenic Print

From the exhibition *Assembly: Eight Emerging*

Photographers From Southern California

FOTOFEST2010

CONTEMPORARY U.S. PHOTOGRAPHY

FOTOFEST, HOUSTON, TEXAS, USA

SCHILT PUBLISHING, AMSTERDAM, THE NETHERLANDS

Sponsors
FotoFest 2010 Biennial
(at time of printing)

MAJOR INSTITUTIONAL AND INDIVIDUAL SPONSORS

Houston Endowment, Inc.

The Brown Foundation Inc., Houston

The Cullen Foundation

National Endowment for the Arts

ROMA

JP Morgan Chase

Eleanor and Frank Freed Foundation

City of Houston through the Houston Arts Alliance

Doubletree Hotel Houston Downtown

Vine Street Studios – Roy Murray

The Trust for Mutual Understanding

Texas Commission on the Arts

The Clayton Fund

Judith and Gamble Baldwin

FOTOFEST BOARD OF DIRECTORS

PRINCIPAL SPONSORSHIP FOR THE FOTOFEST 2010 CATALOGUE

Eleanor and Frank Freed Foundation

PRINCIPAL SPONSORSHIP FOR 2010 BIENNIAL EXHIBITION AND AUCTION ART FRAMING

ROMA

Continental Airlines, Official Airline of
the FotoFest 2010 Biennial

KUHF 88.7 FM

HexaGroup Inc.

iLand Internet Solutions

The Tasting Room / Max's Wine Dive

Under The Volcano

Saint Arnold Brewing Company

The Wortham Foundation

American Society of Media Photographers (ASMP)

Houston Downtown Management District

Greater Houston Convention and Visitors Bureau

ADDITIONAL INSTITUTIONAL AND INDIVIDUAL SUPPORT

Weingarten Realty

The Anchorage Foundation

Bering & James, Inc.

The Oshman Foundation

Andrew and Wendy Bernstein

William and Rosalie Hitchcock

American Institute of Architects

The Art League Houston

Houston Center for Photography

Museum of Fine Arts, Houston – Photography Department

Museum of Fine Arts, Houston – Film Program

Sotheby's New York, Photography Department – Denise Bethel

New World Museum – Armando Palacios and Cinda Ward

Williams Tower Gallery and Sally Sprout

Brookfield Properties – Allen Center

Isabella Court – Kerry Inman

Lawndale Art Center

Colton & Farb Gallery – Deborah Colton

Gremillion & Co. Fine Art, Inc.

The Samuels Foundation – Endowment Fund of
the Jewish Community of Houston

Vincent & Elkins

Florence Cook

FOTOFEST2010 ART MEDIA PARTNERS

Art In America
KUHF 88.7 FM
European Photography
Paris Photo
SPOT – Houston Center for Photography

FOTOFEST2010 MEETING PLACE PORTFOLIO REVIEW AND WORKSHOP SPONSORS

American Society of Media Photographers (ASMP)
Doubletree Hotel Houston Downtown
JP Morgan Chase
Continental Airlines

2010 BIENNIAL EDUCATION AND CURRICULUM SPONSORS, LITERACY THROUGH PHOTOGRAPHY

William Stamps Farish Fund
Vale Asche Foundation
The Arete Foundation
JP Morgan Chase
The Powell Foundation
Houston Young Lawyers Foundation
Intermarine L.L.C.

2010 AUCTION SPONSORS

CORPORATIONS

ROMA
Doubletree Hotel Houston Downtown
Bering & James
Sotheby's, Inc., New York
KUHF 88.7 FM
Gremillion & Co. Fine Art, Inc.

INDIVIDUALS

Scott Asen
Cindy and David Fitch
Slavka B. Glaser
James and Sherry Kempner
Howard Maisel and Eve France
Phuong Tranvan

Drew and Julie Alexander
Joan and Stanford Alexander
Austin James and Blakely Bering
Karen Bering/Jenny and Jay Kempner
Kath and Jorge Blanco
Allan and Jenny Craig
Charles Butt/ Susan and Sanford Criner
Michael and Katy Casey
Krista and Michael Dumas
John and Carola Herrin
Wendy and Mavis Kelsey, Jr.
Meg and Nelson Murray/ Anna and Lee Leonard
Winifred and Carleton Riser
Gregory and Lisa Spier/ Alice and Terry Thomas

Cindi and Robert Blakely
Ellen and Stephen Susman, Susman Family Foundation
Mark Wawro
Benjamin (Bim) and Marion Wilcox

Organizers FotoFest 2010

FotoFest is a member of the international network of
festivals, Festival of Light (www.festivaloflight.net)

©2010 FotoFest, Inc., Houston
www.fotofest.org

©2010 Schilt Publishing, Amsterdam
www.schiltpublishing.com

ISBN 978 90 5330 727 4 (Volume 1)

ISBN 978 90 5330 728 1 (Volume 2)

ISBN 978 90 5330 721 2 (set)

Printed in Germany by:
Wachter GmbH
www.wachter.de

Distribution in the United States:
FotoFest, Inc.
1113 Vine Street, Suite 101
Houston, Texas, 77002

Distribution in all other countries:
Thames & Hudson Ltd
181A High Holborn
London WC1V 7QX
Phone: +44 (0) 20 7845 5000
Fax: +44 (0) 20 7845 50 50
E-mail: sales@thameshudson.co.uk

TABLE OF CONTENTS

Preface

FotoFest 2010 and Contemporary U.S. Photography

WENDY WATRISS and FREDERICK BALDWIN

It has been twenty-seven years since the beginning of FotoFest and twenty-four years since FotoFest's first international Biennial of Photography and Photo-related Art. The 2010 Biennial is the first in which FotoFest's own exhibitions focus exclusively on U.S. photography.

In the past fifty to seventy years, U.S. photography has influenced photographic expression throughout the world. This influence is due not only to the relatively early approval of photography as an art form in the United States—or the size of the U.S. marketplace and the number of U.S. university and college programs giving degrees in photographic study—but also to the particular character of the visual "language" that emerged in U.S. photographic practice, and its acceptance by important individual curators and art institutions. In the 1920s and 1930s, photographic art in the United States gave powerful form to the visual representation of the vernacular in U.S. life. It did so in ways that were not characteristic of photographic development in most other parts of the world.

From Lewis Hines to Paul Strand and, most importantly, the works that emerged from the Works Progress Administration (WPA), followed by the imagery of modernist artists such as Lee Freidlander, Stephen Shore, William Eggleston, Gary Winogrand, Joel Sternfeld, and others, many well-respected photographers paid formal (and formalist) attention to what might be described as the "everyday," subjects too commonplace and ordinary to otherwise deserve the attention of high art. The work of these photographers put "everyday life" and its manifestations in a singularly central position in the representation of the nation. This is part of a particular political and social heritage that had resonances in other forms of creative expression in the United States during the late 1700s and throughout the 1800s. By the mid 1900s, through photography and mass media, a vernacular view of U.S. culture came to play an important role in representing national life for many people both outside and inside the United States. Photography was even described as a peculiarly American expression, a populist medium well suited to a nation that liked to describe itself as democratic and non-elitist.

At a time when the United States is once again at the center of international attention and analysis, and as the phenomenon of Barack Obama is stimulating renewed curiosity about the character of U.S. society, 2010 seemed to be an appropriate time to look at the United States through the eyes of contemporary U.S. artists and curators engaged with photography and photo-based art.

Forty-five artists are represented in FotoFest's CONTEMPORARY U.S. PHOTOGRAPHY exhibitions created for the 2010 Biennial. By commissioning a new generation of U.S. (or U.S.–based) curators to organize these exhibitions, FotoFest hopes to generate a new dynamic for its 2010 Biennial. This format enables audiences to see not only what contemporary U.S. artists are producing and the ideas that are important them, but also how a younger generation of curators is interpreting what is worthy of public exhibition among these works, and why these artists are important in terms of aesthetic practice and content in U.S. photography today.

The curators were selected on the basis of the talent and creativity they had shown in previous exhibitions elsewhere, as well as for their divergent perspectives on the practice and curating of photo-based art. They were given a very broad canvas, asked to select work done between the mid- to late 1990s and 2009 by artists born in the United States. If they selected artists working, but not born, in the United States, the curator(s) needed to show that U.S. social culture is central to the artists' work. The individual works could be classical photography, video, performance art, or multidisciplinary installation pieces as long as they had some connection to the photographic practice or concept. The curators selected for the CONTEMPORARY U.S. PHOTOGRAPHY exhibitions are as follows:

Charlotte Cotton, Creative Director, National Media Museum, Bradford, U.K., and former Curator and Head of the Wallis Annenberg Photography Department at the Los Angeles County Museum of Art (LACMA). At her suggestion, the actual curating for this exhibition was done by the team of curators from LACMA's Wallis Annenberg Photography Department, **Edward Robinson,** Associate Curator, and **Sarah Bay Williams,** Ralph M. Parsons Fellow.

Natasha Egan, Associate Director and Curator, Museum of Contemporary Photography at Columbia College Chicago.

Aaron Schuman, Photographer, Writer, Editor, Curator, and Founder of *SeeSaw Magazine*

Gilbert Vicario, Curator, Des Moines Art Center, Des Moines, Iowa, and former Assistant Curator of Latin American Art and Latino Art, Museum of Fine Arts, Houston.

In conjunction with their exhibitions, FotoFest is presenting a series of forums on curating and curatorial practice. The programs look at how curatorial practices shape what art and artists are publicly presented; the processes that guide what individual curators do, from concept to interpretation to installation; and the role(s) of curators as interlocutors between artists and arts professionals, art audiences, and the general public. What outside forces help determine the decisions curators make in selecting particular themes, types of works, and individual artists? Should curators be "celebrities" in their own right?

. . .

As with previous FotoFest Biennials, the 2010 Biennial is a multifaceted series of events whose mission is to open new opportunities for artists and arts professionals to produce and present work, while enabling arts audiences and the general public to engage with new talent and new ideas through the medium of photography and photo-related art.

In addition to the Biennial's own 2010 exhibitions and curatorial forums, FotoFest is collaborating with more than eighty other arts, civic, and commercial organizations, which have created and are presenting their own exhibitions and events throughout the city. Many of these organizations are represented in Volume II of this catalogue. In addition to the exhibitions by Participating Spaces, FotoFest also presents in Volume II the eighth DISCOVERIES OF THE MEETING PLACE exhibition.

For the first time, FotoFest in 2010 is co-producing its two-volume Biennial catalogue with the international publishing company Schilt Publishing in Amsterdam, to be distributed abroad by Thames and Hudson in London.

Among the Biennial's other programs are FotoFest's twelve-day international Meeting Place portfolio reviews for over 500 artists; workshops on the multimedia world; evenings with the artists; the ninth Biennial international Fine Print Auction; artist book signings in conjunction with special photographic book displays by photo-eye bookstore and gallery; exhibition tours; student observation days; and curriculum programs for grade schools.

WENDY WATRISS and FREDERICK BALDWIN
FOTOFEST CO-FOUNDERS AND CREATIVE DIRECTORS

ACKNOWLEDGMENTS

It is no surprise that a Biennial of this size and scope can only be achieved with the collaboration and support of many people and organizations. Our first acknowledgment goes to the FotoFest staff, whose creative thinking, talent, and long hours of work make the Biennial's many programs possible.

The exhibitions and this catalogue could not have been created without the professionalism of the curators and the artists they selected. The designer of the catalogue and the 2010 publications, Henk van Assen of HvADesign in New York, has done a superb job, and it is a privilege to be able to collaborate with Maarten Schilt of Schilt Publishing in Amsterdam.

We are especially grateful to all the FotoFest 2010 Biennial sponsors named in this catalogue. Among them are the following providers of special funding that has been particularly important to this 2010 Biennial. Major support for this Biennial Catalogue comes from the Eleanor and Frank Freed Foundation in Houston. ROMA Moulding in the United States, Canada, and Europe and ROMA Vice President Tony Gareri have provided 2,700 feet of fine Italian wood molding free of charge for the framing of artworks in the FotoFest 2010 exhibitions and Fine Print Auction. Austin James and Blakely Bering of Bering & James Gallery in Houston not only initiated the connection with the ROMA Moulding sponsorship, but are co-chairing the Fine Print Auction.

We want to particularly recognize and thank FotoFest's Board of Directors, whose members are essential to the forward movement of the Biennial and all of FotoFest's programs in many, many ways.

COLLABORATIONS

Without the collaboration of a number of independent spaces, FotoFest would not be able to present the breadth of exhibition programs it features today. We want to thank the following:

Paul Layne, Executive Vice President, Brookfield Properties, and Joanna Chain, Tenant Relations Manager, Brookfield Properties, for hosting the DISCOVERIES OF THE MEETING PLACE exhibition at ONE, TWO AND THREE ALLEN CENTER.

Armando Palacios and Cinda Ward who have once again provided their beautiful space for one of FotoFest's main Biennial exhibitions at THE NEW WORLD MUSEUM.

Hines Interests and Sally Sprout, Curator, Williams Tower Gallery, for hosting one of the principal CONTEMPORARY U.S. PHOTOGRAPHY exhibitions at WILLIAMS TOWER GALLERY.

Jon Deal for collaborating with one of FotoFest's principal CONTEMPORARY U.S. PHOTOGRAPHY exhibitions at WINTER STREET STUDIOS.

The ART LEAGUE HOUSTON and Vanessa Perez McCalla and Sarah Schellenberg for hosting one of the principal CONTEMPORARY U.S. PHOTOGRAPHY exhibitions.

The Architectural Center Houston (ArCH) and Barrie Scardino and Mat Wolff for their collaboration on the U.S. VERNACULAR AND CHINESE MODERNISM exhibition.

The Museum of Fine Arts, Houston, and Anne Wilkes Tucker, Marian Luntz, and Margaret Mims for their film programming and partnership on the curatorial symposia.

Houston Center for Photography and Bevin Bering and Madeline Yale for their support of the workshops and Biennial as a whole.

Kerry Inman and Inman Gallery for assistance with one of FotoFest's principal CONTEMPORARY U.S. PHOTOGRAPHY exhibitions at ISABELLA COURT.

As well as the following individuals at these organizations and art spaces:
Lawndale Art Center – Christine West
Visual Studies Program, University of Houston Central – Tracy Karner
Houston Downtown District – Robert Eury and Angie Bertinot
Greater Houston Convention and Visitors Bureau – Jorge Franz, Lindsay Brown, Celia Morris, and Nathan Tollett
Kinzelman Art Consulting – Julie Kinzelman
Colton & Farb Gallery – Deborah Colton
Poissant Gallery – Meg Poissant

SPECIAL SUPPORT

We want to thank every single staff member listed in this catalogue and the excellent consultants with whom we have worked, particularly Antoine Vigne and Kellie Honeycutt at Blue Medium for their help with national and international press; Henk van Assen at HvADesign for all the Biennial design, and Arnaud Dasprez and Cory Jensen at Hexagroup Inc. for the website design. We thank Frank Heltsche and Wachter GmBH for the catalogue production, and Jim Walker and Earthcolor for production of the other FotoFest publications. Once again, Polly Koch did a remarkable job of copy editing the Biennial catalogues. We want to especially recognize and thank James "Brock" Kobayashi for the outstanding, year-round technical support he gives to FotoFest.

Introduction

Contemporary U.S. Photography

CHARLOTTE COTTON

For the 2010 FotoFest-curated exhibition program, four curators were invited to make propositions about contemporary U.S. photography. Their selections of lens-based and video artists offer four contrasting and overlapping narratives of the United States, photography, and U.S. photography.

In keeping with the enduring spirit of FotoFest, the curators of **CONTEMPORARY U.S. PHOTOGRAPHY** have responded to the Biennial's chosen theme by introducing us to provocative and aspirant talents within the sphere of photography and film. Each exhibition represents the exciting substance of new U.S. photography in works that look beyond the established conventions of this quintessentially American medium. Collectively, the artists and the bodies of work that have been chosen for this year's FotoFest open up new lines of artistic inquiry and comprise a summary of the forms and frameworks that contemporary U.S. photographers are giving to the medium. Another bridging schema of these exhibitions is their reassessing and re-evaluating of key moments and practitioners that have shaped the history of U.S. photography and constructed enduring fables of American life. Similarly, the currents of new visual and social influences, including how we use image-making within our lives and what we choose to represent, ripple through FotoFest's presentation of contemporary U.S. photography.

All four of the selections of contemporary U.S. photographers bring together distinct historical moments or instigators of radical change within the visualization of American culture. In **THE ROAD TO NOWHERE?** exhibition, Natasha Egan has conflated a politicized photographic lineage, from the Farm Security Administration to Robert Frank's *The Americans* of the mid-1950s to the *New Topographics* exhibition of 1975, with the socioeconomic reality of twenty-first-century America in the wake of its earlier golden age. Her selection of eighteen photographers convincingly narrates our melancholic and sometimes biting fables about America. **THE ROAD TO NOWHERE?** articulates a number of themes that Egan outlines in her essay, covering the economy, race, class, violence, and the decline and ruination of U.S. post-war optimism. She has cleverly interwoven photographic projects with distinct forms and agendas to constitute a

powerful whole. In the context of this exhibition, Brian Ulrich's deadpan photographs of empty stores and shopping malls speak to Michael Robinson's film showing the crumbling, fading fabric of the 1960s World's Fairs in America and Canada set to an eclectic, confusing soundtrack. In turn, the incidental spectacles created in Tim Davis's *Retail* (2001) series of photographs, capturing the reflections of corporate retail signs in the darkened windows of small-town American houses, and Jeff Brouws's documentation of inner-city graffiti, isolated in his photographs, carry an ominous charge from the unseen forces and harsh realities that govern marginalized U.S. culture.

THE ROAD TO NOWHERE? includes film and photographic projects where there is a meaningful contradiction or distance between the artists's chosen subject and its visual form. Trevor Paglen's long-exposure night sky photographs are deeply accomplished and ethereally beautiful, not unlike the thousands of amateur and professional photographs of the open sky at night that people have created for decades. But Paglen's richly aestheticized night skies were derived from his careful calculations of the transit of classified U.S. satellites and his successful tracking of their movements in the reflections of sunlight off their metallic surfaces. In a related vein, in Christina Seely's gorgeous night landscape photographs within her *Lux* (2005–2010) series, she has mapped the forty-five cities on the globe (she shows the U.S. cities here) responsible for an exponentially high percentage of global CO_2 emissions, their literal glow visible from NASA satellites. An-My Lê intentionally used the language of black and white photography in her *29 Palms* (2003–2005) body of work, which depicts U.S. soldiers in training for tours of duty in Iraq and Afghanistan. Lê cites the history of war photography, which began in the 1860s, when it was only able to represent the post- or pre-battle stillness and the surrounding landscapes. Lê has photographed these contemporary soldiers, who were acting out staged battle scenes, with unnerving detachment and the sense of the repetitions of history. These scenes and the consequences of believing in our "clean" twenty-first-century wars become bound together.

The title of Aaron Schuman's exhibition—WHATEVER WAS SPLENDID: NEW AMERICAN PHOTOGRAPHS—takes as its cue a phrase used by Lincoln Kirstein in his 1938 introduction to Walker Evans's "prophetic" (to quote Schuman) book *American Photographs*. In a focused manner, yet in parallel with Egan, Schuman has explored the renewed timeliness of Evans's photography, created in an earlier period of deep social and economic trouble in the United States. Both exhibitions ponder the circumstances and the consequences that a sensitive photographer in America must bear witness to. In the opening paragraphs of Schuman's essay, he identifies two "chapters" within Evans's American Photographs with which all of his selected photographers for the exhibition can justifiably be seen to resonate. For Schuman, the book begins with an expression of the diversity of American life, from its workers to its disenfranchised, and then moves into a lexicon of its spaces, from the vernacular and industrial to the downright used.

The metaphor of things and people being used up pervades this exhibition. Will Steacy's *Down These Mean Streets* (2008–2009) is an A to Z of the remnants of violence and neglect that suffuse the long nights of U.S. inner cities. Steacy's photographs carry the heavy suspense of places where everything is broken and wild. RJ Shaughnessy's black and white, flash-illuminated photographs of fences, street signposts, and poles buckled by vandalism and car accidents in Los Angeles have a parallel tempo of bleak dread and order unravelled. Craig Mammano's *A Few Square Blocks* (2007–2008) is a series of portraits showing women—standing, seated, and lying, dressed and undressed. There is arbitrariness in the photographic series that embodies the randomness of Mammano's encounters with these sidelined New Orleans women. His photographs convey the bankruptcy of both seduction and innocence in the women's varying degrees of willingness to adopt feminized attributes for Mammano. The photographs are flat, dreadful, and exploitative in their exposure of the women; you want to cover up the women's vulnerability and end these deeply ambiguous photographic exchanges.

There are other Walker Evans-referencing tenors within **WHATEVER WAS SPLENDID**. Todd Hido's subtle interiors of foreclosed homes, Tema Stauffer's *American Stills* (1997–2007), and Jane Tam's observations of her American-Chinese family life bring the sparse and quiet poetry of Evans's work into play. The exhibition also resonates with Evans's passion for American vernacular culture. Hank Willis Thomas has manipulated late twentieth-century advertising geared toward African-American consumers and thus drawn out the connotations and cultural stereotyping embedded within them. For his *Nirvana* (2007) project, Jason Lazarus made a call for photographic submissions in response to his question, "Do you remember who introduced you to the band Nirvana?" Lazarus scanned and framed the amateur snapshots with their submitted commentaries to create a poetic narrative of late twentieth-century masculine rites of passage and collective memory.

In the **MEDIANATION: PERFORMING FOR THE SCREEN** exhibition, Gilbert Vicario's choice of a historical precedent for contemporary U.S. image-making is more recent. He cites David Antin's 1976 analysis of the then emergent artistic form of video as taking its aesthetic and technical cues from the industry of television, by then a mainstream medium. **MEDIANATION** draws out a line of inquiry into how the commercially available and commercially driven technologies of today, and the ways of seeing they engender, are shaping new artistic practice. Vicario defines this moment as one where technologies are being usurped and where the forms and formats of how we make, consume, and comprehend imagery are being changed. In an era where the personal computer has taken over from the television set and where telecommunications are secondary to our web-based conversations, he suggests that there are new vehicles and constructs for contemporary artists to co-opt and subvert. Vicario has selected artists (as distinct from merely selecting works or objects) who use the formal and technological proper-

ties of contemporary media to narrate their commentary on sexuality, societal desires, and politics.

In **MEDIANATION**, two artists, Kalup Linzy and Leslie Hall, dramatically bridge performance art and the new, default tools of self-published media epitomized by YouTube, MySpace, and MP3s. Linzy has used the revived and now ubiquitous format of the talent show as the ostensible storyline for his video *Melody Set Me Free* (2002). Playing a host of mainly female stereotypes of African-American youth, Linzy satirizes both contemporary ideas of stardom and the over a century-old clichés of African performers, singers, and even visual artists in America. He has made the worn stereotyping of African-American artists the primary theme of his video *Conversations Wit de Churen: As da Art Wold Might Turn* (2006) as well. Leslie Hall has intentionally developed her artistic practice in order to become an Internet "superstar." It is not just her strikingly garish, gold lamé hot pants-wearing persona, or her energized live performances with her band the Ly's, or indeed her museum of bejewelled sweaters that has brought her international attention. Leslie Hall has very cleverly adopted the languages of amateur YouTube videos, Blip and MP3 downloading of music, and TV shopping to create a true fan base and a wide dissemination of herself as a distinctly retro and alternative pop idol.

It's interesting that some of the artists selected for MEDIANATION create more hybrid forms of art that explore the possibilities of, for example, social networking and online searching, but combine these with aesthetics and art references that are essentially pre-digital. While Laurel Nakadate used Craigslist.com to enlist the middle-aged men who would collaborate with her on the *Lucky Tiger* (2009) project, there are historical layers that are as equally important within the work. Nakadate, well known for her ingénue performances, staged a series of cheesecake photographs as a "gift" for her enlisted male participants. Nakadate and each of her collaborators then coated their fingertips with fingerprinting ink and pored over the photographs, which were then framed and would become the documentation and the substance of the work of art. Toward different ends, artist Daniel Joseph Martinez has deployed a similar embedding of vernacular photography and its mode of dissemination in his mail art project. Martinez consciously and actively fails to document his travelling along an 800-mile Alaskan pipeline through annotated postcards, with their depictions of mute or banal landmarks through the landscape, which he sent out during his exploration.

Emilio Chapela's *According to Google* (2008) is a weighty but succinct meditation on the contradictions and awesome quantity of knowledge generated by Google's image search engine. Chapela's forty-volume "encyclopaedia" makes a bombastic physical form out of his searches of keywords ranging from "beauty" to "communism." This artwork asks us to question our construction and absorption of knowledge, as well as the "officialising"

of information that printing and binding give even an unedited and random assembly of images. Chapela has consciously integrated our daily use of Google and other search engines to learn, verify, and confirm information in the lexicon of hypothesis testing and game playing that has preoccupied artists since Marcel Duchamp and that was a mainstay of Conceptual Art practice.

The legacy of Conceptual Art since the early 1960s is the most pronounced historical underpinning of **ASSEMBLY: EIGHT EMERGING PHOTOGRAPHERS FROM SOUTHERN CALIFORNIA** showing the work of eight artists who have graduated from Southern Californian art schools, selected by the curatorial team of the Wallis Annenberg Department of Photography at the Los Angeles County Museum of Art. This theme reflects a nationwide refocusing upon a period when artists were preoccupied with what it meant to make art, and what art could speak of in a time of political and societal anxiety. It has a unique resonance in Southern California, an axis along which the scope of Conceptual Art photography and video was once defined, not only through U.S. artists who were based in the region but also through its gravitational pull on artists internationally who were preoccupied with parallel issues. California has remained strongly aligned to its Conceptual heritage because its strong network of art schools, with all the discursive and risk-taking energy this implies (as opposed to art institutions or the art market), constitutes a critical mass of artistic practice. The ground that Robert Heinecken laid at University of California at Los Angeles, starting in 1961, for exploring photography outside of its traditional genres, 9 concepts, or aesthetics still remains fertile. Many artists who have plotted out and contributed to the range of Conceptual photography and film are aligned with Southern Californian art schools, including John Baldessari, James Welling, Judy Fiskin, and John Divola, and they safeguard a supremely generous and expansive climate for emergent photographers and artists.

There is a range of Conceptual Art-driven practices at play within the selection for **ASSEMBLY.** Nicole Belle's and Augusta Wood's photographs depict temporary performances or interventions within daily life and its environments, strongly informed by the heritage of Conceptual Art in the Americas and Europe. Belle and Wood both subtly reorganize and tip the ordinary into sites and scenes that express the artists' subjective and emotional states. Peter Holzhauer, Whitney Hubbs, and Joey Lehman Morris are all photographers who are out in the real world, observing and capturing the moments where life throws up psychological paradoxes and visual confusions. All three photographers, in their own way, are deeply concerned with the final rendering of the viewer's experience of their work. They are not satisfied simply with their success at "finding" the pictures that are waiting to happen all around us showing life's visual contradictions, but they also strive to acknowledge the inherent physicality of photography. For instance, Morris's prints are sometimes propped up or laid flat on the floor, reworking the playfulness with which photography's material (albeit quite flat) properties have

been treated in Conceptual photography installations since the 1960s. Hubbs has used the symbolically loaded and rich language of black and white photography to create a subjective language of signs. Just as the photographic print no longer constitutes the default vehicle for a photographic idea or even documentation, Hubbs's use of monochrome is far from neutral, and both these elements in the monochrome and the physical form of the print reveal themselves to be extremely active choices for a young artist in a chromatic, screen-based age. Similarly, Matthew Brandt, Asha Schechter, and Matt Lipps are each creating photographic bodies of work that consciously require viewers to acknowledge their highly process-driven means. Whether it is the psychologically charged use of the analogue, or 'wet', darkroom in Brandt's modestly sized landscapes and portraits, or the heightened visual language and embodiment of digital processes in Schechter's *Picture* (2009) series, or the degree of craft involved in Lipps's montages, each of the artists selected here has a highly astute sense of the increasingly heavy symbolic weight of photography's material form in an increasingly dematerialized world.

Each of these four exhibitions about contemporary U.S. photography, representing over forty artists, offers up a provocative overview of what preoccupies young U.S. image-makers today. Their choices of ostensible subjects under analysis range from our ongoing wars, poverty, identity, and celebrity to more philosophical issues concerning what of American culture stands on a threshold or lies in ruins. This bridging of tangible and lived experiences with the intangibility of collective memory and consciousness at the beginnings of a new century seems to be the ample challenge and also the fuel for contemporary photographers.

CHARLOTTE COTTON
CREATIVE DIRECTOR, NATIONAL MEDIA MUSEUM, BRADFORD, U.K.

Editor's note: Charlotte Cotton was originally commissioned by FotoFest to be one of the curators for the FotoFest 2010 CONTEMPORARY U.S. PHOTOGRAPHY exhibits. At that time, she was Curator and Head of the Wallis Annenberg Photography Department at the Los Angeles County Museum of Art (LACMA). At her suggestion, the actual curating of ASSEMBLY: EIGHT EMERGING PHOTOGRAPHERS FROM SOUTHERN CALIFORNIA was done by the team of photography curators at LACMA.

Exhibitions

Whatever was Splendid: New American Photographs

AARON SCHUMAN

WILL STEACY

RJ SHAUGHNESSY

TODD HIDO

GREG STIMAC

CRAIG MAMMANO

JANE TAM

RICHARD MOSSE

MICHAEL SCHMELLING

HANK WILLIS THOMAS

JASON LAZARUS

TEMA STAUFFER

Whatever was Splendid: New American Photographs

AARON SCHUMAN

Seeking support for what eventually became *The Americans* (1958), Robert Frank conceded in his 1954 Guggenheim Fellowship application that "'The photographing of America' is a large order—read at all literally, the phrase would be an absurdity."[1] Similarly, to curate an exhibition that represents and succinctly defines the whole of contemporary photography within the United States more than fifty years on, read at all literally, seems equally absurd. In practical terms, the country's current photographic landscape, with its sheer volume and vast variety, offers any aspiring surveyor an expansive visual territory that would be impossible to chart fully or accurately. As Frank also noted, photographs of America are "anywhere and everywhere—easily found, not easily selected and interpreted."[2]

The same holds true today, if not more so—pictures are anywhere and everywhere, and therefore the task of meticulously sifting through them for potential treasure is a formidable one, which relies not only on an intricate knowledge of the terrain, but also on the occasional shimmer of good fortune. Such an endeavor, at times seemingly futile and ill-fated, is nevertheless incredibly tempting. Despite its limitations, omissions, contradictions, and inevitable imperfections, this venture has within it the potential to instigate some fascinating journeys and to produce a number of valuable insights, into both the country and the photographic medium at large. With that in mind, the challenge becomes twofold. First, and most obviously, it is necessary to examine what photography says about the United States: what is the U.S. today—as a place, a culture, a concept, and so on—and how is it seen, explored, expressed, experienced, and understood through photographs? Second, one is compelled to discern what the United States specifically says about photography: how is photography today—as a medium, apparatus and tool—utilized, shaped, transformed, and defined by those who practice it in, and apply it to, the U.S.? And inevitably, faced with such sweeping motifs and grand concerns, one is led toward the central and perhaps most difficult question of all—where does one begin?

1
Robert Frank, "Guggenheim Fellowship Application Form: Concise Statement of Project, October 21, 1954," in *Looking In: Robert Frank's The Americans*, edited by Sarah Greenough (Gottingen, Germany: Steidl; Washington, D.C.: National Gallery of Art, 2009).
2
Ibid.

In "Walker Evans and Robert Frank: An Essay on Influence", Tod Papageorge notes that Evans's seminal 1938 monograph, *American Photographs*, was "bound in black… bible cloth, the cover of hymnals."[3] The book has certainly lived up to its binding in recent decades, having gained a reputation and importance of nearly biblical proportions, particularly within American photographic circles, where its influence can be perceived far beyond Evans's most literal, obvious, and immediate disciples. And as its title suggests, Evans's tome might serve as an ideal starting point for an exploration of how the United States is both seen in, and related to, photography. John Szarkowski once wrote, "It is difficult to know now with certainty whether Evans recorded the America of his youth, or invented it. Beyond doubt, the accepted myth of our recent past is in some measure the creation of this photographer, whose work has persuaded us of the validity of a new set of clues and symbols bearing on the question of who we are. …[I]t is now part of our history."[4]

American Photographs is divided into two chapters—the first very generally exploring people and places, the second reflecting more specifically on the country's traditional and vernacular architecture. Many have cited how the second set of images in particular, with their formality and directness—their "straight-ness" as it has been coined—has played a significant role in various photographic approaches and concerns of the twentieth century, such as those employed by the New Topographics and the Dusseldorf School, along with their numerous descendants, followers, imitators, and admirers. But if this second chapter demonstrates Evans's consistency, stoicism, and discipline, the first chapter celebrates the diversity and range of his photographic vision, embracing a plethora of photographic possibilities and expanding the medium's potential far beyond the strictures of the formally, thematically, or aesthetically delineated series. It is within this chapter where most of the new "American" myths, clues, symbols, and histories that Szarkowski recognized in Evans's work reside— the laborers, soldiers, and citizens of the city streets; the barbershops, farm stands and shotgun shacks; the main streets, civic statues, and grandiose boardinghouse facades; the cars, cars, and more cars, roaming freely, sitting in neat rows, or lying abandoned by the side of the road; the ubiquitous advertisements, torn billboards, political placards, movie posters, playbills, cryptic graffiti, and meticulously hand-painted storefront signs; the ghettoes, the poor, the homeless, and the flood refugees; the god-fearing family, the loving couple, the man in the crowd, and the lonely, dolled-up girl looking out to sea. This profoundly ambitious and extensive visual collection—found within just the first fifty pages of Evans's book—not only serves as a document of America in Evans's time, but also prophetically catalogues a landscape, character, cultural experience, and set of symbols that remain both poignant and familiar within the country to this day. And in particular, this index bears an uncanny resemblance to the America described and preserved within *photography* since Evans, including that of today's most exciting, perceptive, intelligent, and original practitioners.

3
Tod Papageorge, "Walker Evans and Robert Frank: An Essay on Influence," in *Walker Evans and Robert Frank: An Essay on Influence* (New Haven, Conn.: Yale University Art Gallery, 1981).
4
John Szarkowski, "Introduction," in *Walker Evans* (New York: Museum of Modern Art, 1971).

"The tracing of influences in photography is at best a perilous business," Szarkowski reminds us,[5] and there would be little sense in trying to determine the precise effect of Evans's work on contemporary photographers seventy years later, as it has inevitably been filtered through many generations of creative experimentation, technological advancement, cultural change, and critical evolution. But looking at *American Photographs* today, it is difficult to deny its lasting impression, and it is hard not to postulate that—even in cases where its influence is not direct—Evans's eye certainly resides in the medium's collective unconscious, particularly in respect to the photographing of America. "The modern photographer, like everyone else, is bombarded by a continuous flood of camera images," Szarkowski continues, "an assault on his eyes so massive and chaotic that he often does not himself know which pictures have left a residue of challenge in his mind. The influence of an exceptional photographer works less through his pictures' first impact than through their staying power: their ability to implant themselves like seeds in a crevice of the mind, where the slow clockwork of germination begins."[6]

In the introductory essay written for *American Photographs* in 1938, Lincoln Kirstein stated:

"[Evans] can be considered a kind of disembodied burrowing eye, a conspirator against time and its hammers. … Here are the records of the age before imminent collapse. His pictures exist to testify to the symptoms of waste and selfishness that caused the ruin and to salvage *whatever was splendid* for the future reference of the survivors."[7]

Over the course of the last eighteen months, the economic, social, cultural, and political climates of both the United States and the world at large have frequently been likened to those of Evans's time. Despite our survival of the Great Depression, as well as the rest of the twentieth century, similar symptoms of waste and selfishness have recurred, and once again we find ourselves in an age that is seemingly threatened with, if not in the midst of, imminent collapse. The exhibition WHATEVER WAS SPLENDID represents an attempt to explore the parallels that exist—in America and in photography—between our own time and that of Evans, as well as the enduring power of *American Photographs* as discerned through contemporary photographic practice within the United States. The artists who are included in this exhibition undoubtedly reflect the originality, ingenuity, and multiplicity of voices and visions that can be found within current U.S. photography, but they all inherently possess a familiar "burrowing eye" as well, and share Evans's determination to record, testify, and salvage what they can of their own precarious age for potential future survivors.

In *Down These Mean Streets* (2008-2009), Will Steacy boldly investigates America's inner cities—"the neighborhoods you wouldn't want to be in at night; the parts of towns you drive through, not to,"[8] as he describes them himself—places where collapse has already occurred and where any sense of hope or salvation has seemingly

5
Ibid.
6
Ibid.
7
Lincoln Kirstein, "Photographs of America: Walker Evans" in *American Photographs* (New York: Museum of Modern Art, 1938).
8
Will Steacy, "Down These Mean Streets: Artist Statement," http://www.willsteacy.com/ (October 10, 2009).

been abandoned long ago. Like those of Evans, Steacy's images act as "lyric documents" (Evans's phrase, as noted by Papageorge),[9] recording frankly and with striking clarity the decay, dilapidation, and desolation that confront him on his nocturnal urban expeditions, whilst at the same time evoking a subtle yet physically palpable atmosphere that lies just beneath the visible surface, in this case one of fear, danger, and desperation. Within this series, a surprising number of Evans's own "clues and symbols" crop up in the details—an abandoned car, a handsomely built Victorian house, a barbershop sign, and so on. Yet such clues have been further exposed and speak distinctively to our own time: the car has not only been scrapped, but torched as well; the house is boarded up and falling apart; and the barber's sign is all but entirely obscured by gangland tags and graffiti. Furthermore, Steacy adds many of his own, more contemporary, symbols to the mix, including the deserted towers of a half-built housing project, a sidewalk stained with blood, a window shattered by the impact of a bullet, and a roadside memorial to a murdered brother. As much as his approach, attitude, and visual vocabulary might echo those of Evans, these are records that surely testify to an urban experience of the twenty-first century.

With *Your Golden Opportunity is Comeing Very Soon* (2008–2009), RJ Shaughnessy also hits the streets with his camera, or rather, he photographs where the streets themselves have been hit. Trawling through the parking lots, the avenues, and the long boulevards of Los Angeles at night, Shaughnessy has found and cleverly brought together a collection of easily overlooked sites where the street and its furniture have literally been scarred by the physical impact of automobiles. Signposts have been kinked and crooked, and now point in the wrong directions; plaster walls and cement pillars have had their smooth surfaces violently scraped off; once neat fences have been twisted, disfigured, and distorted; thick steel bollards have been bashed and bent, and now look impotent and forlorn. Captured straight on, in black-and-white, with a powerfully harsh flash, the images take on an air of vintage evidence, like crime scenes captured under the blinding light of intense scrutiny. And what at first seem to be the insignificant remnants of forgotten minor accidents become suggestive traces, which bear within them much wider implications. At the same time, Shaughnessy's photographs possess a certain graphic if not abstract sensibility—rather than signaling accidents, the pictures suggest that his subjects could be the oeuvre of a deconstructivist sculptor, catalogued by a photographer possessing strong formalist inclinations. Although the legacy of *American Photographs* may not be as discretely obvious in Shaughnessy's series as it is within Steacy's, the spirit of Evans is certainly embedded within it in that Shaughnessy has similarly, in the words of Kirstein, "elevat[ed] the casual, the every-day and the literal into specific, permanent symbols."[10] "A garbage can, occasionally, to me at least, can be beautiful," Evans once wrote. "Some people are able to see that—see and feel it. I lean toward the enchantment, the visual power, of the aesthetically rejected object."[11]

9
Papageorge, "Walker Evans and Robert Frank."
10
Kirstein, "Photographs of America."
11
Walker Evans, *Walker Evans at Work: 745 Photographs Together with Documents, Selected Letters, Memoranda, Interviews, Notes* (London: Thames and Hudson; New York: Harper, 1982), 220.

Todd Hido's work possesses a similar sense of enchantment with the rejected, but it leaves the city behind, first turning to suburbia in *Foreclosed Homes* (1996–1997) and then retreating to rural byways in *A Road Divided* (2008–2009). Yet Hido's imagery suggests that he is less interested in the spurned objects that he photographs than in the light, the space, and the atmosphere that inhabit them, leaning more toward the lyrical rather than the documentary side of the photographic spectrum as delineated by Evans. In both series, Hido certainly elevates the everyday, yet does so not through the presence of things, but rather through their absence, and the subtle aura that is left behind. The interiors presented in *Foreclosed Homes*—rooms almost entirely stripped bare, with only the soft light left seeping in through their windows—certainly testify to both specific events and a wider state of affairs within America today, but they do so in a hushed whisper. Similarly, the bleak and bleary byways of *A Road Divided* seem to hum quietly in a minor key, reflecting a long and troublesome journey ahead while also hinting at the possibility of change just over the horizon.

Greg Stimac's video *Peeling Out* (2007) presents a sequence of country roads quite similar to those found in Hido's body of work, but rather than humming, it screeches and roars as a series of pickup trucks, muscle cars, classic roadsters, and Trans Ams race with unjustified urgency into the distance. With each cut to a new road and a new vehicle, a distinct sense of frustration, anger, and aggression grows as tires spin and smoke rises, which then gradually dissipates as the cars ease out of view. Despite the fact that this work consists of moving images, there is a straightness and determined stillness to Stimac's camerawork—a matter-of-factness—that recalls that of Evans and lends a familiar "visual power" to both the subject before the camera and the artist behind it. Again, as Evans himself stated, "There is a deep beauty in things as they are."[12]

Stimac employs a similar visual approach in *Car Wash* (2006), another video work in which the camera stands stoically and straight-faced on the side of the road as its subject intermittently screeches—in this case, a high school girl posing for passing cars with a handmade sign while screaming, "Car wash! Getch your car washed! Over there! Woo-hoo!" repeatedly over the rush of traffic. In one sense, the piece records the same naïve entrepreneurial spirit so often celebrated by Evans: one is reminded of the iconic image of two young boys holding up watermelons by a roadside fish market and fruit stand—its signage having been painstakingly hand-painted as well—which resonates strongly within the first chapter of *American Photographs*. Yet as the video progresses, the girl's incessant fake smile, skimpy neon-pink dress, and perky cheer-leader moves seem to contaminate the innocence of the scene with a somewhat exploitative and overtly sexualized tone, more typical of American commercialism today. Metaphorically at least, it could easily be surmised that a girl standing on a street corner, dancing and waving in a skin-tight outfit as passing drivers honk and shout, is selling more than a car wash, no matter what her sign might say.

12
Walker Evans, 1967 interview with *The New York Times*; quoted in David Travis, *Walker Evans: Leaving Things as They Are* (Chicago: Art Institute of Chicago, 1987), 4–5.

Craig Mammano's *A Few Square Blocks* (2006–2009), a collection of remarkably intimate portraits made in New Orleans, employs an unapologetic rawness in style and approach that shifts notions of sexualization and exploitation from the implicit to the explicit. His subjects, women who pose both clothed and unclothed, oscillate between elegance and desperation, confronting the viewer with a brazen openness that is equally refreshing and disconcerting. Both literally and figuratively, these women bare themselves to the camera, and assume a nakedness of spirit as well as of body that is rarely achieved within the contemporary photographic portrait. Instead of cloaking the female—and in particular the female nude—in sexual performance, fantasy, lust, and desire, as so much of American media does today, Mammano's roughly hewn pictures genuinely uncover his subjects' individuality, presenting them as candidly as possible. Both the photographs and the women possess, in Evans's words, a "purity and a certain severity, rigor, simplicity, directness, clarity...without artistic pretension in a self-conscious sense of the word."[13]

With a similar sense of rigor, simplicity, directness, and clarity, Jane Tam's *Foreigners in Paradise* (2006–2008) examines the hybridization of culture and national identity that she herself has experienced within her own Chinese-American home. Having adopted an Evans-like "straight" strategy, Tam sets out not to explore and define symbols representative of the United States at large, but rather to discern what clues of her grandparents' Chinese heritage remain as the family becomes more and more Americanized with each successive generation. Within a conventional American setting, small details—such as red flip-flops left by a door, the walls of a kitchen protected with tinfoil, and her grandparents scouring the local park for ginkgo nuts brought down by heavy rains—all point to remnants of traditional Chinese life. And yet the photographic approach and surrounding mise-en-scène suggest that, for Tam and the other relatives of her generation portrayed in the photographs, such sights are as American as any other.

Alternatively, Richard Mosse follows the United States, its military might, and its frontline soldiers into foreign lands—the deserts of Iraq—where he cunningly extracts some of the American sights and symbols that they have transported with them from home. In *The Fall* (2009), the prevalent theme of the derelict automobile returns yet again, although in these instances the vehicles have not only been abandoned and torched, but riddled with bullets and blown to pieces by bombs as well. The metal corpses lie destroyed and disgraced in a vast no-man's-land, at once terrifying testaments to war and eerily beautiful memento mori, soon to be subsumed by the approaching sand storm.

In his photographic series *Breach* (2009) and its video counterpart, *Theatre of War* (2009), Mosse shifts his tone from the sublime to the ridiculous, documenting soldiers as they leisurely occupy and inhabit the lavish ruins of one of Saddam Hussein's

13
Walker Evans, "Lyric Documentary" (lecture, Yale University, March 1, 1964); reprinted in *Walker Evans at Work*, 220.

former palaces. They lounge by a giant turquoise swimming pool, casually lift weights in sun-drenched courtyards, and calmly smoke cigarettes whilst taking in the view. Such scenes would not seem out of place in the mansions of Malibu or on the board-walks of Venice Beach if it weren't for the surrounding rubble, the combat fatigues, the inconspicuous heavy weaponry, and the scorched Arabian desert stretching off into infinity.

And finally, in his video piece *Killcam* (2008), Mosse returns home to a veteran hospi-tal with some of the wounded, interspersing various sequences of recovering ampu-tees playing Iraqi-themed combat video games with digital battle footage—found leaked online—of real American missile strikes and assassinations from the ongoing war. In fact, *Killcam* cleverly confuses the line between image and reality, and ultimately calls into question the premise of the 'real' United States altogether when one of the repatriated soldiers explains over *Killcam*'s closing credits, "Actually, coming back here is stepping back into a computer game. Over there is real life. ...[T]here's less reality over here. People only see and hear what they want to."

It is important to note that Evans was perfectly conscious of, and fascinated by, the inherent relativity, imperfect subjectivity, and deceptive clarity of the photographic image, both in terms of others' images and his own. Szarkowski once wrote that "a beginning photographer hopes to learn to use the medium to describe the truth; the intelligent journeyman has learned that there is not enough film to do that,"[14] and Evans was certainly one such journeyman. As his title affirms, *American Photographs* is about both a country and a medium in equal measure; its opening sequence of images—*License Photo Studio, Penny Picture Display, Faces, Political Poster*—more than hints at the fact that the book is as much an interrogation of photography as it is of America, if not more so.

Similarly, in *The Week Of No Computer* (2007–2009), Michael Schmelling focuses not so much on any particular subject matter in the obvious sense, but rather on the pro-cess of looking for, looking at, making, and manipulating photographic images from the perspective of one who is obsessed with, and heavily involved in, the medium in its many contemporary forms. Like Evans, Schmelling embraces the act of openly referencing photography , even making pictures of pictures: one photograph captures a William Eggleston print casually hanging on the wall of a corporate-looking corridor, and another shows a framed portrait of a young Evans himself with a spookily similar picture of Hedi Slimane, torn from *The New Yorker*, pinned beneath it. Furthermore, amongst his traditionally "straight" photographs, Schmelling incorporates a number of experiments, including double exposures, photocopies, creased posters, flatbed scans, and pictures laid on top of other pictures, as well as self-referential snapshots that curiously explore his own surroundings as a photographer: stacks of Kodak print boxes, a Polaroid image of his own camera, a darkroom enlarger, exposure notes,

14
John Szarkowski, *Atget* (New York: Museum of Modern Art, 2000), 99.

outtakes, tearsheets, contact sheets, and so on. Again, there is certainly a "rigor, simplicity, directness, and clarity" at work here, but there is also a fascinating self-consciousness that, through its sincerity, manages to escape the dreaded realms of "artistic pretension." Perhaps the project is cryptically summed up best by the note Schmelling scrawled to himself on a picture he pulled from a book and then scanned into a diaristic image of his own: "reading/looking at walker evans book standing naked in your office."

Hank Willis Thomas's *Unbranded* (2006–2008) is likewise interested in interrogating the photographic medium itself and, more specifically, what he calls the "empire of signs"[15] —or what Roland Barthes called the "what-goes-without-saying"[16] —in advertising photography. Thomas also makes pictures out of pictures, in this case appropriating and manipulating magazine advertisements from the last forty years that have targeted African American consumers or featured African American subjects. The resulting images—stripped of their branding and context—poignantly reveal a number of disturbing stereotypes, generalizations, and aspirational assumptions that reside deep within contemporary American culture, and uncover a number of painful truths about the country's attitudes regarding race, gender, class, and ethnicity. Perhaps even more curious is the fact that Evans's first chapter contains a similar experiment: two cropped details of advertising posters featuring African Americans, both entitled *Minstrel Showbill*, from 1936. And for all intents and purposes, not much seems to have dramatically changed in terms of the visual language surrounding race in America, despite the passing of more than seventy years.

In some ways, *Nirvana* (2007–2009), a series of photographs collected and then re-presented by Jason Lazarus, reverses Thomas's approach in that it takes amateur snapshots (never originally intended for general consumption) and provides them with a purely public platform and context, enabling the photographs to both individually and collectively reflect much broader cultural issues. To make this work, Lazarus posed a question: "Do you remember who introduced you to the band Nirvana?" He asked other people to send him an answer written on the back of a photograph, and then scanned, enlarged, and framed a selection of the submitted images, with their corresponding texts handwritten onto the prints themselves. Remarkably, this simple question provoked a number of astonishingly tender and painful responses, which together, amongst other things, paint a subtly moving portrait of male roles, relationships, identities, and masculinity within the United States today: "Dave…introduced me to Nirvana…he carved my name into his arm"; "Mikey, my mom's second husband…he was around until I was 13"; "My father introduced me to all grunge music"; "I listened to Nevermind for the first time with [my uncle]…I lost him to AIDS in 1994." In addition, these photographs and their accompanying texts convey a sincerity, an authenticity, even a sense of truthfulness that most of today's publicly exhibited photographs lack, specifically because *Nirvana*'s imagery is not the considered

15
Hank Willis Thomas, "Unbranded: Artist Statement,"
http://hankwillisthomas.com/portfolio.html (October 8, 2009).
16
Roland Barthes, *Mythologies*, translated by Annette Lavers
(New York: Hill and Wang, 1972), 11.

creation of a single, purposeful, "professional" photographer, but is instead the result of a large, collective effort evidencing very private, personal memories.

Finally, Tema Stauffer, who focused American masculinity and male adolescence in her portraiture series *The Ballad of Sad Young Men* (2008), includes several such portraits within her broader and more extensive body of work: *American Stills* (1997–2009). Returning to the eclecticism of the first chapter of *American Photographs*, and under a similarly sweeping heading, Stauffer presents an assortment of sharply poetic observations of a country that at times can be angry, melancholy, brutal, and cold, but can also be enchantingly majestic and profoundly moving. Throughout the series there is a critical yet immensely forgiving sense of real compassion at work—a profound love for the subject, with all of its flaws—which strikes straight at the soul of the matter, in the most ordinary places and everyday moments. Rather than simply testifying to waste, selfishness, imminent collapse, and so on, Stauffer's

Stills represent a truly committed and heartfelt attempt at unearthing the "splendid" from the "whatever" of contemporary America.

At its heart, WHATEVER WAS SPLENDID is centrally informed by the legacy of *American Photographs*, and by Evans's vital contributions to the nation's photographic traditions, as well as the practice of photographing of the United States in general. But it is by no means intended as a nostalgic update or sentimental plea for photography (or, for that matter, America) to return to its past. As much as Evans's legacy has provided both the inspiration and a reinforcing framework for the exhibition (and, in many cases, for the work of the participating photographers), WHATEVER WAS SPLENDID is first and foremost the manifestation of a fertile terrain—that of contemporary photographic practice within the United States—where Szarkowski's "slow clockwork of germination" continues to develop, adapt, propagate, and flourish in a variety of fresh and fascinating ways. Consciously or not, all the photographers represented here have, in their own distinct ways, expanded upon many of the themes, strategies, clues, symbols, "certain sights, [and] certain relics of American civilization past or present"[17] first glimpsed in *American Photographs*. And like Evans, they have both reinvigorated American photography and redefined their country—conceptually, aesthetically, culturally, politically, historically, photographically, and so on—within very contemporary terms, celebrating both the United States and its photography, as Kirstein put it, "with all [its] clear, hideous and beautiful detail, [its] open insanity and pitiful grandeur."[18]

AARON SCHUMAN

PHOTOGRAPHER, WRITER, EDITOR, CURATOR, AND
FOUNDER OF *SEESAW MAGAZINE*

17
Kirstein, "Photographs of America."
18
Ibid.

Will Steacy

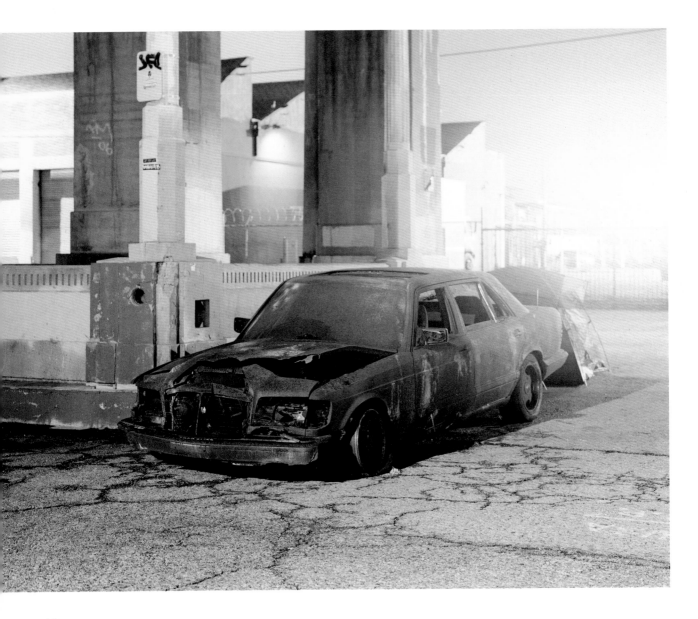

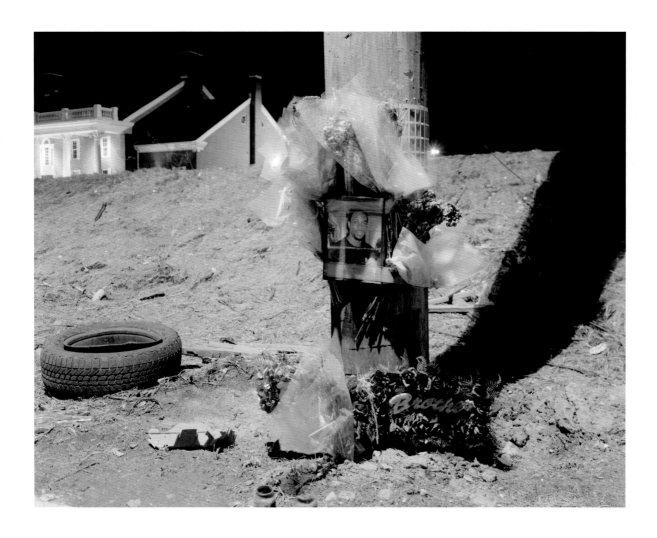

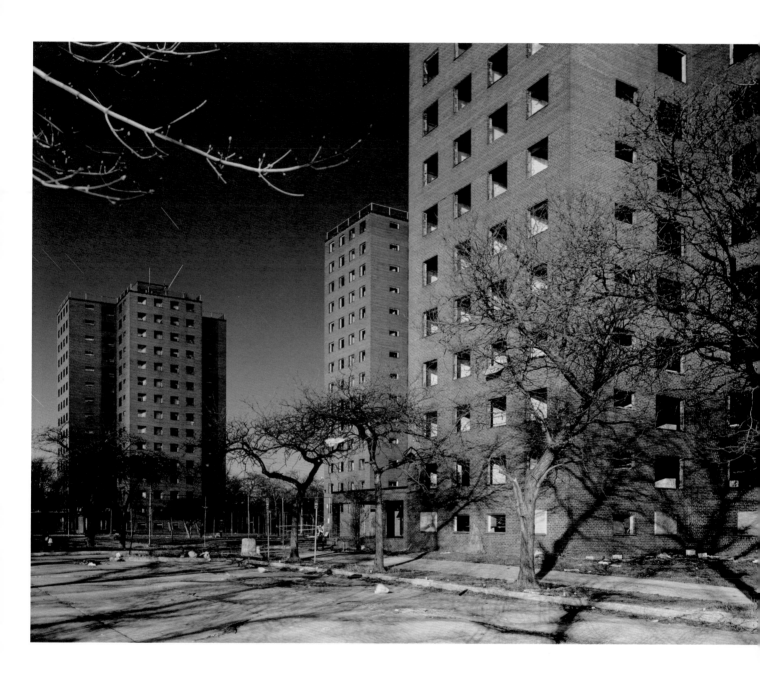

RJ Shaughnessy

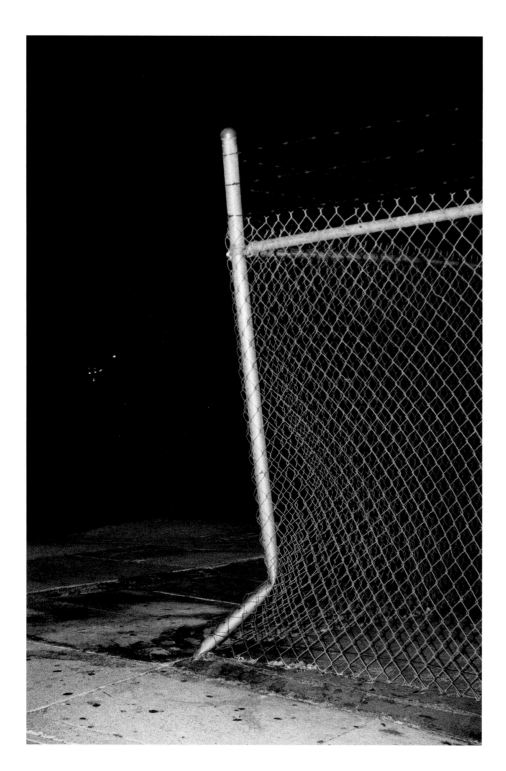

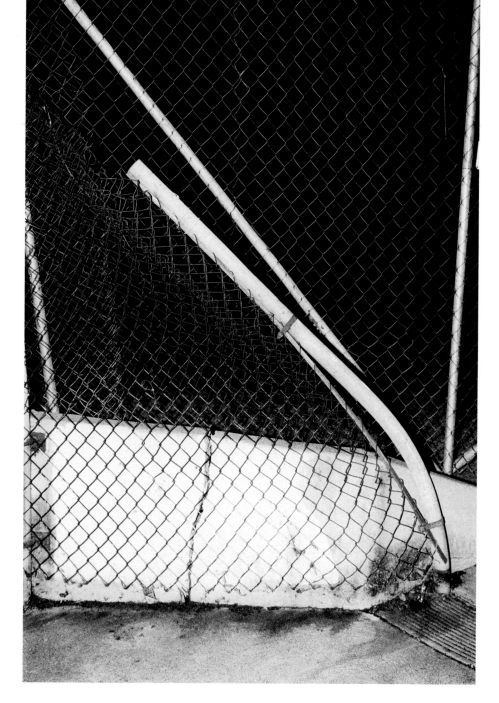

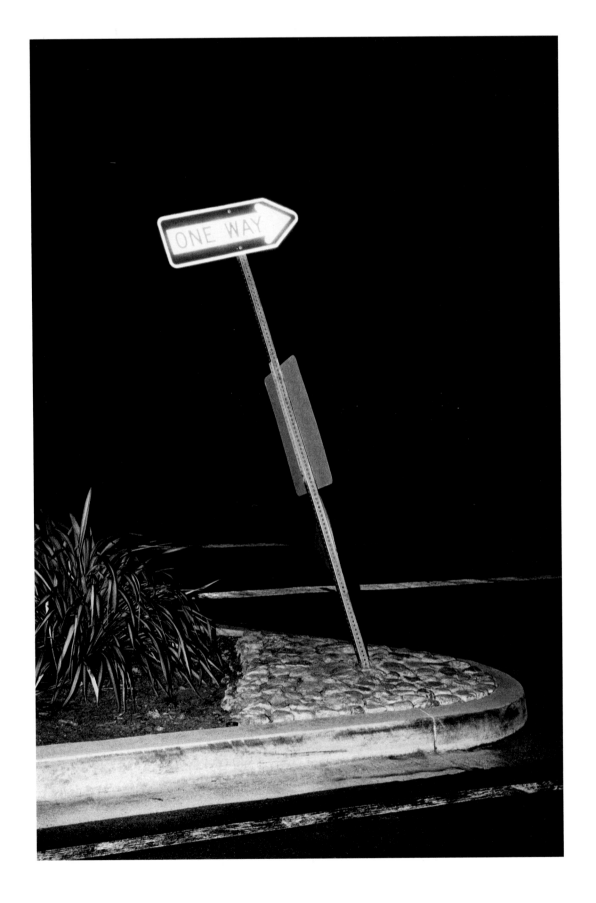

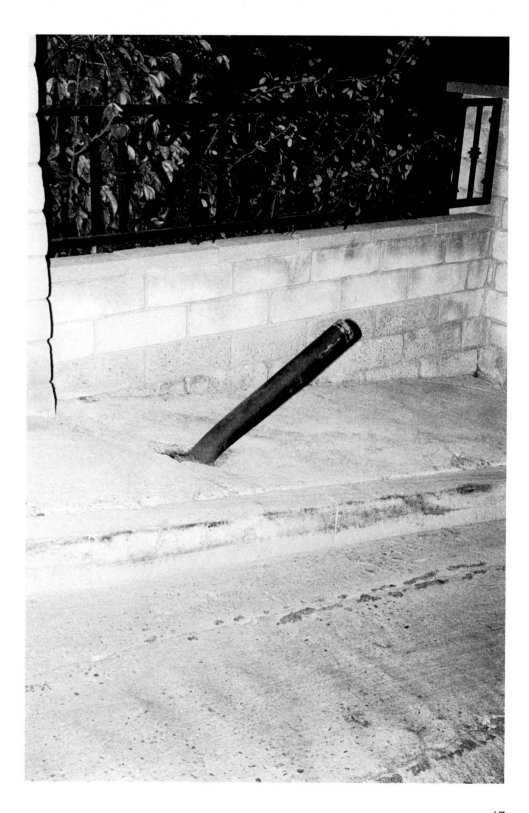

LEFT
RJ Shaughnessy
Glendale Blvd. #1, 2008
From the series *Your Golden*
Opportunity is Coming Very Soon
LightJet Print

RIGHT
RJ Shaughnessy
Ronda Vista Dr., 2008
From the series *Your Golden*
Opportunity is Coming Very Soon
LightJet Print

Todd Hido

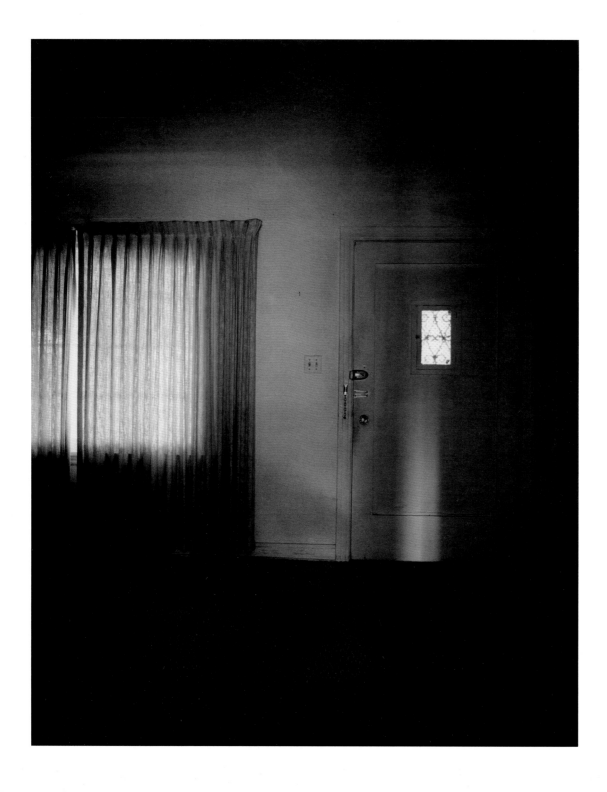

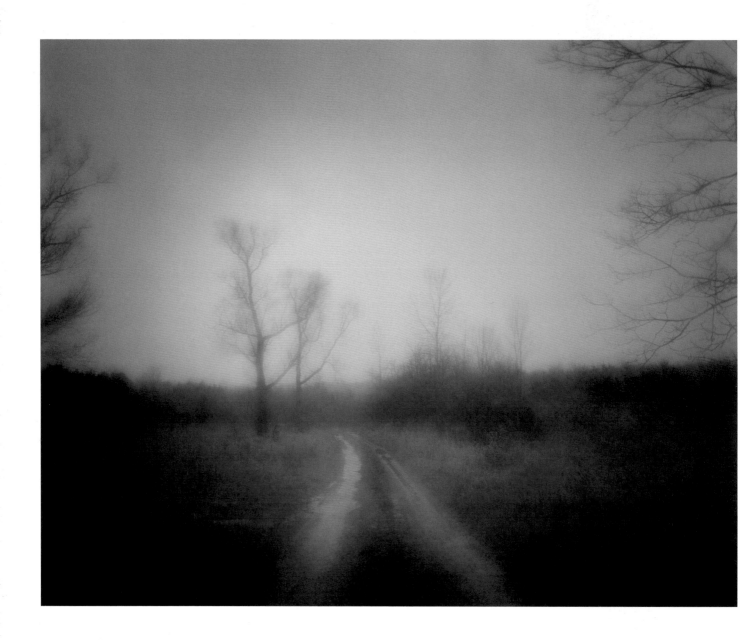

LEFT

Todd Hido

#8614, 2009

From the series

A Road Divided

Chromogenic Print

Courtesy of Stephen Wirtz

Gallery, San Francisco

RIGHT

Todd Hido

#1927-A, 1996

From the series

Foreclosed Homes

Chromogenic Print

Courtesy of Stephen Wirtz

Gallery, San Francisco

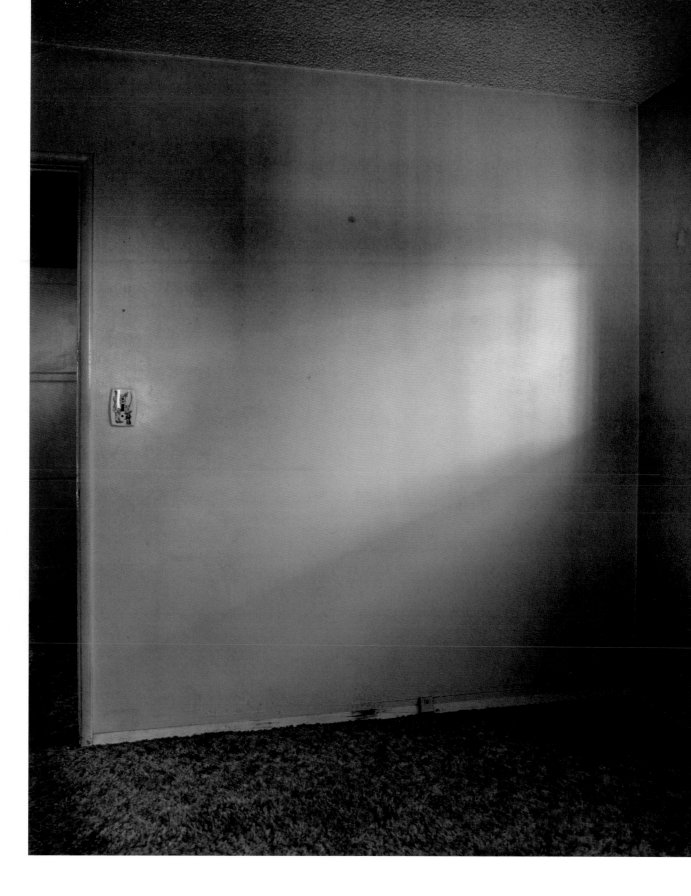

Greg Stimac

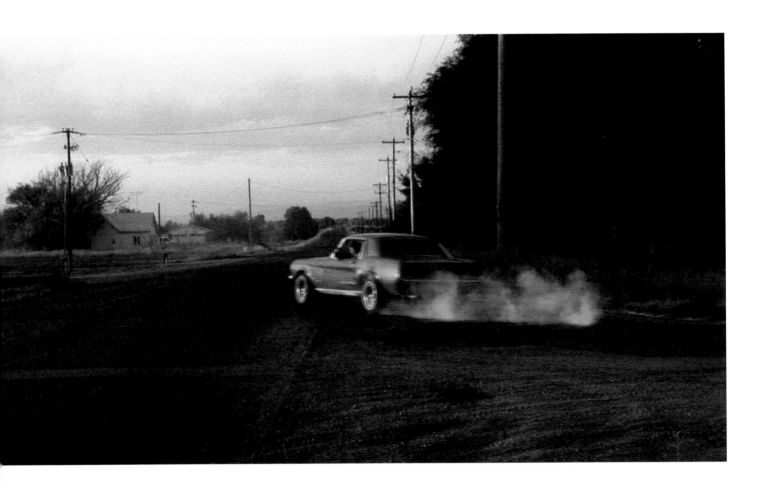

Greg Stimac
Peeling Out, 2007
Video Still

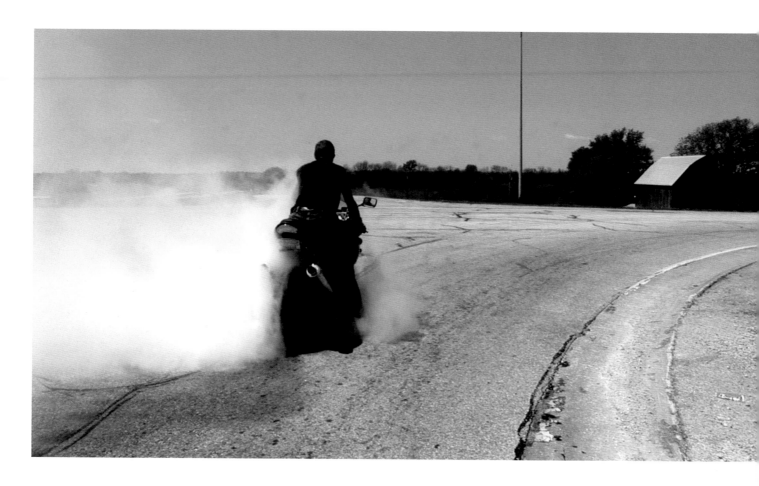

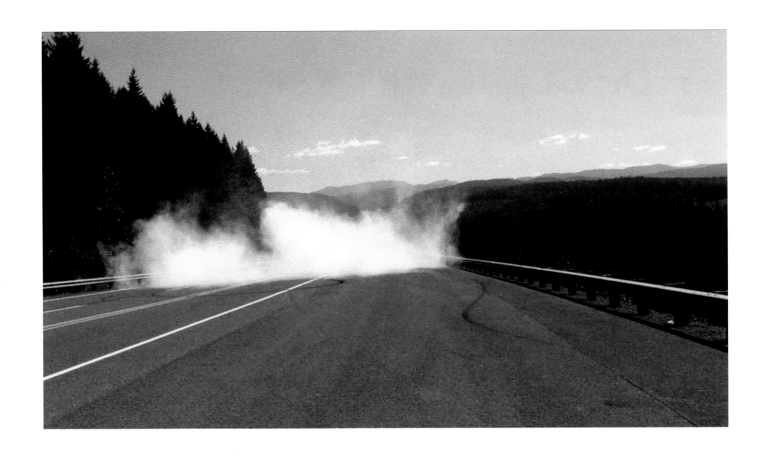

Greg Stimac
Peeling Out, 2007
Video Still

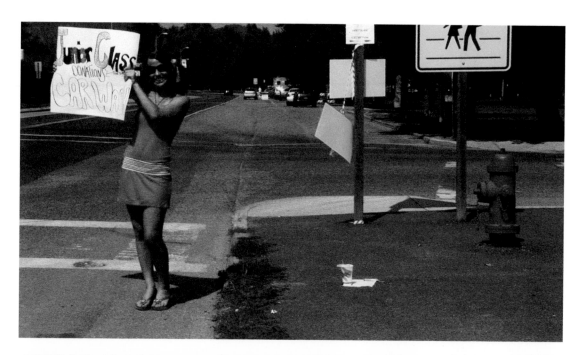

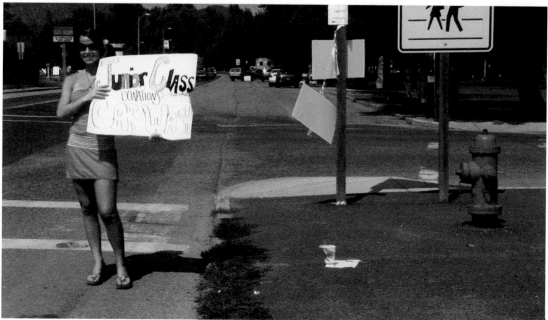

LEFT

Craig Mammano

Ce Ce, New Orleans, 2008

From the series *A Few*
Square Blocks

Archival Pigment Print

RIGHT

Craig Mammano

Paia, New Orleans, 2008

From the series *A Few*
Square Blocks

Archival Pigment Print

Jane Tam

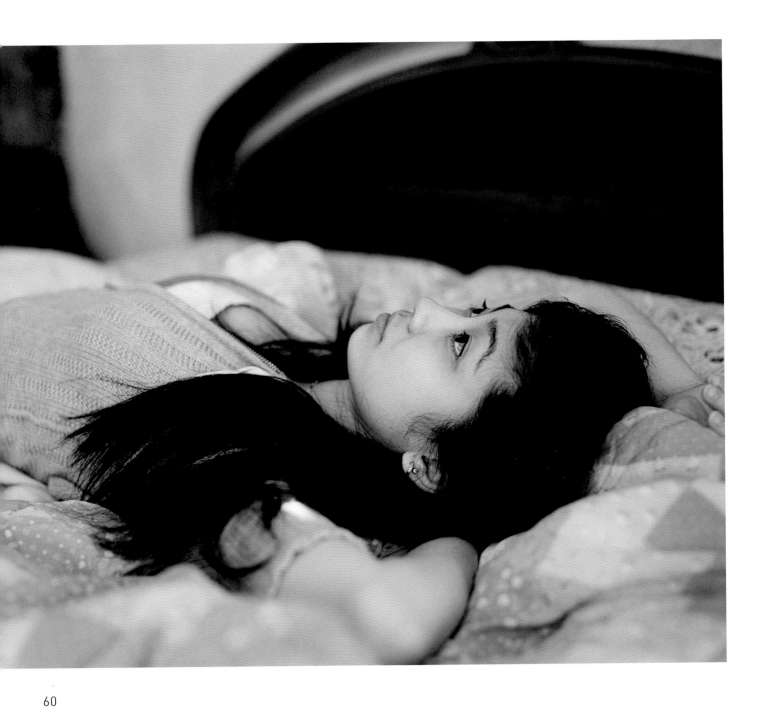

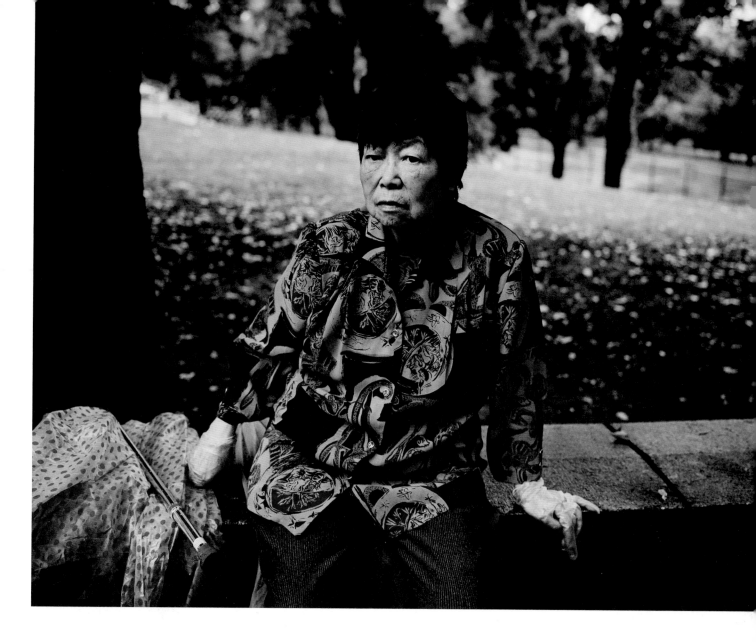

Jane Tam
Grandfather Helping Grandmother
Up The Hill to Pick Ginkgo Nuts, 2007
From the series *Foreigners in Paradise*
Archival Inkjet Print

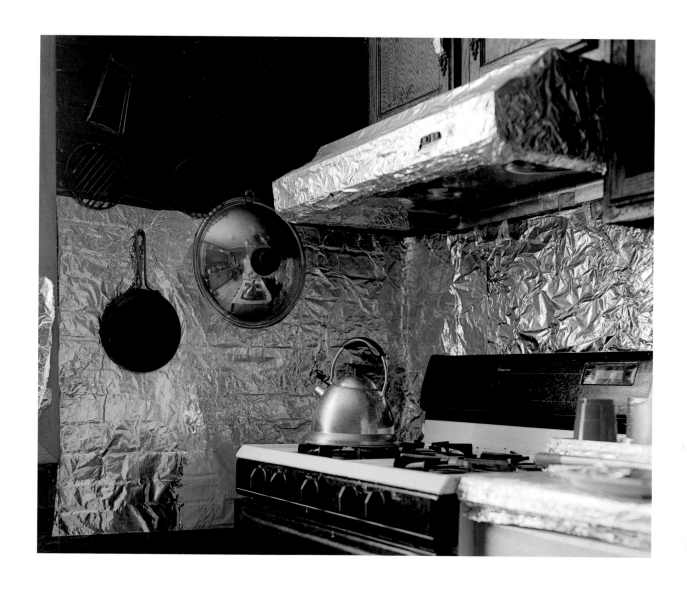

Jane Tam
Aunt's Tin-Foiled Stove Top, 2006
From the series
Foreigners in Paradise
Archival Inkjet Print

Richard Mosse

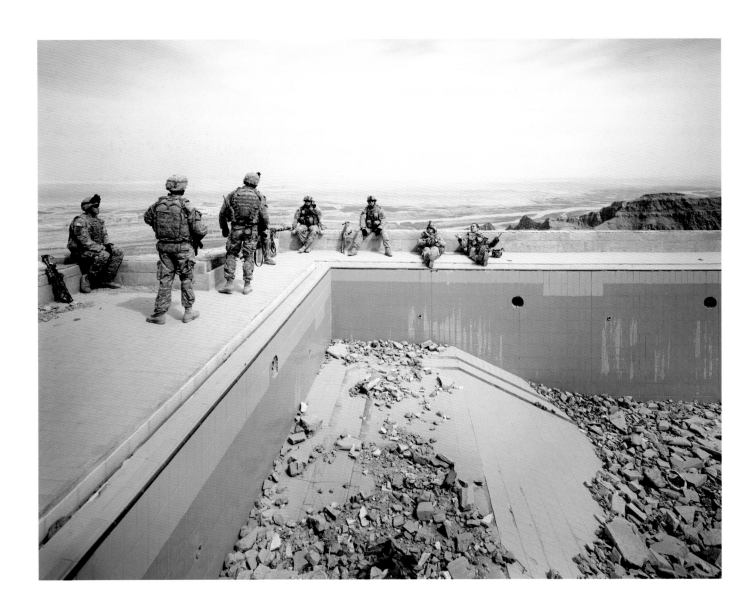

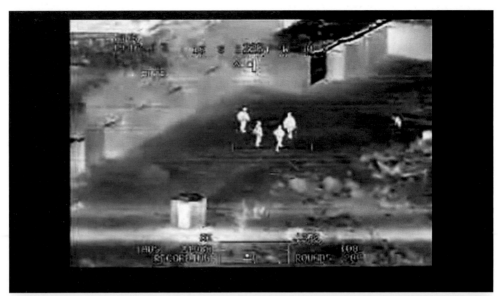

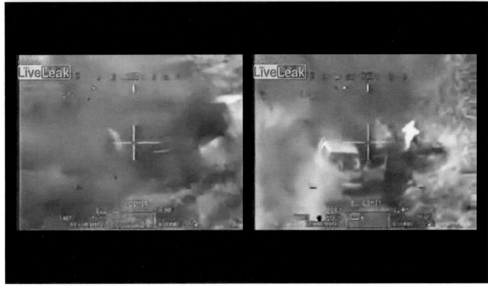

LEFT

Richard Mosse

Pool at Uday's Palace, Jebel
Makhoul Mountains, Iraq, 2009
From the series *Breach*
Digital C-print
From the Collection of
Jeffrey N. Dauber

RIGHT

Richard Mosse

Killcam, 2008
Video Stills
Courtesy of the Artist and
Jack Shainman Gallery, New York

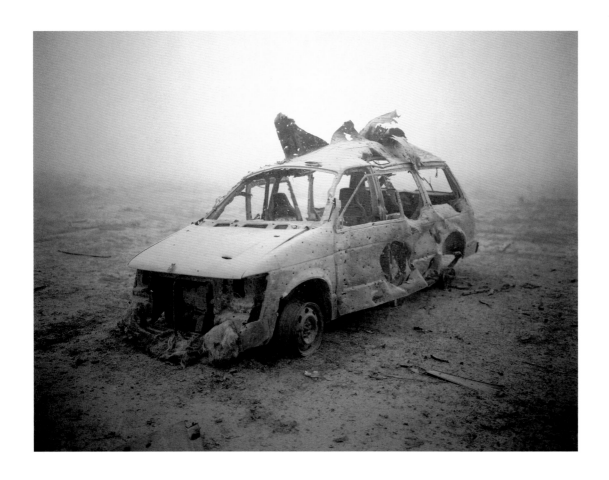

Richard Mosse

Space Wagon Mosul, 2009

From the series *The Fall*

Digital C-print

Courtesy of the Artist and

Jack Shainman Gallery, New York

Richard Mosse

Cigarette at Al Faw Palace, 2009
Baghdad, Iraq
From the series *Breach*
Digital C-Print
Courtesy of the Artist and
Jack Shainman Gallery, New York

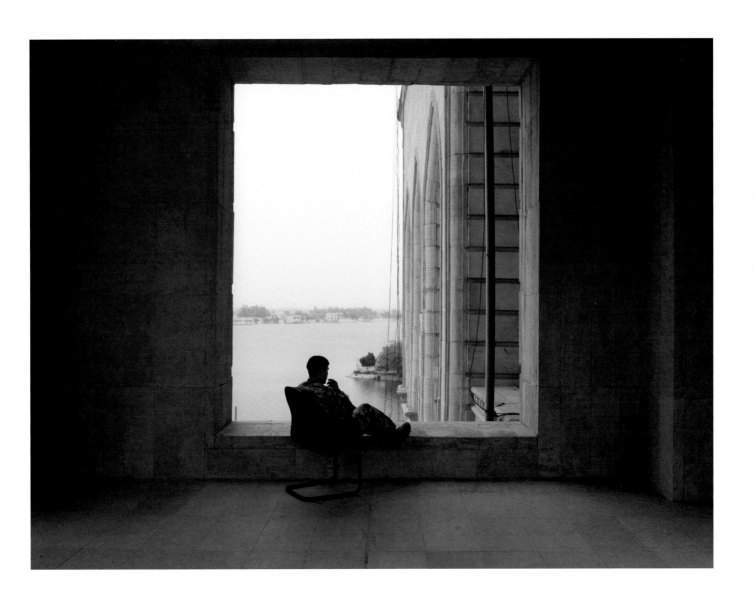

Michael Schmelling

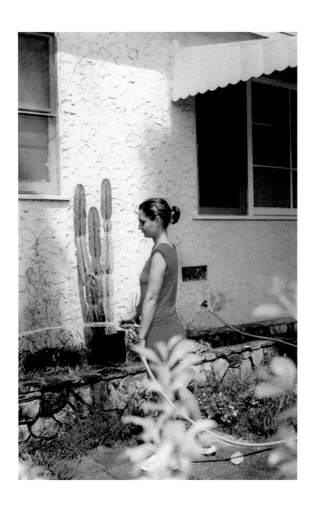 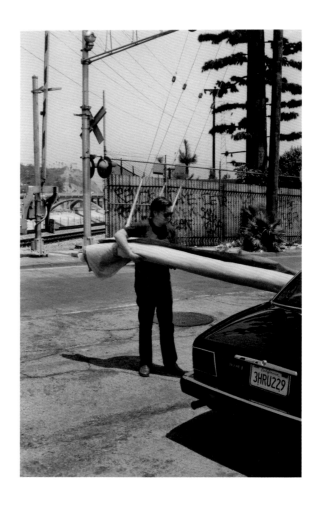

Michael Schmelling
2_Pasadena, 2008
From the series *The Week
Of No Computer*
Chromogenic Print

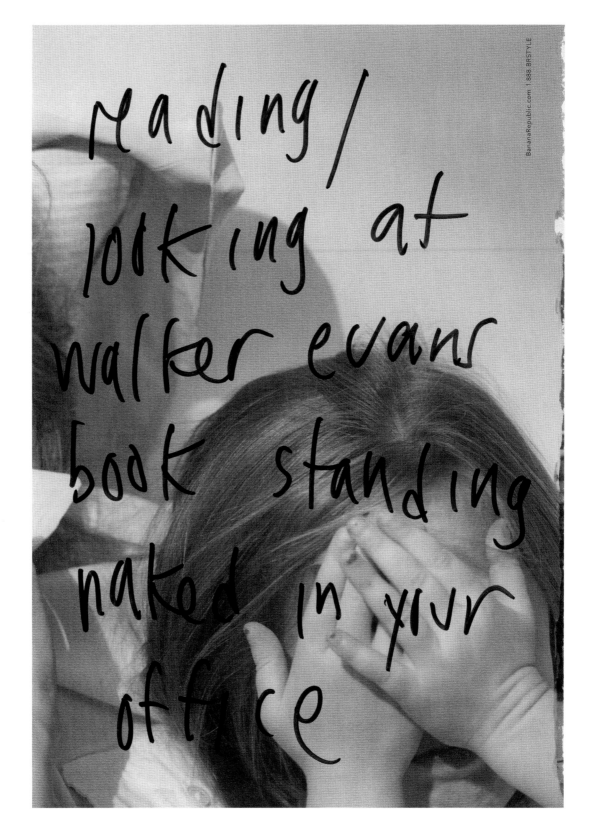

reading/
looking at
walter evans
book standing
naked in your
office

Michael Schmelling
reading_Evans, 2007
From the series *The Week
Of No Computer*
Chromogenic Print

69

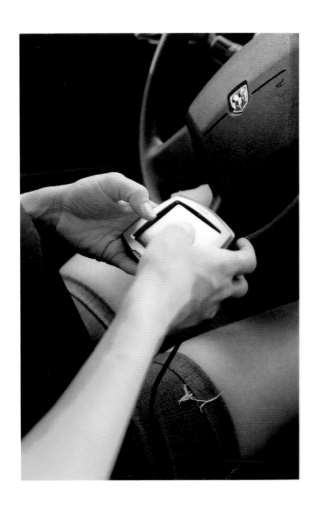

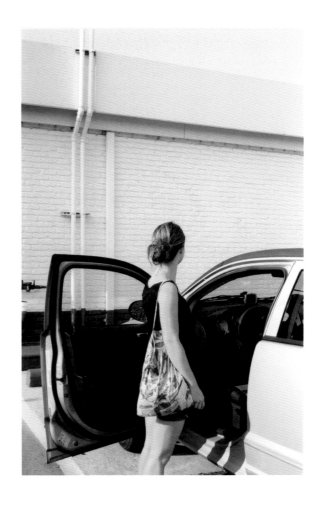

Michael Schmelling

2_gps_rental, 2008

From the series *The Week Of No Computer*

Chromogenic Print (diptych)

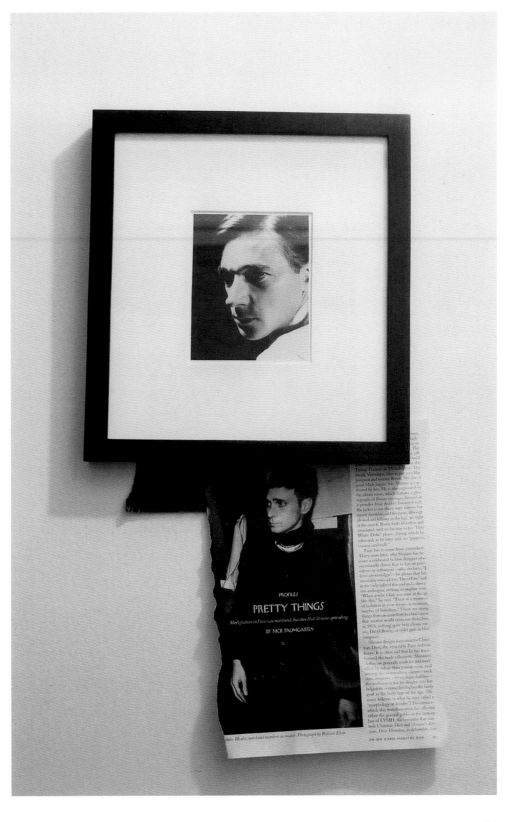

Michael Schmelling
Evans Slimane, 2007
From the series ***The Week
Of No Computer***
Chromogenic Print

Hank Willis Thomas

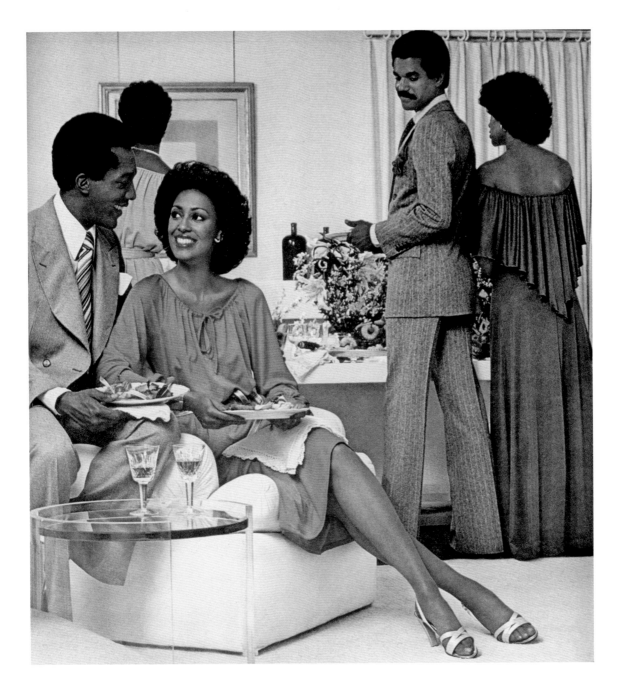

LEFT
Hank Willis Thomas
***Available in a Variety of Sizes
and Colors,*** 1977/2007
From the series ***Unbranded***
Lambda Print
Courtesy of the Artist and
Jack Shainman Gallery, New York

RIGHT
Hank Willis Thomas
Movin' on up, 1976/2008
From the series ***Unbranded***
LightJet Print
Courtesy of the Artist and
Jack Shainman Gallery, New York

Hank Willis Thomas
Slack Power, 1969/2006
From the series ***Unbranded***
LightJet Print
Courtesy of the Artist and
Jack Shainman Gallery, New York

Hank Willis Thomas
Are you the Right Kind of Woman for it?, 1974/2007
From the series *Unbranded*
LightJet Print
Courtesy of the Artist and
Jack Shainman Gallery, New York

Jason Lazarus

Trinity, the girl I lost my virginity to and a die hard Kurt fan, introduced me to Nirvana on the tape playing boombox in her bedroom.

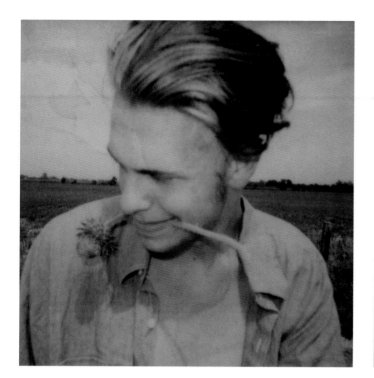 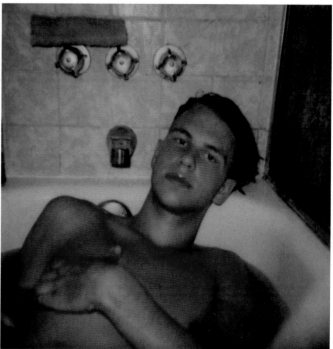

Dave was my cover boyfriend in high school. Dave introduced me to Nirvana and mushrooms. He carved my name into his arm with a razor blade and when I tried to break up with him, he read me a love poem over the phone that I later recognized as lyrics from Pink Floyd's 'Dark Side of the Moon'.

LEFT
Jason Lazarus
*Trinity (*from *Nirvana),* 2007
Archival Inkjet Print
Courtesy of Andrew Rafacz
Gallery, Chicago

RIGHT
Jason Lazarus
*Dave (*from *Nirvana),* 2007
Archival Inkjet Print (diptych)
Courtesy of Andrew Rafacz
Gallery, Chicago

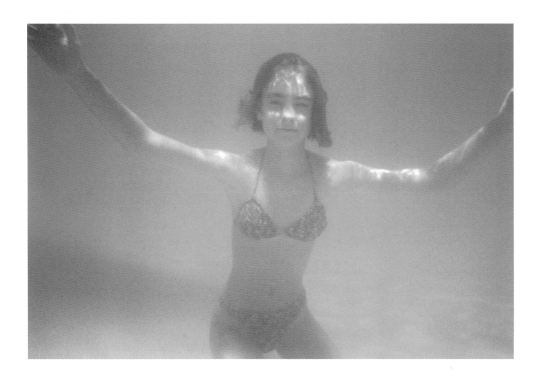

My daughter Caitlin introduced me to Nirvana. I took this picture of her in the Caribbean in 1994. In the week after this picture was taken, she broke her back and spent the next six years in rehabilitation. I remember clearly Cobain's voice as the soundtrack of this time when she lost so much

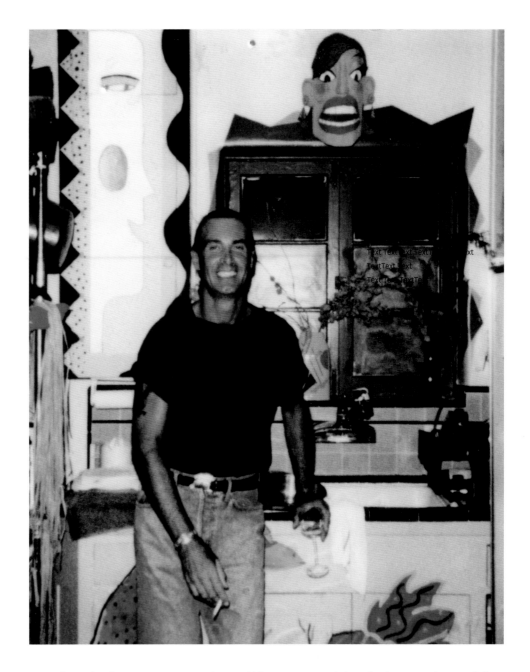

My uncle used to fly me out to Los Angeles as a kid. He was my early introduction to music, especially the Ramones and Joy Division. He paid me $100 to coat check his parties at 8 years old. I listened to Nevermind for the first time with him, straight through at the kitchen table. I lost him to AIDS in 1994.

79

Tema Stauffer

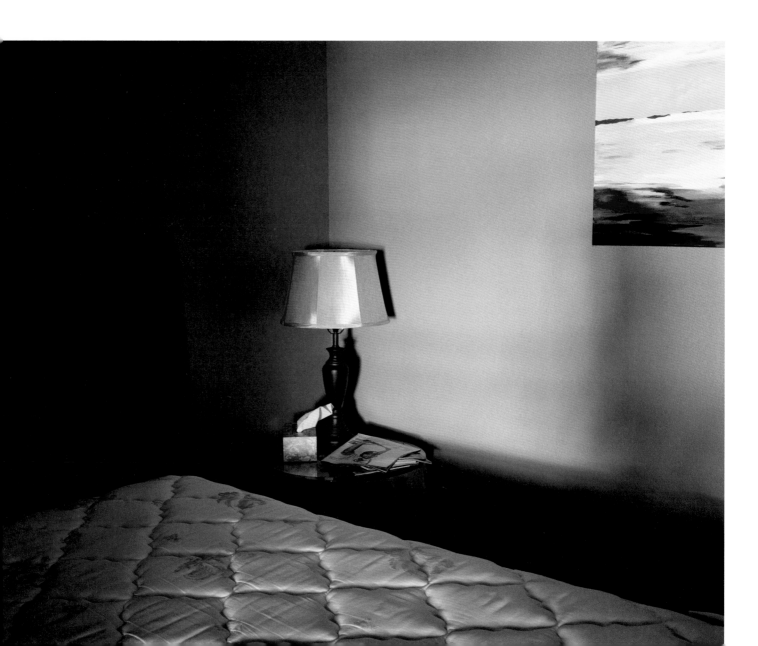

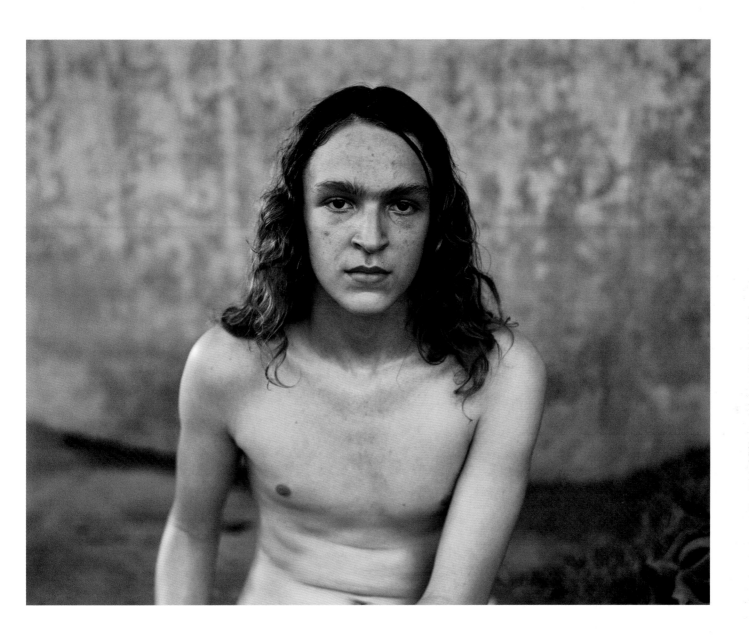

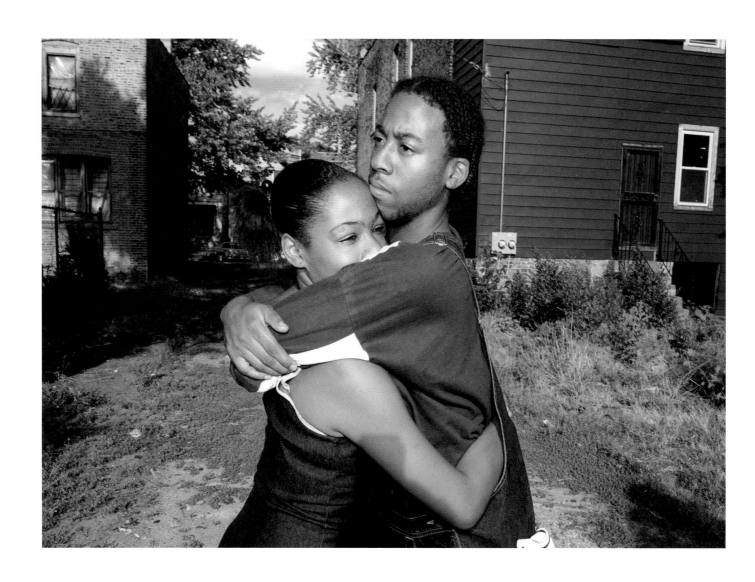

Tema Stauffer
Couple Embraces,
Chicago, Illinois, 2000
From the series
American Stills
Digital C-print
Courtesy of Daniel Cooney
Fine Art Gallery, New York

82

Tema Stauffer
Winter Gas Station,
Minnesota, 2003
From the series
American Stills
Digital C-print
Courtesy of Daniel Cooney
Fine Art Gallery, New York

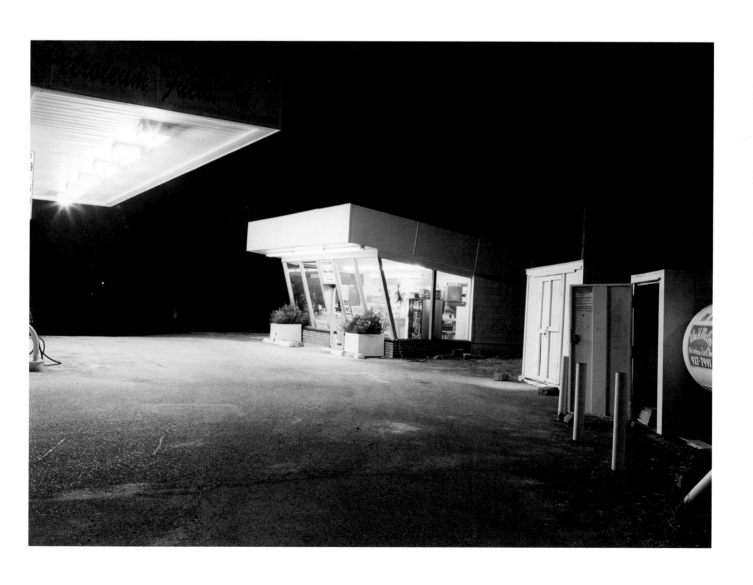

Assembly:
Eight Emerging
Photographers
From Southern
California

**WALLIS ANNENBERG
PHOTOGRAPHY DEPARTMENT AT
THE LOS ANGELES COUNTY
MUSEUM OF ART**

NICOLE BELLE

MATTHEW BRANDT

PETER HOLZHAUER

WHITNEY HUBBS

MATT LIPPS

JOEY LEHMAN MORRIS

ASHA SCHECHTER

AUGUSTA WOOD

Assembly: Eight Emerging Photographers From Southern California

EDWARD ROBINSON and SARAH BAY WILLIAMS

ASSEMBLY presents recent work by eight significant photographers—Nicole Belle, Matthew Brandt, Peter Holzhauer, Whitney Hubbs, Matt Lipps, Joey Lehman Morris, Asha Schecter, and Augusta Wood—who have emerged from the Southern California region in the last decade. Approaching the making of photo-based arts in a number of different ways, they create work that both reflects the cultural heritage of the region as well as suggests important trends in current American photographic practice. Over its relatively short course, the cultural history of Southern California has been one of ongoing dialogue between utopian ideals and apocalyptic apprehension—the boosterism of the "end of the road" state, heralded for its promise and abundance, in tension with concerns about the fragility of its natural and built environment. Photographers working in Southern California have long responded to its exceptional physical terrain, as well as the presence of its entertainment industry with the liminal lure of image sundered from reality to generate a dream realm for consumption. The region's artistic output in particular has been marked by an emphasis on the materiality of production and innovative attention to conceptual experiment, supported by a strong and sustained academic network.

Building upon a photographic tradition drawn alternately to the region's daylight or to its klieg light, the photographers assembled here reckon with the radical changes now posed by digital production and emerging social media. In diverse and highly personal ways, their work suggests common interests in examining the physical make-up, presentation, and dissemination of photo-based art; a greater acceptance of the mediated experience a photo-driven world offers for the formation of contemporary identity; and a greater interest in the possibilities for curating one's own understanding of the world. Some of the photographers revisit the inherent fragility and provisional materiality of historic photographic processes, while others engage the indexical possibilities of performance—self, appropriated image, altered environment— to open new realms of attention and meaning. All engage, in various ways, with the relationship of memory to the formation of personal experience and understanding. In total, the assembled achievements of these eight photographers do not offer any

definitive statement of one museum's imprimatur so much as hope to suggest the vitality and richness of American photographic practice today.

Nicole Belle

Home is the realm of Nicole Belle's photographic explorations, where the normative trappings of domestic tranquility are upended by the figurative convolutions of the photographer herself. In her series *Apartment* (2008–2009), Belle has enacted before the camera performances of private meaning, unfamiliar scenarios of vivid bodily action and movement that nonetheless suggest their own fervent logic. She works with her own corporal contortions and makes unconventional use of objects in her home, turning her domain into the palette of her psyche. A desiccated ham tangled in crisscrossed string hangs nakedly and equivocally in front of her comfortably clothed feminine waist. She tangles herself in a chair balanced on top of a kitchen table, threatening to topple a bowl of fruit. Detritus and scraps fill a bucket, the beginnings of compost, the fuel that will grow more food. Later we see that the ham has been partially consumed. This ham was, in fact, just part of Belle's kitchen, tied ingeniously in twine by her husband so that it could hang easily; over time the ham became part of soups and other meals. What at first appears to be absurd becomes part of Belle's desire to capture a connection between a person and the space in which she lives. The viewer searches for sense in the image in the same way that a character in the prose of Samuel Beckett wanders, searching for answers that do not exist. Belle proposes an absence of explicit disclosure, and in so doing, she creates new meaning.

Belle takes inspiration from Viennese Actionism of the 1960s, practiced by a group of artists including Rudolf Schwarzkogler, Günter Brus, Otto Muhl, and Hermann Nitsch. The Viennese Actionists staged sometimes violent and always unconventional happenings that utilized the human body in disturbing and seemingly destructive ways. Schwarzkogler's work particularly interests Belle—he performed and photographed six "actions" during his short life (he was dead at twenty-nine, the casualty of a leap or fall from a window). His performances used figures covered in bandages (anonymity for effect and perhaps to prevent recognition that could cause job loss), employing various items—from razor blades to dead chickens—to perform what appeared to be castration and trepanning. While Schwarzkogler was working against the grain, reacting against conservatism and traditional beauty with a language of uncomfortable subject matter—nudity, blood, death, violence—Belle presents the viewer with not so much a descent into the darker possibilities of the human psyche as an exploration that leads to amusement and pleasure. By exposing herself as a lone figure accomplishing feats of household playfulness, she lets us know that we are not alone.

Matthew Brandt

The desire to create new meanings through an emphasis on the physical properties of photographic production is vividly present in the work of Matthew Brandt. His series

Lakes and Reservoirs (2006–2008) suggests the lengths the artist will go in his investigation. Photographing water bodies in the western United States, Brandt has soaked each chromogenic print in the water of its depicted subject for varying times, from days to weeks to months. He monitors the soaking prints until the breakdown of color material achieves a desired, unique look. By emphasizing the materiality of the print —not as a finely finished, indexical record of a subject, but rather as one that is as much at the mercy of physical forces as any other object in the world—Brandt embraces the anticipation of decay. Underscoring the transformative properties of the photographic registration itself, Brandt writes, "When a photograph becomes more blurred or scratched, an invisible veil or screen emerges between viewer and subject. This veil, which is always present but conventionally repressed, is allowed to breathe in my work."[1] If photographers once sought solace in the landscape as a place where nature's eternal processes reside, Brandt focuses on a more immediate presence in the photographic production itself. "I often leave prints out in the sun, or buried in the soil, simply to see how they change. [Because] many of my works are made with nonarchival materials, the outcome of their passages is still undetermined. They exist in a natural system of decay and transformation." Exploring the critical notion of "aura" elicited by photographic reproduction, Brandt suggests that "using organic material helps highlight a uniqueness that is often lost in the industrial gloss of photography."[2] By embracing their deterioration, Brandt thus reclaims the uniqueness of his photographic works.

Eschewing contemporary conventions of digital printing, Brandt returns to more unpredictable historical processes. Rather than emphasizing the interaction with light as a fundamental component of the photographic process, his use of such processes as salted paper printing and gum bichromate (an archaic color process typically pigmented with watercolor and valued for its density) serves to highlight the role of liquids in photographic printing. "Liquid is essential for all forms of life. It reflects a particular shapeless freedom with a multitude of transformational properties, as water to ice, milk to cheese, or metal to photograph."[3] Such an interest in the evolution of photographic printing necessarily engages with history. Brandt's interest as a young artist in reckoning with decay as an inherent component of transformation is notable. He suggests that this awareness comes from his grappling with the Buddhist beliefs he was exposed to in childhood.

In still another series, Brandt has explored the material process by adding residue drawn from the subjects he depicts in his photographs. In *North, East, South, West* (2007), Brandt added dust collected from the high-rise office buildings seen in his images; the dust thus served as the pigment base for the representation of its source. "In essence, the building's dust was used to portray its image," he says.[4] For his image *Bees and Butterfly* (2007), Brandt incorporated the grounded up remains of twenty-three dead bees and a butterfly he found washed up onshore. A recent series of

1
Matthew Brandt,
Artist Statement, 2008.
2
Ibid.
3
Ibid.
4
Ibid.

portraits similarly employs liquids that are uniquely related to its individual subjects. *Dennis* (2007) depicts a prostrate infant; the five by five-inch image was printed on salt paper with the aid of his mother's breast milk. Another portrait is even smaller, its poignantly miniature size dictated by the use of its subject's tears for its printing. In all of his work, Brandt discovers anew that from the limitations of the physical world emerge bountiful possibilities for generation.

Peter Holzhauer

Peter Holzhauer is on a mission to teach his viewers to see anew. Based in Los Angeles, he guides our attention to the accidental, the presence of well-intentioned but unfortunate urban planning, and the misplacement and even defacement of the natural setting. Holzhauer's approach is that of a visual anthropologist, surveying the city and countryside for signs of what has become of us—how the consequences of our use of the land have created the fabric of our environment today. In his series *The Marine Layer* (2005–2008 and *Los Angeles Class* (2005–2008), Holzhauer has exposed form in the world where form might easily be ignored. Telephone wires crisscross at the heights of palm trees. Malt liquor advertising—"Expect Everything"—hangs ironically over a cluster of downtrodden homes. A billboard with a celebrity endorsement for cognac obscures another house, yet it is in turn dwarfed by its surroundings—streets, palms, telephone poles, and the Los Angeles hillside behind it dense with still more homes. In Holzhauer's deadpan portrayal of the metropolis, daily ironies sharpen under perpetual sunshine through the clash of prosperity and destitution, the jumble of the natural and the man-made. In his choice of subject, Holzhauer explores the nature of nostalgia and the lingering on of the past. His series *Residue of the Reel* (2005–2008) reflects on the contrast of this sunny environment with his upbringing in Maine, including his former work as a boat stern man. Holzhauer recalls how on a return visit to Maine, when he ran into his former boat captain and told him of his new home, "He looked at me like I was crazy."[5] Yet Holzhauer is committed to reckoning with the nature of this new and different environment. Frequent scenes of absurdity include Holzhauer's photograph of a prominent electrical wall outlet that appears as something talismanic and even living. Los Angeles architecture, such as the Bonaventure Hotel downtown, glitters in ethereal accomplishment. Water takes the form of giant blocks of ice, melting slowly on the curb. Discarded plastic cups litter a dirty puddle like stars forming the northern sky. Holzhauer documents claims on the local terrain by individuals we will never see or know, such as the person who, while repainting a wall, painted around the creeping vines clinging to the cinderblocks rather than removing this tenuous living things. Here, we are transported to the moment of this decision and to the moment when Holzhauer pressed the shutter to record it. We are reminded of being products of our surroundings, even as life feels largely accidental. How we perceive these accidents of incident, and how we learn from them, determines our future.

5
Peter Holzhauer, quoted in Micol Hebron "1 Image, 1 Minute," X-tra 10, no. 1 (Fall 2007), http://www.x-traonline.org/past_articles.php?articleID-27.

Whitney Hubbs

There are many reasons why people steal—material need, a feeling of entitlement, the gesture of rebellion. Perhaps more enigmatic is why someone would feel she has stolen something when nothing of substance has been taken: the feeling that by finding something so precious and otherworldly it seems impossible it could have been *paid for* by currency or deed. Whitney Hubbs has remarked that she "steals" moments by photographing them. In her series *Day for Night* (2008–2009), Hubbs has assembled instants from her life in California and its environs, documenting her experience to tell a story made of memories. Her work has a distinctly urban feel, the life of a twenty-something, apartment-dwelling Angelino residing in a neighborhood thick with trees and landscaping that obscures an underlining natural desert. Other images demonstrate the ease with which one can escape the sprawling metropolis—the ocean as an exclamation point at the end of the road; an anomalous, isolated patch of snow a short drive up into the mountains. Her subjects are landscapes, still-lifes, water, caves, and friends. Her themes are sexuality, death, love, loneliness, disappointment, and light.

Throughout all her work, memory is ever fleeting, grasped without avail as a means by which to make sense of the present. Hubbs describes her experience in high-contrast black and white photographic prints, yet all incorporate passages that obscure visually through darkness or light, washing away immediate description. Evoking the difficulty of ever recalling fully the features of a friend, the faces of her subjects are often turned away or in shadow. The disorientation of recollection is also suggested in scenes of the horizontal landscape upended and displayed vertically. By arraying such images in grids, Hubbs abandons the unfolding of linear narrative, offering in its stead a free range of associations that hold no beginning or end. In one photograph, a hand reaches down to squelch the spray of a garden sprinkler head, as if to say, "Mankind made this, but it doesn't have to be this way—my hand can stop what man has made real." Through her photographs, Hubbs affirms that she exists even as she evokes a private understanding, one that is nonetheless inviting. The viewer of this personal history can never comprehend the full story. Yet by participating in the possibilities of visual association that the photographer provides, we form our own narratives and thus bestow meaning on experience.

Matt Lipps

In his radical reassembly of photographic imagery, culled for their significance to his personal history, Matt Lipps exploits appropriation's inherent possibilities for generating new relationships and meaning. His recent series *Home* (2008) presents in large-format, seamless prints a record of his sculptural constructions. Contoured cutouts of Ansel Adams's monumental landscapes, affixed to cardboard backing and propped on a tabletop, appear before background surfaces composed of multicolored images of the artist's childhood home. By casting the abstracted cutouts into sharp relief, Lipps

has created shadows that heighten a sense of the materiality of process and provide still further a physicality to the passing of time. The contrast between reproductions of Adams's renowned images of national parks—in the precise black and white printing that was valued by the master modernist photographer—and the abraded photocopied reproductions of Lipps's assembled photographs of his family home is striking. The visual pairings of particular Adams landscape formations with particular rooms are also deliberate. Lipps has described his constructed images as "portraits through landscape" of different family members, including himself. Coming into possession of Adams's widely available reproductions at a young age led to Lipps's early, profound fascination with the possibilities of the medium. (Further associations with "home" are made through the varying arrays of Lipps's backdrop colors, which correspond to recommended marketed groupings of Benjamin Moore paint colors.)

Lipps's photographs foster new linkages between the constructs of personal identity and his exploration of the history of his chosen medium. An evocative examination of the conditions for the formation of individual identity, his series reflects the artist's situation that he describes as being "in-relationship-to, alongside, and around" photography. Raised and practicing in California, Lipps recognizes that he lives in "the capital of that image-producing media industry (Hollywood)." His willingness to challenge his relationship to these forces of personal and professional tradition informs his work. It is his achievement to have found in the city of Los Angeles—"one hyperreal, photo postcard backdrop"—such fruitful grounds for new photographic meaning.[6]

Joey Lehman Morris

In a different way from Lipps, Joey Lehman Morris emphasizes the physical properties of photographic material to invigorate a renewed dialogue between photography and the presence of place. Highlighting the sculptural elements of their construction, Morris installs his large-format prints for exhibition in deliberate and surprising positions. In *Doubled Over and Unfolding (For a Matter of Height and Depth)* (2007), his photograph of a man-made waterfall is hung askew, propped against a wall by a wood post. His photograph of the rocky surface of the desert, *George Mallory's Cradle (Waxing Gibbous)* (2007), lies flat on the gallery floor so that the shadow cast by the framed print parallels the direction of the shadows recorded in the image. Morris's photographs primarily depict his native landscape of the American Southwest, but they include occasionally absurd scenes of man-made constructions. As investigations into the nature of language's relationship to image, Morris's photographic work evokes Southern California's conceptual artists, such as Robert Cumming. Extending his inquiry into the possibilities for disrupting language's dominion over associated image, Morris has titled one photograph depicting bright salt flats and expansive blue sky as follows: "In this site, I propose a bi-level parking structure. On the western edge of the top level stands a wall equivalent to the height of the structure that obscures the view of the sun setting. On the bottom level, a single car is parked. In the back seat,

6
Matt Lipps, correspondence with the authors, November 2, 2009.

a young man is constructing explicit—yet tender—memories, though for the last time and in the third person."

Morris's emphasis on the sculptural presence of his installed photographic work also provides a means by which to explore the nature of time and attention, and with it, his willingness to embrace the ambiguities of photographic practice. As he observes, "A photograph can only prolong a very small and very altered variant of the thing that it wishes to fix and preserve. My images do not promote preservation, but they do opt for a type of stillness."[7] Frequently working in the desert, Morris identification of the importance the importance of stillness reflects his desire to create new ways to describe changes in the landscape. His work *Black Mountain Detachment: Two Nights, From Waxing to Full Stated* (2008), reflects the stillness of prolonged attention as well as the artist's efforts to pare his subjects down to their minimal surfaces and textures, a process he calls "photographic subtraction." Photographing by moonlight with long exposures over two nights, Morris conceptualized the work so that the making of the image coincided with its particular visual effect. The result strikingly contrasts the pitch-dark face of the mountain against the bright, craggy surface of the desert floor. By applying forethought and stillness to the recording of an extreme yet actual horizon, Morris heightens our awareness of the landscape. By offering an evocative sense of place, he expands a sense of possibility for new meaning.

Asha Schechter

Through his photography, Asha Schechter creates a field on which to explore new expressions of the visual. By stressing the physical artifact of the photographic medium, he paradoxically proposes an infinite malleability in the imagery's purpose and meaning. Each of Schechter's photographs is composed of pictures culled from a variety of sources—high school publications, community newspapers, pictures of the artist's own making—and positioned onto a plane that is formed from the abstracted enlargement of a color or the fragment of an image seen in the foreground. The total assembly of imagery is then rephotographed to make a single, seamless large-format print. Schechter's images frequently depict the New Age communities in Northern California, where the artist was raised. His final format provides a stated "framework" in which to make sense of an alternative lifestyle culture, one about which he continues to be ambivalent. Bringing diverse elements together, Schechter seeks to animate reappraisal, where meaning can grow through a fluctuation between the specific and the open-ended.

Creating space for exploration, both psychological and creative, Schechter emphasizes the disparate material properties of the assembled photographic imagery—the ragged edge of a newsprint tear, the shadowed frames of slides, the backs of prints marked with annotation. Variations in reproduction quality are also underscored, such as the inclusion of a loose stack of overlapping prints, depicting the inconsistent tonal

7
Joey Lehman Morris , Artist Statement, 2009.

range of a printed blue sky. Schechter's openness to the provisional signals as well the influence of digital production. He says of his practice, "It becomes like a zooming in and out on the photographs, suggesting that if one were to continue to look further or more closely, there would be other images that are not visible. The narrative then is not limited to the editing choices I have made, but is left relatively open."[8] It is not simply the predominant use of Photoshop, however, that concerns Schechter, but rather the broader implications of technical innovation for visual understanding. "I wonder whether this work will look very '2000s' in a few years, when digital production changes, and the artifacts in these images refer to a time period as specifically as a daguerreotype or a dye transfer print."[9] Rejecting, like many of the other photographers seen in *Assembly*, the conception of the photograph as a frame for direct registration of empirical observation, Schechter thus emphasizes the evidence of imagery's very production. In the pixilated realm of digital photography, imagery's free-floating, provisional nature suggests a radical revision of our understanding of experience, including a greater acknowledgment of the discursive forces of cultural context. Thus, the artist raises a last consideration: "[Will] this nostalgic relationship with photographic materials continue into the digital age?"[10]

Augusta Wood

Augusta Wood explores the persistence of memory and the ways in which imagery and text can interact to give meaning to an experience. Her photographs serve as both documents of existing spaces—domestic residences, landscapes, sites private and public—and constructions into which she inserts the additional markings of words. In so doing, the artist pursues her stated desire to interrupt the normative "presumption of pictorial stability."[11] Wood incorporates phrases—etched in snow, stitched over a window screen, drawn across the floor (in honey that attracts flies)—culled from a personal archive that combines her own poignant remarks with texts published by others. In one image, the phrase "the chaos of warm things," a line attributable to Jonathan Franzen's novel *The Corrections*, appears in words shown as shadows thrown across a kitchen corner by the late afternoon sunlight. Other phrases seen in her images, such as "unfolding in pieces," do not so readily offer up their origins. By virtue of bestowing personal attachment onto texts through the very act of their collection and deployment, Wood makes the distinction between author and beholder insignificant. In her scenes, which are both true and fictional, the multiple roles of the artist— author, director, collaborator—gain a heightened attention and ambiguity. Thus, it becomes poetry. [What becomes poetry, not clear here?] Wood's fascination with using the interplay of word and image to create new meaning recalls the work of such diverse artists and thinkers as Italo Calvino, Roland Barthes, Ed Ruscha, and Barbara Kruger. Yet through the intensity of her vision and the poignancy of her textual adaptations, Wood achieves a particularly powerful balance between ambiguity and significance.

8
Asha Schechter,
Artist Statement, 2009.
9
Ibid.
10
Ibid.
11
Augusta Wood,
Artist Statement, 2009.

Photographic exploration also provides the artist with ways to understand the relationship of the past to the present. Wood describes her concern as one of the "mapping" and "navigation" of personal history, similar to statements made by such other *Assembly* photographers as Peter Holzhauer, Whitney Hubbs, Matt Lipps, and Asha Schechter. In her most recent series, *I have only what I remember* (2009), Wood continues to investigate the ways photography can elicit meaning from the personal archive that is memory and the ways its association with a sense of place can shape identity. As seen in *Sesame Street (1980, 2008)* (2008), she revisits what was once the center of her early life, the former home of her grandparents, now emptied in final preparation for its sale to new inhabitants. Wood projects into these rooms multiple, overlapping family snapshots that bring to life once more the arts, artifacts, figures, and circumstances that shaped her past experiences and thus her present memories. The sight of herself as a small child standing before an obsolete television set—the construction of the documented past—elicits an inescapable reckoning with past experience, urging us to recall anew the former presence of rooms and relationships that shape our current selves.

In total, the eight artists of ASSEMBLY—Nicole Belle, Matthew Brandt, Peter Holzhauer, Whitney Hubbs, Matt Lipps, Joey Lehman Morris, Asha Schechter and Augusta Wood—offer an enlarged sense of the possibilities for photographic practice today. Drawing on Southern California's cultural heritage with its emphasis on material construction and conceptual experiment, their work suggests broader trends in contemporary American practice, including a desire to curate one's own life in an ever more digital world. The works on view represent early achievement in these diverse artists' promising careers. How their photographic investigations will continue to unfold remains, therefore, a subject of much interest and excitement.

EDWARD ROBINSON
ASSOCIATE CURATOR, WALLIS ANNENBERG PHOTOGRAPHY DEPARTMENT AT
THE LOS ANGELES COUNTY MUSEUM OF ART (LACMA)

SARAH BAY WILLIAMS
RALPH M. PARSONS FELLOW, WALLIS ANNENBERG PHOTOGRAPHY DEPARTMENT AT
THE LOS ANGELES COUNTY MUSEUM OF ART

Editor's note: Charlotte Cotton was originally commissioned by FotoFest to be one of the curators for the FotoFest 2010 CONTEMPORARY U.S. PHOTOGRAPHY exhibits. At that time, she was Curator and Head of the Wallis Annenberg Photography Department at the Los Angeles County Museum of Art (LACMA). At her suggestion, the actual curating of ASSEMBLY: EIGHT EMERGING PHOTOGRAPHERS FROM SOUTHERN CALIFORNIA was done by the team of photography curators at LACMA.

Nicole Belle

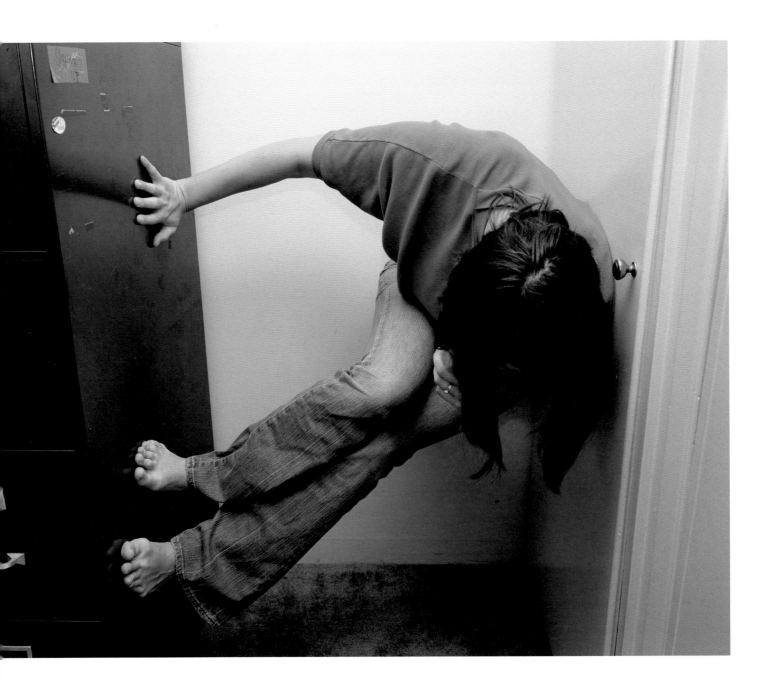

LEFT
Nicole Belle
Untitled, 2008
From the series *Apartment*
Inkjet Print

RIGHT
Nicole Belle
Untitled, 2008
From the series *Apartment*
Inkjet Print

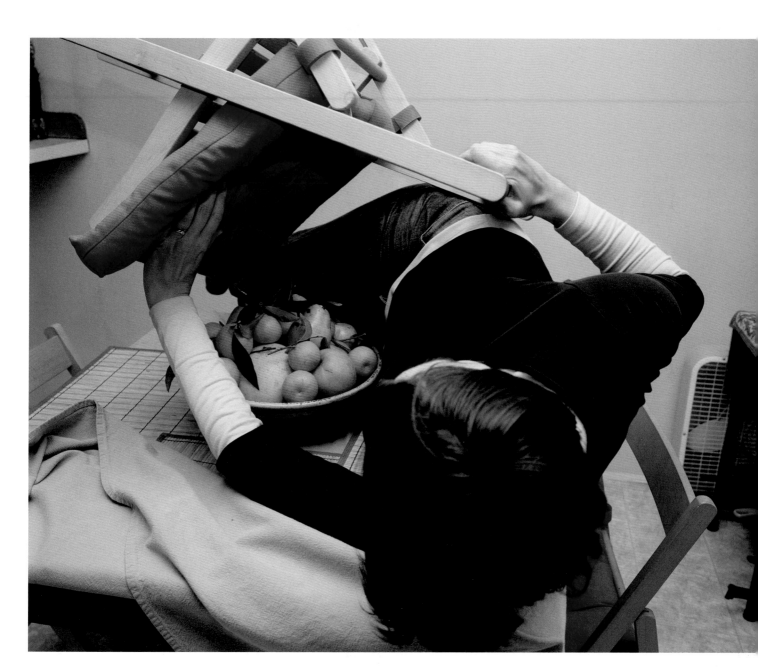

Nicole Belle

Untitled, 2008

From the series *Apartment*

Inkjet Print

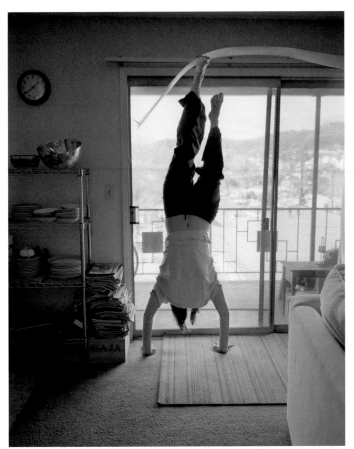

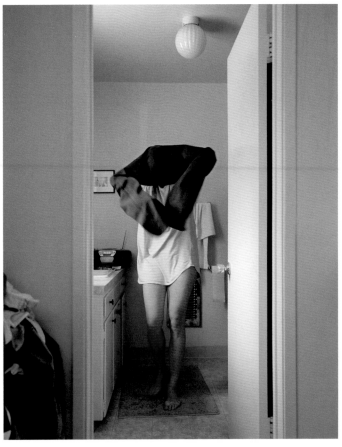

Nicole Belle
Untitled, 2008
From the series *Apartment*
Inkjet Prints

Matthew Brandt

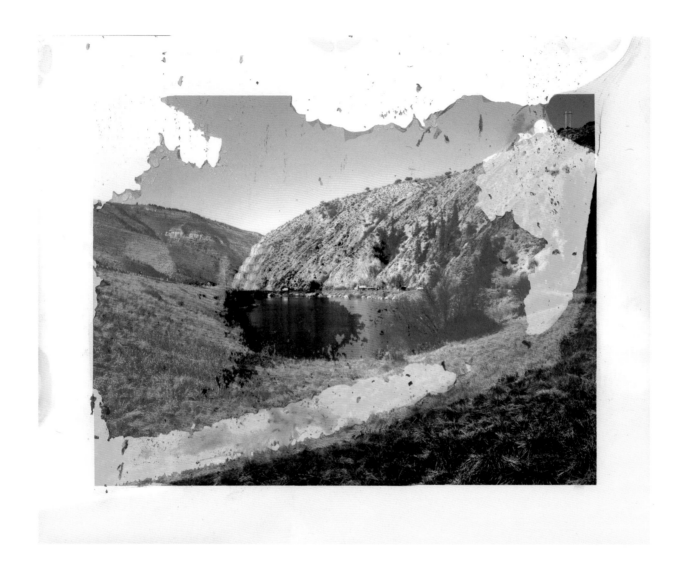

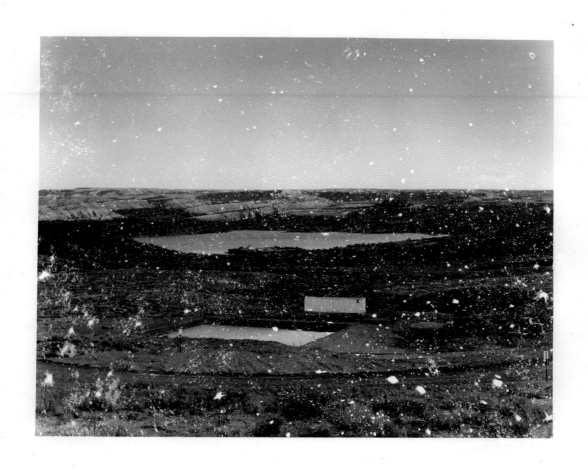

LEFT
Matthew Brandt
Wilma Lake CA 1, 2008
From the series *Lakes
and Reservoirs,* 2008
Chromogenic Print soaked
in Wilma Lake water

RIGHT
Matthew Brandt
Alcova Reservoir OR 6, 2008
From the series *Lakes
and Reservoirs*
Chromogenic Print soaked
in Alcova Reservoir water

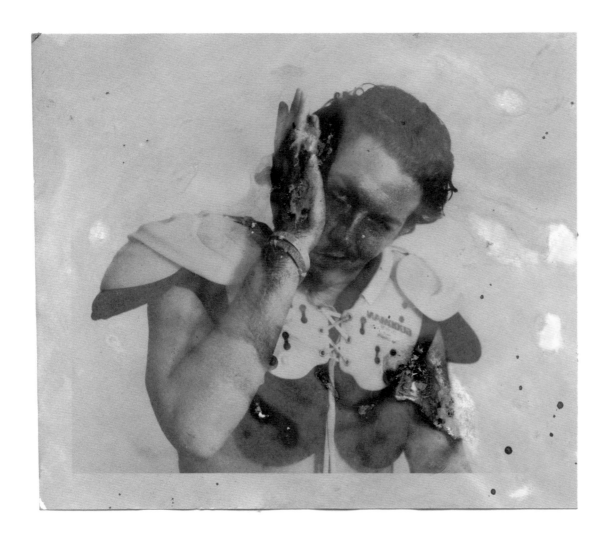

Matthew Brandt
Charles, 2007
From the series *Portraits*
Salted paper print
with his mucus

Matthew Brandt

George, 2007

From the series *Portraits*

Salted paper print with his
vomit and washed in Oblate
Missions Holy Water

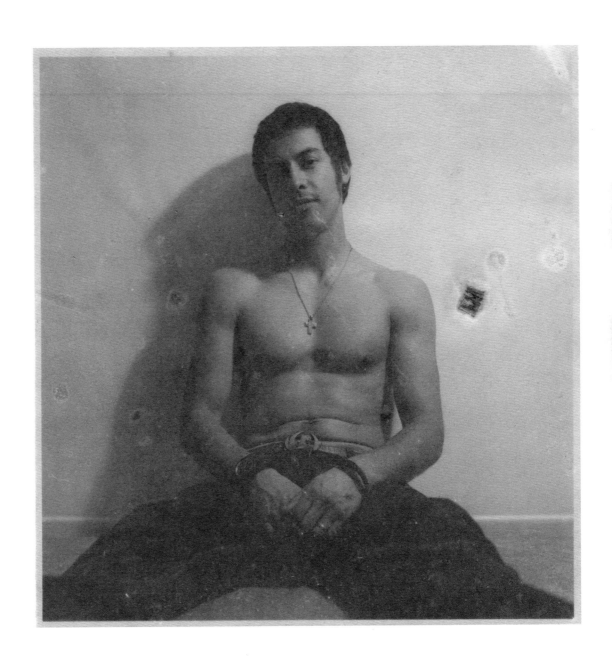

Peter Holzhauer

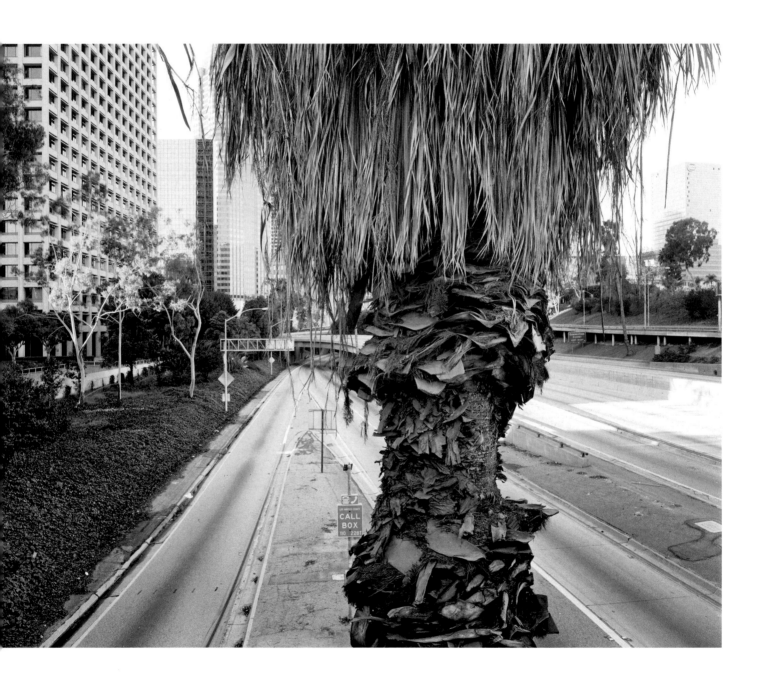

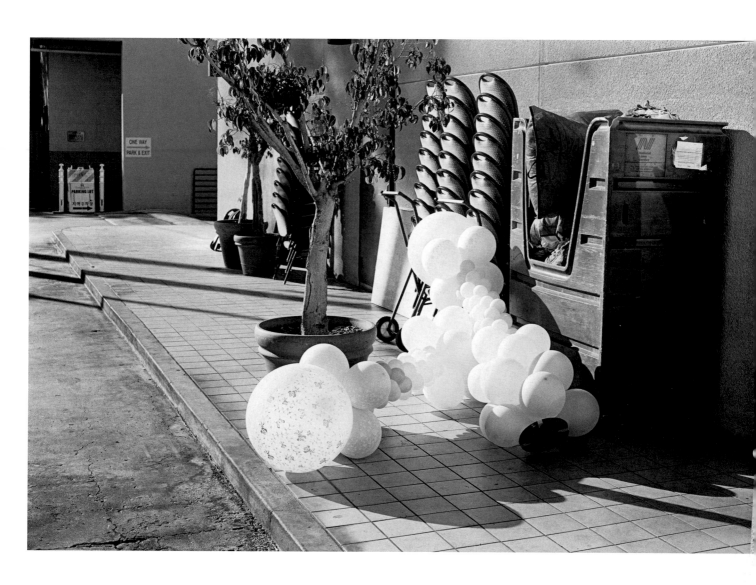

LEFT

Peter Holzhauer

110 Sentinel, 2005

From the series

Los Angeles Class

Silver Gelatin Print

RIGHT

Peter Holzhauer

Balloons, 2008

From the series

The Marine Layer

Silver Gelatin Print

105

Peter Holzhauer
Plants, 2008
From the series
The Marine Layer
Chromogenic Print

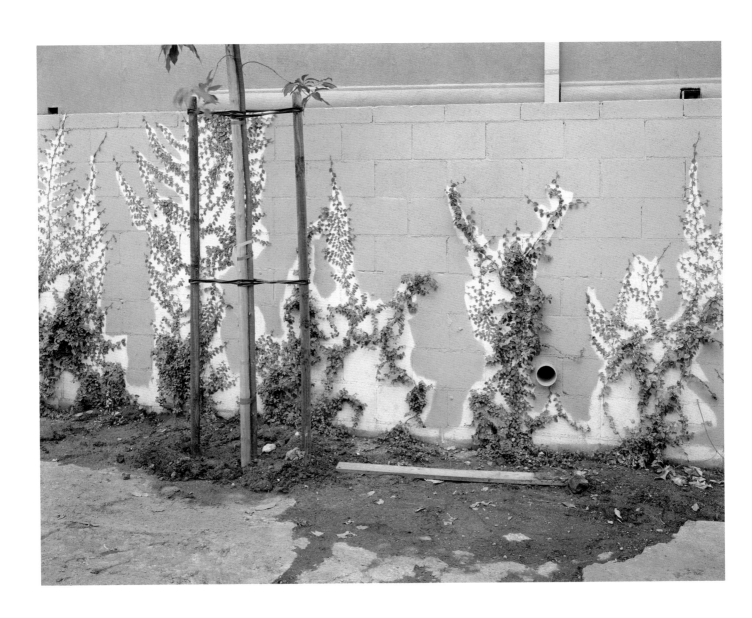

Peter Holzhauer
Cerritos, 2008
From the series
The Marine Layer
Chromogenic Print

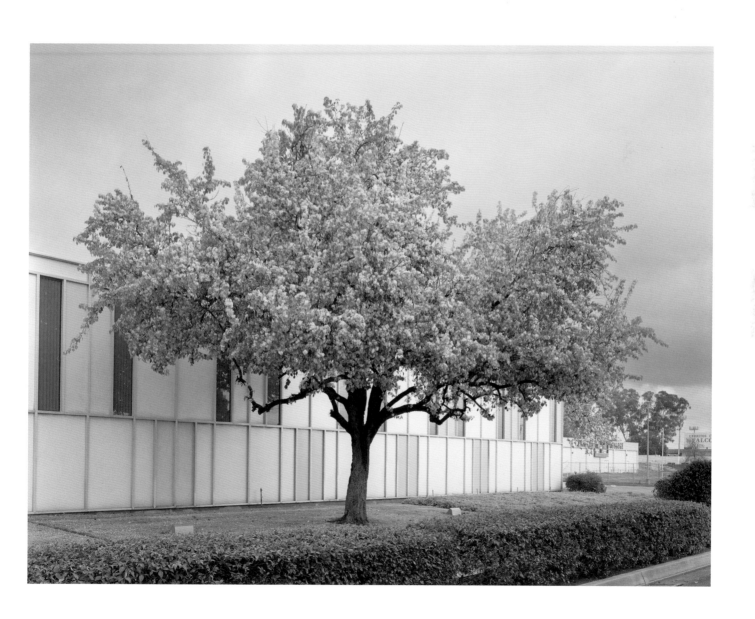

Whitney Hubbs

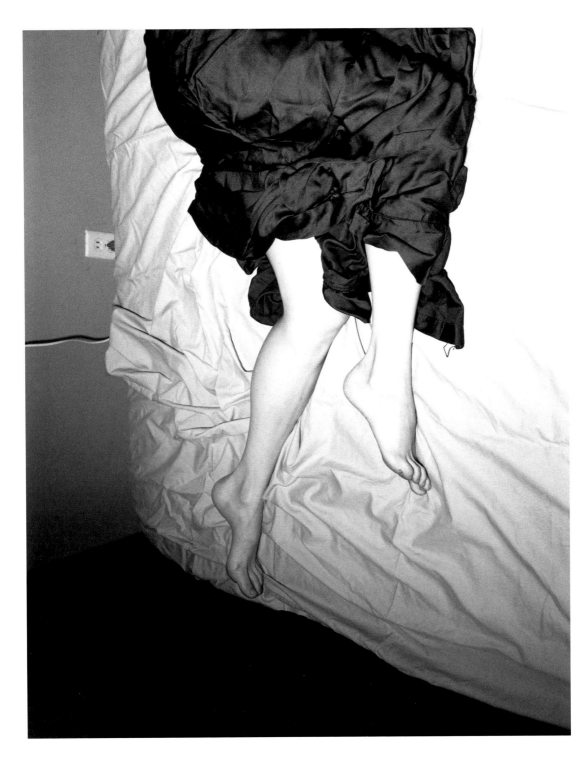

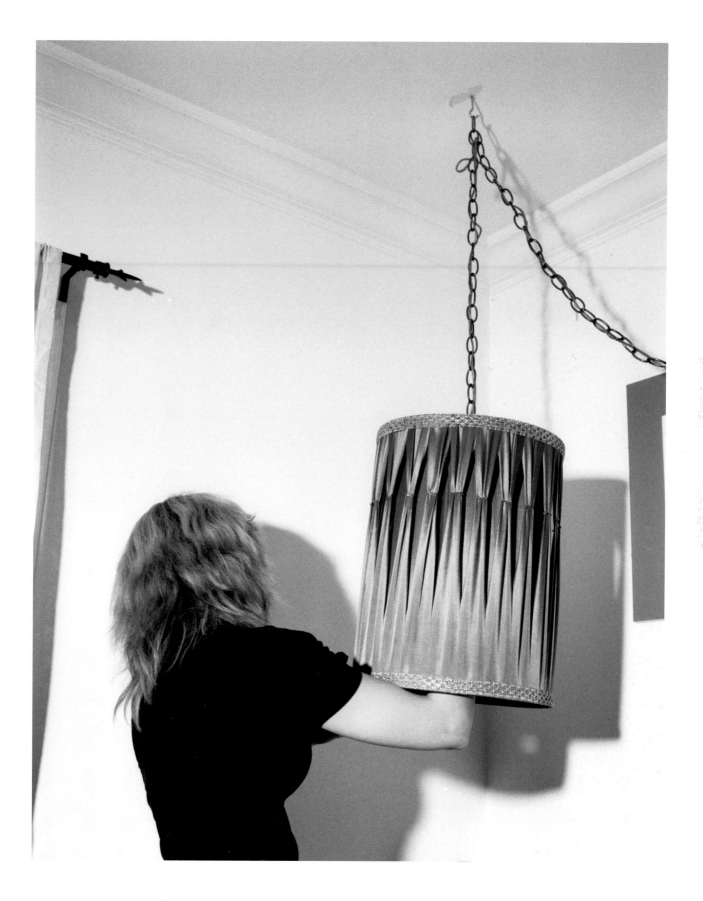

Whitney Hubbs

From the series *Day for Night,* 2008–2009

Silver Gelatin Prints

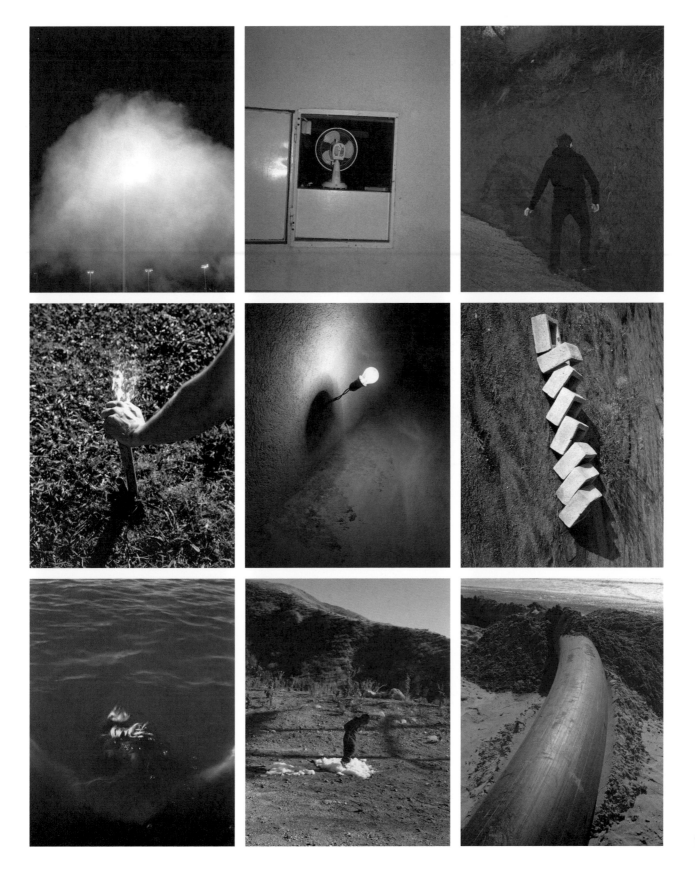

Matt Lipps

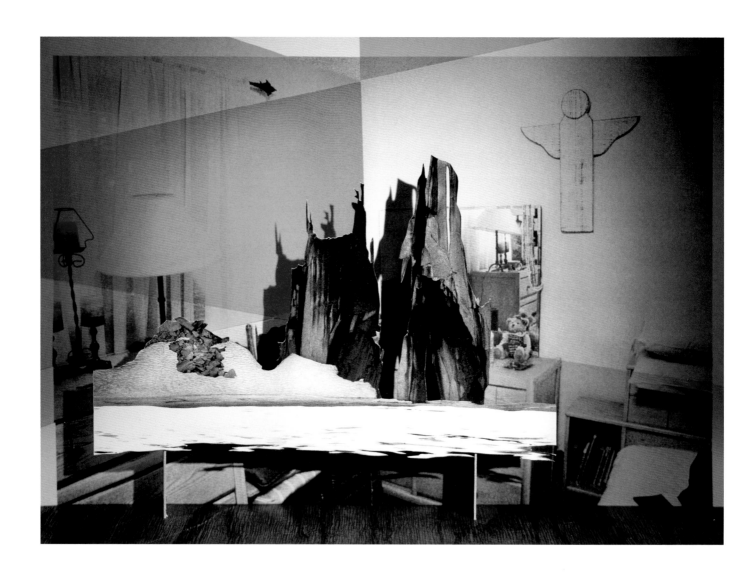

LEFT

Matt Lipps

Untitled *(kelly),* 2008

From the series *Home*

Chromogenic Print

RIGHT

Matt Lipps

Untitled *(bedroom),* 2008

From the series *Home*

Chromogenic Print

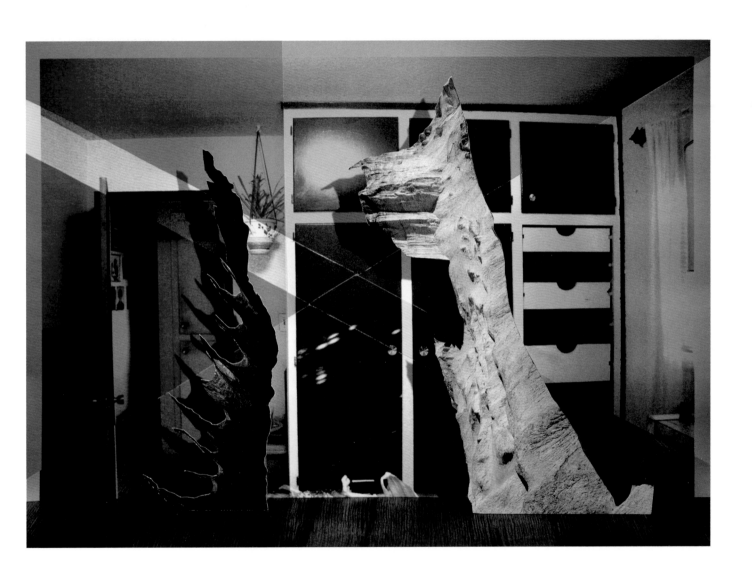

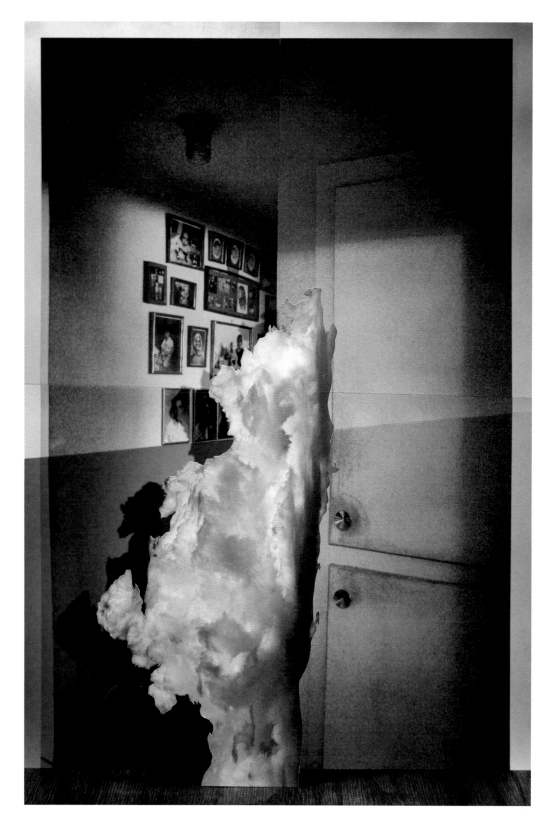

Matt Lipps
Untitled *(hallway)*, 2008
From the series *Home*
Chromogenic Print

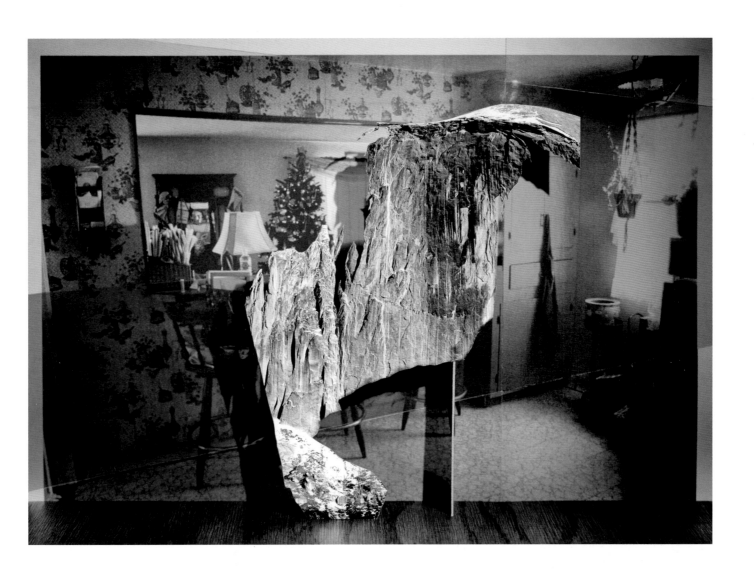

Joey Lehman Morris

LEFT

Joey Lehman Morris
States United: Soft Shoulder/
Split Vista (In Short and
In Blue), 2007
Chromogenic Print on acrylic,
oil stain on oak frame

RIGHT

Joey Lehman Morris
Black Mountain Detachment:
Two Nights, From Waxing
to Fully Stated, 2008
Chromogenic (LightJet) print
on Dibond, Lacquer on poplar

116

LEFT

Joey Lehman Morris
*Doubled Over and Unfolding
(For a Matter of Height
and Depth),* 2007
Chromogenic Print on acrylic,
oak frame and post

RIGHT

Joey Lehman Morris
*George Mallory's Cradle
(Waxing Gibbous),* 2007
Silver Gelatin Print on Dibond,
oil on poplar frame

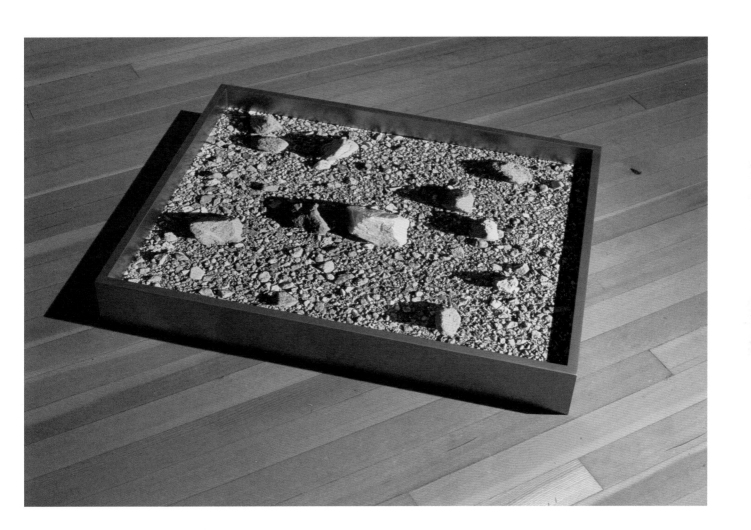

Asha Schechter

LEFT
Asha Schechter
Picture 11, 2009
From the series *Assembly*
Chromogenic Print

RIGHT
Asha Schechter
Picture 06, 2009
From the series *Assembly*
Chromogenic Print

LEFT

Asha Schechter

Picture 04, 2009

From the series *Assembly*

Chromogenic Print

RIGHT

Asha Schechter

Picture 09, 2009

From the series *Assembly*

Chromogenic Print

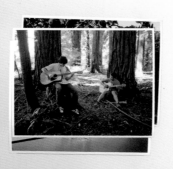

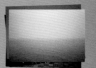

Augusta Wood

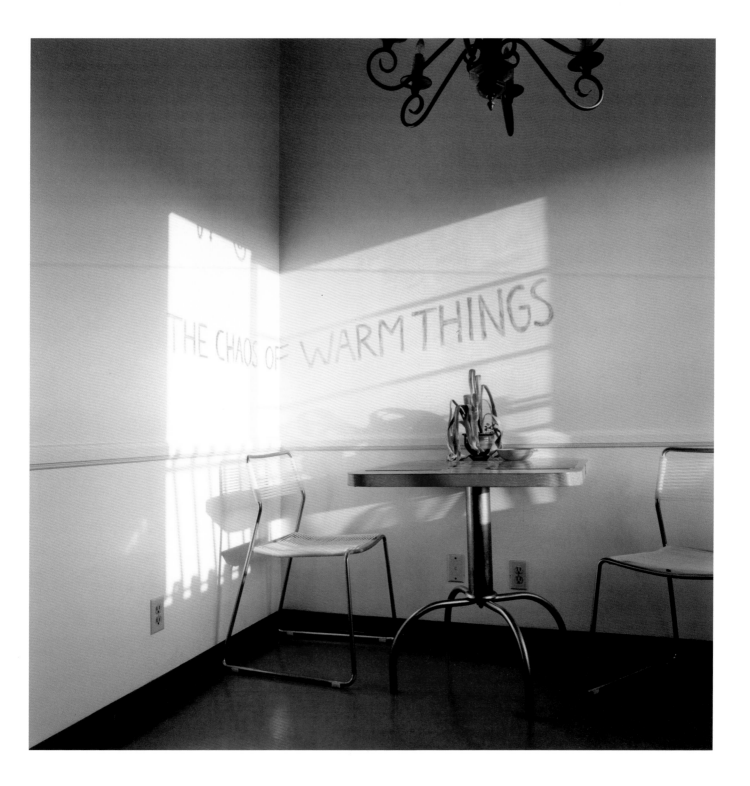

Augusta Wood
family to go through, 2006
From *text series*
Chromogenic Print

Augusta Wood
the chaos of warm things, 2006
From *text series*
Chromogenic Print

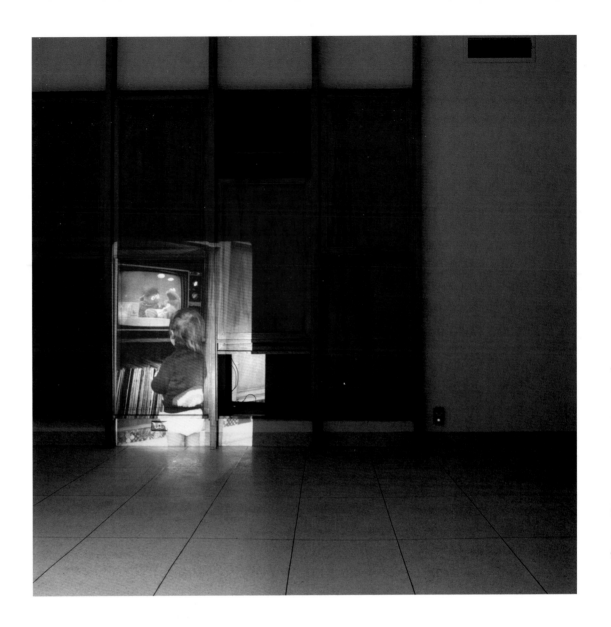

LEFT
Augusta Wood
it turns into nothing
on his tongue, 2005
From **text series**
Chromogenic Print

RIGHT
Augusta Wood
Sesame Street (1980, 2008), 2009
From *i have only what i remember*
Chromogenic Print

The Road to Nowhere?

NATASHA EGAN

BRIAN ULRICH

TIM DAVIS

GRETA PRATT

EIRIK JOHNSON

MYRA GREENE

SHEILA PREE BRIGHT

JEFF BROUWS

AN-MY LÊ

DAVID ORESICK

JEFF BROUWS

TREVOR PAGLEN

PAUL SHAMBROOM

ERIKA LARSEN

GREG STIMAC

NIC NICOSIA

VICTORIA SAMBUNARIS

CHRISTINA SEELY

JASON LAZARUS

MICHAEL ROBINSON

GREG STIMAC

The Road to Nowhere?

NATASHA EGAN

Photography has a long history of reflecting in a documentary way, or questioning in an artistic way, the zeitgeist. Among the most remarkable examples in twentieth-century U.S. photography are the 180,000 photographs produced between 1936 and 1943 for the history section of the U.S. Farm Security Administration under Roy Stryker. With visual integrity and some notable artistic strategies, Walker Evans, Dorothea Lange, Gordon Parks, and forty-one other now highly regarded photographers set out to make the economic crisis public. Subsequent decades were no different. In the mid-fifties Swiss photographer Robert Frank famously exposed a racially divided America in his 1958 book *The Americans*. In the 1960s such photographers as Garry Winogrand, Diane Arbus, and Lee Friedlander emerged. Winogrand's chance observations of daily life delved far beneath their whimsical appearance, Arbus analyzed a populace hidden beneath the idealized surface of the era, and Friedlander sought to understand the decade by looking straight at it without theoretical or academic filters. This period also brought innovators in color photography like William Eggleston and Stephen Shore, who challenged the tradition that saw black and white work as the only serious photography for social observation. The 1970s brought photographers like Robert Adams, Lewis Baltz, and Frank Gohlke, who, like Friedlander, produced unromantic descriptions of the American landscape, both social and physical, but with a more a direct concern for environmentalism, a questioning of capitalism, and an interest in national identity. The Reagan era, characterized by low taxes and corporate raiders, was illustrated strikingly by Tina Barney's portraits of the American wealthy. And the 1990s explosion of unbridled American consumerism was quintessentially documented by German artist Andreas Gursky in his large, complex images of endless rows of Nike shoes and garishly illuminated tiers of candy.

The geopolitical and economic tumult in the first decade of the new millennium, regarded by some as the close of the American Century, has similarly left its signature on contemporary U.S. photography. Each of the eighteen photographers in the exhibition THE ROAD TO NOWHERE? makes work that, while revisiting enduring American themes, calls into question the actual trajectory of our long-term national projects.

In the short span of fewer than ten years, the profound self-confidence of the late 1990s, characterized by the United States' apparent geopolitical hegemony after the dissolution of the Soviet Union and a robust New Economy erected upon Silicon Valley technological innovation and Wall Street financial power, has been displaced by extreme anxiety about the fundamental economic instabilities and environmental degradations wrought by unfettered capitalism. America's celebrated "unipolar moment" increasingly appears to have been just that, a moment, whose tranquil triumphalism was soon pierced by the September 11 attacks, the ensuing complicated military interventions in Iraq and Afghanistan, and the spectacular implosion of the country's financial system. A belief in the seeming unassailability of the U.S. model among even the mainstream population has now given way to a sense of vulnerability as unemployment rises and as broad-based participation in the country's rising prosperity increasingly appears to have been illusory, resting on a credit-induced property bubble.

Like the photographers working in earlier decades discussed above, the majority of the artists in THE ROAD TO NOWHERE? might usefully be thought of as "cultural documentarians," defined here as those taking an artistic approach—whether objective or subjective—to understanding a particular society and culture, in this case the United States of America. Some manage this emphasis on U.S. life with directness and others with irony or humor. Through photography and video, they address a diversity of related themes including economic insecurity, race, war, and the contemporary American landscape. While the work is oftentimes critical, a quintessentially American optimism is evident throughout.

THE ECONOMY
In the early 2000s, the United States was marked by extreme rates of consumption and the "War on Terror." Wartime political leaders generally seek to strike a balance between the needs of civilians at home and the soldiers in the field. The Bush Administration, however, chose to fund an expensive war while urging American consumers to spend, a phenomenon facilitated by cheap credit and record low mortgage rates. In 2005 personal savings in the United States fell into negative territory for the first time since the Great Depression.[1] But consumers didn't feel the pressure to stop spending until the credit market imploded in 2008. Mortgage delinquencies, foreclosures, and unemployment soared, and the retail market plummeted. The photographs of Brian Ulrich, Tim Davis, Greta Pratt, and Eirik Johnson offer singular observations of U.S. consumer culture and the new economic insecurity.

Brian Ulrich has vividly illustrated the rise and fall of consumer culture in the United States since President George W. Bush encouraged citizens to boost the economy through shopping after the attacks on September 11, 2001—thereby equating consumerism with patriotism. Ulrich initially captured excessive consumption in the

1
"Savings Rate Falls to Minus Territory: First Such Depletion since the Depression," *Chicago Tribune*, January 31, 2006

bustling big-box retail stores. With the recent financial decline, the consumption-based model of the late twentieth century has suffered, transforming communities, the environment, and the American urban landscape. The title of series *Dark Stores, Ghost Boxes and Dead Malls* (2008–2009) are taken from retail industry terms for emptied, vacant, and dying retail stores. Ulrich's recent work seeks these out and records the remnants of a consumer world now abandoned and stripped of their brand and identity. Ulrich's pictures serve as reminders of the futility of consumption without foresight.[2]

Looking at retail from a different but related perspective, Tim Davis examines the increasingly vivid presence of commercial interests in small-town America. Photographing at night using only the available light from nearby street lamps and parking lots, Davis explores how illuminated retail signs leak into consumer consciousness and literally reflect upon the American landscape. Illuminated Dunkin' Donuts, McDonalds, KFC, and Jiffy Lube signs are found reflecting off of houses in small towns or suburbia. Davis states, "In all my work, light is cultural and political. It is put there by someone for a purpose—to invite citizens to share their money with corporations, to keep workers working, and to, in a sense, visually describe democracy."[3]

In the 1770s, on the eve of the American Revolution, Patrick Henry uttered the words, "Give me liberty or give me death," enshrining the word "liberty" as a descriptor of the American experience. Over a hundred years later, to celebrate the centennial of the United States, the Statue of Liberty was given to the American people by the French. This monumental statue, portraying a woman escaping the chains of tyranny, has become a universal and ubiquitous symbol of the United States. In 2008 the Liberty Tax Service embarked on a nationwide advertising campaign by dressing workers in Statue of Liberty costumes and having them wave banners on street corners to attract clients. Fascinated by the interpretations of U.S. history embedded in American society, Greta Pratt decided to speak with the wavers—in fact, day laborers—she encountered. Some were disabled and homeless, and almost all were seeking full-time work and struggling to make ends meet in the current economic crisis. Similar to some of Arbus's portraits in the 1960s, Pratt has used the often desolate urban environment as her backdrop to highlight the individual rather than the employer or employee.[4]

While Ulrich, Davis, and Pratt are focusing on the recent repercussions of the current economic crisis, Eirik Johnson observes communities in the U.S. Pacific Northwest that have been suffering for decades. Since 2005 Johnson has photographed throughout Oregon, Washington, and Northern California, capturing the tenuous relationship between industries dependent on natural resources and the communities they support. For nearly 150 years, timber had been the leading industry in the region, but the adverse environmental impact of these declining industries has been increasingly at odds with the contemporary ideal of sustainability. In Johnson's words, "Homes lie vacant and storefronts are closed indefinitely. Town streets are empty other than the

2
Brian Ulrich, artist's project statement for *Copia*, http://notifbutwhen.com.
3
Tim Davis, artist's writing for *Illuminations*, http://davistim.com.
4
Greta Pratt, e-mail correspondence with author, July 8, 2009.

occasional teenagers who wander with no particular destination. They recall a young Kurt Cobain who spent his high school years drifting and struggling for purpose in the mill town of Aberdeen, Washington. An eerie, unhurried mood pervades these communities as they search for their own refashioned sense of purpose."[5] Through landscapes, portraiture, and still-lifes, Johnson has revealed a place imbued with an uncertain future and communities no longer built upon the riches of massive old-growth forests.

RACE AND CLASS

As photography has evolved, its ability to offer neutral depictions has been much debated, from whether there is such a thing as the objective camera, to questions of the very desirability of neutrality, especially when it comes to conveying the controversial. During the 1970s and 1980s, this issue of oversimplified neutrality versus the racism found in clearly subjective depictions of race and class in America became an important area of study for art historians attempting to understand how photography actually works.

Throughout her life, Myra Greene has been questioned about her accumulation of white friends, as if her African-American heritage should dictate a particular social circle. Conversations about race in the United States tend to focus on the position of the "other," often against ideas of whiteness, a concept that is rarely openly discussed. Greene's project *My White Friends* (2008) explores the challenges of describing race in any guise. Greene's subjects are confidants, mentors, and peers who have helped shape her understanding of her identity, even though their racial profiles are radically different. Greene's photographs ask the viewer to consider where whiteness resides. Is it in gesture or material environment? In some images the environments suggest traditional arenas of whiteness, dictated by a sense of wealth and power, while others are more ambiguous. The subjects' gestures vary from showing ease to betraying vulnerability, and their gazes shift from evasive to confrontational. Greene's photographs force the black photographer, her white friends, and the general viewer to examine friendship as well as stereotype.[6]

Sheila Pree Bright explores suburban life within the African-American culture. Although suburbia was at one time synonymous with white flight, photographed humorously by Bill Owens in the 1970s and surrealistically by Gregory Crewdson in the 1990s, Bright's subtle *Suburbia* project (2005–2007) contrasts the U.S. media's projection of stereotypical African-American attempts to become "suburban" with a more realistic picture of middle-class African-American life. Bright seeks to explore the variations in an existence that subverts the stereotype rather than accepting the television-based fiction. Her images are as much about the assumptions of perception as the construction of identity.[7]

5
Eirik Johnson, e-mail correspondence with author, October 12, 2009.

6
Myra Greene, correspondence with author, June 2009.

7
Sheila Pree Bright, artist's project statement for *Suburbia*, http://sheilapreebright.com.

In documenting graffiti in the northeastern United States, Jeff Brouws has discovered that urban environments are one of the few places in the United States where political viewpoints are expressed directly—unlike in Europe, where one encounters sociopolitical commentary almost everywhere. Quoting Martin Luther King Jr.'s "violence is the language of people that haven't been heard," Brouws's text-based project *Language of the Unheard* (2006–2008) explores the political and vernacular expression of the language-filled cityscape. Chronic poverty and racial segregation don't register in the consciousness of most Americans, and poor urban inhabitants often feel invisible and forgotten. The graffiti in Brouws's photographs pithily expresses the social realities of the inner city and directly confronts societal issues such as race and poverty.[8]

WEAPONS AND WAR

Critics such as Susan Sontag have questioned the effectiveness of photography as a recorder of war—be it to promote or prevent armed conflict. Many iconic images celebrated as having great social power have been questioned or exposed as not what they seem. And yet a very real picture of a helicopter gunner responding to the death of a comrade in Vietnam clearly had a huge effect when published in *Life* magazine. Many photographers, including those whose work is in this exhibition, have sought to reveal indirectly their feelings about war.

Triggered by the attacks on September 11, 2001 and the claim that Iraq possessed weapons of mass destruction and posed a threat to world security, the United States launched wars in Afghanistan on October 7, 2001, and in Iraq on March 20, 2003. The United States has embedded photojournalists with military forces in both Afghanistan and Iraq, but much of the imagery that is released by the media is censored and sanitized by a government hoping to control the story and by editors with political concerns. Although An-My Lê's petition to be an embedded photographer in Iraq was denied, in 2003 she was granted permission to photograph U.S. troops performing training exercises in preparation for deployment to Afghanistan and Iraq. The series *29 Palms* (2003–2004) takes its name from the Marine base in Southern California's Mojave Desert where Lê photographed American soldiers both rehearsing their own roles and playing the parts of their adversaries. They were occasionally asked to dress up and act as Iraqi police and civilians, and sometimes linguists wearing traditional Iraqi clothing were brought in to create verbal confusion in Arabic. The military housing was tagged with mock anti-American graffiti, and fake villages had been built of particleboard. Lê's pictures from *29 Palms* in many ways subversively mirror the media's sanitized view of the two wars. They present no blood, no gore, no cruelty, no shock. They simply show the preparations for battle. Mountains and desert dominate the series, their vastness making the elements of war appear small and toylike. Soldiers almost disappear into the landscape, and Lê's work rarely shows us their faces or provides hints of their emotional states or dispositions.[9]

8
Jeff Brouws, e-mail correspondence with author, October 11, 2009.
9
Karen Irvine, "An-My Lê: *Small Wars*," in An-My Lê: *Small Wars*, exh. broch., October 27, 2006–January 6, 2007 (Chicago: Museum of Contemporary Photography at Columbia College Chicago, 2006).

David Oresick offers a raw, transparent, and seemingly authentic view of war from the perspective of those closest to it. *Soldiers in Their Youth* (2009) is a series of montages assembled from videos found on the Internet that were created by American soldiers and civilians reacting to the war in Iraq. The project is divided into two sections: part one, *Soldiers in Their Youth*, is made from footage of soldiers on the ground, and the second part, *After the War*, examines the lives of veterans and their families after combat experience. By making editorial selections from hundreds of clips, then cutting, juxtaposing, and, perhaps most significantly, changing the context in which the images are viewed, Oresick has created works where new meanings are made. Blank white spaces interrupt the video to give the viewer time to reflect or to anticipate what will be seen next, and to illuminate the space within, making the viewer aware of his or her own presence even though the official position is to keep war remote.[10]

During the Cold War, the ordinary citizen had very little contact with long-range nuclear bomber aircraft or intercontinental ballistic missiles, and nobody attempted to enter this secretive world. Influenced by Wim Wenders's 1997 film *The End of Violence* in which crime is stopped by surveillance cameras installed on every street corner in Los Angeles, Jeff Brouws, with his photographic typology of surveillance cameras throughout the United States, has revealed a ubiquitous presence of monitoring in public spaces and questioned how that has affected our privacy. With its Orwellian tone, heightened by homeland security rhetoric, the surveillance camera emerges as a symbol of the government's monitoring of its citizens.[11]

Inspired by the methods of early astronomers Kepler and Galileo, who documented the previously unseen moons of Jupiter in the early seventeenth century, geographer Trevor Paglen began a project of photographing classified American satellites in the night sky. Paglen has extended and developed this body of work by translating observational data into a software model that describes the orbital motion of classified spacecrafts. With these tools, he can calculate the position and timing of overhead reconnaissance satellite transits and photograph them with telescopes and large-format cameras using a computer-guided mechanical mount. The resulting photographs record trails of sunlight reflected from the hulls of obscure spacecraft hurtling through the night sky.[12]

As with all wars, technology often shifts, yet certain weapons that become obsolete may retain their symbolic meaning. Paul Shambroom is fascinated by the obsolete weapons on view in communities across the United States. Town squares, city parks, armories, and VFW and American Legion posts all display retired weapons from past wars involving the United States. Initially built for combat, these objects play entirely different roles in their new settings: as memorial, tourist attraction, retail signage,

10
David Oresick, artist's project statement for *Soldiers in Their Youth*, http://davidoresick.com.
11
Brouws, e-mail correspondence with author.
12
Trevor Paglen, artist's project statement for *The Other Night Sky*, http://paglen.com.

135

playground equipment, historical artifact. Shambroom hopes that pictures of these weapons will lead us to consider the complexities of a community's response to war and remembrance of war in America. His fascination and curiosity is driven by several questions. Why is a machine that was made for killing used as a memorial to the dead? Does a tank or artillery weapon help a community mourn and heal from its losses, or is it intended to inspire new generations of warriors? Can it do both? As these weapons age, as their surfaces weather, and as technologies turn obsolete, do the weapons lose their association with violence and death? With our nation once again at war, what can these relics of previous wars teach us about the United States and other societies' proclivity for armed conflict, and humanity's implicit, ongoing endorsement of war?[13]

Another obvious context for predator and prey, one often seen as nostalgic, recreational, and related to the American sensibility of self-reliance, is hunting. A tradition passed down through families for centuries, hunting has been a means of survival and, by extension, a sacred sport. For some, learning to hunt is a rite of passage. Erika Larsen has spent numerous years photographing hunting in the U.S. Her thoughtful portraits and landscapes occupy an unusual place in the world of photography: she has been a contributing photographer to the sportsman's mainstay, *Field and Stream* magazine, and as such, her work celebrates and is celebrated by hunters. In her series *Young Blood* (2006-2007), Larsen has focused on children as they learn to hunt. Her subjects seem somber, mature, and comfortable within their environment. For them, the thrill is in learning to follow their instincts and being immersed in nature. They not only carry on a sacred tradition, but also learn to embrace the environment. They have direct contact with life and death and become part of that cycle. No longer just observers, these children are working parts of nature.[14]

Greg Stimac began his exploration of recreational gun use during the summer of 2004 when he made repeated trips to unregulated rifle ranges in Missouri and California. Armed with a medium-format camera and a (thankfully) long cable release, Stimac would take a picture as his subjects opened fire. Sometimes catching the blur of bullets leaving the barrel or a momentary burst of light and smoke, Stimac's *Recoil* (2006) pictures are remarkable for the relationships implied or suggested among the people in the frame. The shooters' responses range from intense to casual, while their companions demonstrate anything from total absorption through mild curiosity to completely indifferent boredom.[15]

SOCIAL LANDSCAPE

The phrase "social landscape" was first used in the title of an exhibition at the George Eastman House in Rochester, New York, curated by Nathan Lyons in 1966—*Toward a Social Landscape*. Part of Lyons's endeavor was to distinguish between the kind of picture produced by Lee Friedlander and that of Ansel Adams—perhaps more pre-

13
Paul Shambroom, artist's project statement for *Shrines Series*, http://paulshambroomart.com.
14
Audrey Mast, "Trophies, Guns and Unicorn Bait," in *Loaded: Hunting Culture in America*, exh. cat., March 18–April 29, 2009 (Chicago: Glass Curtin Gallery at Columbia College Chicago, 2009), and e-mail correspondence with author, October 10, 2009.
15
http://mocp.org/collections.

cisely, between the world we live in on a daily basis and the abstract beauty of a very small national park. Most of the work in this exhibition could be considered social landscapes.

Influenced by such work as Hilla and Bernd Becher's serial typography of disappearing industrial sites, Conceptual artist Greg Stimac set out to create a photographic series showing people throughout the United States mowing their lawns. From Midwestern suburbs to towns in Florida and Texas, Stimac traveled with his camera listening for the sound of mowers. The people in his photographs are a true cross section of U.S. culture, and the lawns themselves vary dramatically, from weed-ridden plots and brown patches of dry grass to verdant lawns surrounding pristine homes. Through its deliberate formal repetition, the series draws attention to the mundane labor required to maintain a lawn while at the same time addressing the ritualistic aspects of the effort. In the end, the scope and variety of Stimac's survey underscore the predominance of the lawn as a social landscape.[16]

Nic Nicosia has traveled by car between Dallas and Santa Fe many times over the years, never becoming disenchanted or bored with the beauty of the mutable scenery he passes. Nicosia's habitual trek takes him from the manicured lawns of the Dallas suburbs to the stark, jagged edges of the desert. He also moves from the soft rolling hills of north Texas to the vast minimal landscapes of New Mexico. More than half of the drive follows Interstate 40, which parallels historic Route 66, considered one of the great American driving experiences, a symbol of America's vibrant nomadic spirit as recorded by Robert Frank and Jack Kerouac, and the road taken to California by many families during the 1930s. 9½ hours to SaFe (2003–2004) documents one of Nicosia's solitary automobile trips. The entire drive was filmed in real time with three video cameras inside the car. One was mounted facing the front, with one to the rear, and an additional handheld camera was manipulated by the artist. At least one camera was running at all times, whether Nicosia was driving, filling the car up with gas, or taking a break to stretch or change the video tapes. The result is an unnervingly monotonous yet ultimately intriguing and personal document.[17]

Through straight-on focus, detail, and uniform lighting, Victoria Sambunaris reduces her subject matter of everyday landscapes and common industrial parks to crisp clear images of forms in neutral space. Shot during two road trips through Texas, Wyoming, Indiana, Wisconsin, and Iowa, on five by seven-inch negatives, Sambunaris's images capture at once the vastness of the American landscape and the subtle, sometimes overwhelming, cues to its underlying capitalist mentality. As she explains, "It is the anomalies of an ordinary landscape that have become the focus of my work: massive warehousing, infinite distribution facilities, and systematized shipping terminals. These numerous paradigmatic structures, I sense, portend the future of landscape and our relationship to it."[18]

16
Ibid.
17
http://collectionsonline.lacma.org.
18
Victoria Sambunaris, e-mail correspondence with author, October 13, 2009.

Christina Seely's series *Lux* (2005–2010), titled after the system for measuring illumination, examines the disconnect between the immense beauty created by human-made light emanating from the earth's surface and the environmental impact of the carbon dioxide produced by the world's wealthiest countries, evident in the brightest areas detected on a satellite map. The three regions most visible in NASA images are the United States, Western Europe, and Japan, which together emit approximately forty-five percent of the world's CO_2 and, along with China, are the top consumers of electricity. This body of work focuses on Seely's imagery of the cities in the United States: Boston, Chicago, Houston, Las Vegas, Los Angeles, and New York. Eventually, *Lux* will comprise photographs of the forty-three brightest cities in the world, but the project is less about the individual locations than their effective interchangeability and the global ramifications of consumption. Reflecting this, each photograph is titled simply *Metropolis*, accompanied by a notation of the city's latitude and longitude. Seely's photographs explore the realities of dealing with the infrastructure of these urban environments and their excessive energy consumption, but she consciously takes an indirect approach to the subject. "I am interested in the dialectic between the surface documentation of the photograph and the complex reality that lies beneath the surface," she explains, "how beauty can suggest the simple and ideal while both subtly reflecting and obscuring a darker more complicated truth."[19]

For the last six years, Jason Lazarus has investigated individual and cultural obsessions by weaving together personal and public moments of significance; his work humanizes public moments while making the universal personal. These moments range from the splat of bright red blood from a dead bug on his windshield, to a picture of Spencer Elden as a high school senior (Elden was the naked baby floating on the cover of Nirvana's *Nevermind* 1991 album), to the aura of light in the night sky above Barack Obama's election night rally in Chicago's Grant Park. In lieu of using the camera to address a traditional single topic, Lazarus makes photographs that embrace his long-term commitment to documenting moments of shared public relevance, whether overt or covert, moments that speak to the tensions, conflicts, and ideologies that reveal our personal experience.[20]

THE END OF THE AMERICAN CENTURY

Michael Robinson's 2007 film *Victory Over the Sun* takes its title from the 1913 Russian Futurist opera written by Kruchonykh and Khlebnikov in which the plot revolves around an angry group trying to capture and extinguish the sun. Robinson's film surveys the abandoned grounds of three World's Fairs—those in Seattle ('62), New York ('64), and Montreal ('67). Robinson's father beautifully filmed the actual fairs back when they portrayed a hopeful and celebratory future. However, visiting the sites four decades later, Robinson learned how corporate and competitive the fairs actually were, and their "striving for the future" took on a darker meaning. To enhance the sinister undertones, Robinson has mixed science-fiction atmospherics with orchestral splendor and

19
Christina Seely, artist's project statement for *Lux*, http://christinaseely.com and http://mocp.org/collections.
20
Jason Lazarus, e-mail correspondence with the author, September 13, 2009.

chanting drones that fall somewhere between the operatic and the ludicrous. The text being chanted is a mixture of excepts from Ayn Rand's 1938 novella *Anthem* and Oscar Wilde's 1894 play *Salome*, and the singular voice in the second section is from a scene in the 1987 film *Masters of the Universe*, where the villain Skeletor gains control of the universe and declares himself God. All three sources are about power and the connections between the reckless ego and the subconscious drive to end all things. The music is a string quartet version of the Guns N' Roses 1992 ballad "November Rain." And the chorus, "Nothing lasts forever, even cold November rain," is in line with both the failed projections of the future asserted by the three world fairs and the apocalyptic quality of the now-abandoned spaces.[21]

Greg Stimac individually filmed three white Mustangs for both their iconic muscle car status and the idea (suggested by their name) of three white heroic horses. In each of the three-channel synchronized video projections, the car horn was held down and recorded until each burned out and died. The three horns start out sounding the same, then slowly each becomes individual and distinct, fading and dying at different rates. As aggressive and annoying as car horns can be, in this triptych the noise is quickly transformed and reduced to a meditative and lamenting chorus until the last garbled mutter.[22]

Perhaps the horns are the last gasps of the American Century or merely a comment on an exhausted metaphor in twentieth-century photography. The artists in THE ROAD TO NOWHERE? welcome our enjoyment of their deliberate confusion of photography with reality and their own reflections on meaning in U.S. culture. Hyper-aware of the cultural motifs identified and popularized by their counterparts in the previous century, these artists are not cooperating with current theory or criticism and deliberately leave it unclear whether they are looking in the rearview mirror or keeping their eyes firmly on the road ahead.

NATASHA EGAN

ASSOCIATE DIRECTOR AND CURATOR, MUSEUM OF CONTEMPORARY PHOTOGRAPHY
AT COLUMBIA COLLEGE CHICAGO

21
Michael Robinson, e-mail correspondence with the author,
October 7, 2009.

22
Greg Stimac, e-mail correspondence with the author,
May 29, 2009.

Brian Ulrich

Brian Ulrich
Kids R Us, 2008
From the series ***Dark Stores,***
Ghost Boxes and Dead Malls
Archival Pigment Print
Courtesy of the Artist

Brian Ulrich

Circuit City, 2008

From the series *Dark Stores,*

Ghost Boxes and Dead Malls

Archival Pigment Print

Courtesy of the Artist

Brian Ulrich
Value City, 2008
From the series *Dark Stores,*
Ghost Boxes and Dead Malls
Archival Pigment Print
Courtesy of the Artist

Brian Ulrich
Saks Fifth Avenue, 2008
From the series *Dark Stores,*
Ghost Boxes and Dead Malls
Archival Pigment Print
Courtesy of the Artist

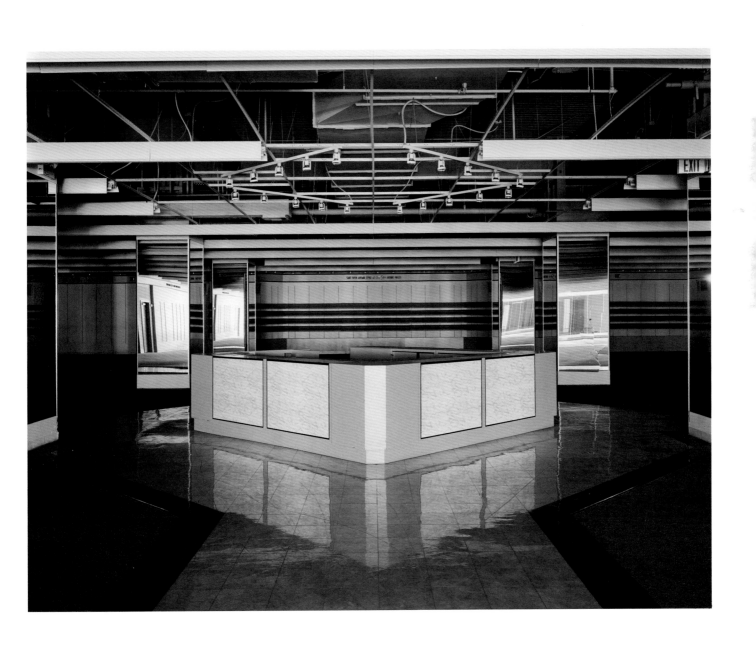

Tim Davis

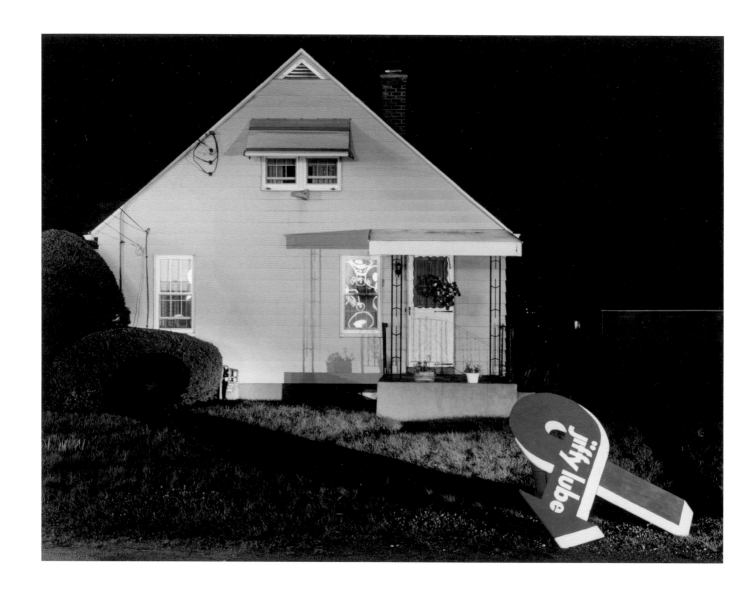

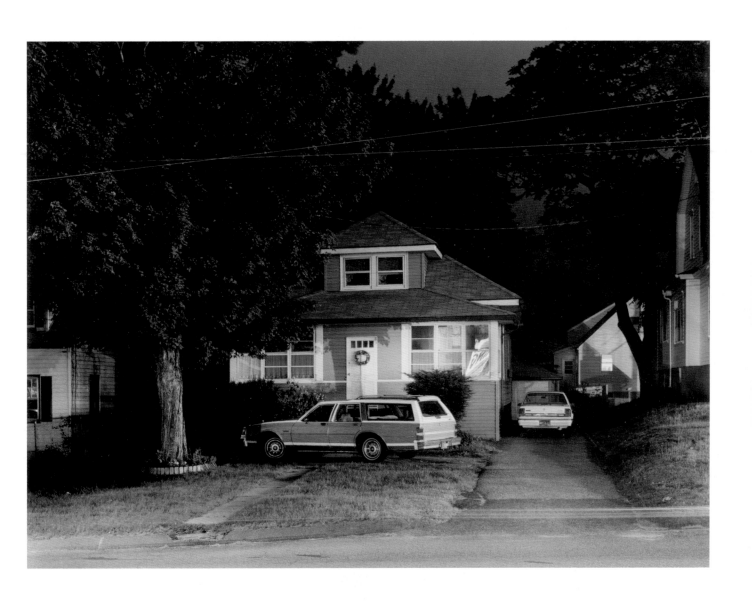

Tim Davis

Dunkin Donuts (Retail), 2001

Chromogenic Print

Courtesy of Greenberg Van Doren

Gallery, New York

Tim Davis

KFC (Retail), 2000

Chromogenic Print

Courtesy of Greenberg Van Doren

Gallery, New York

Greta Pratt

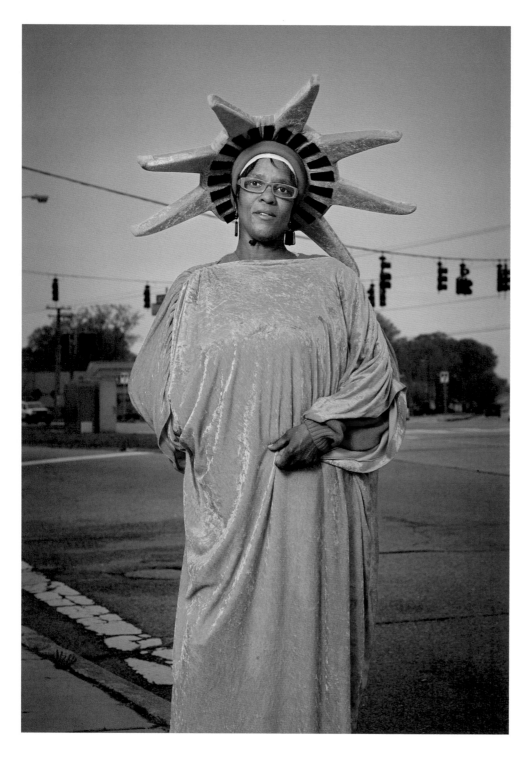

Greta Pratt
Alice Chatman, 2009
From the series *Liberty*
Archival Pigment Print

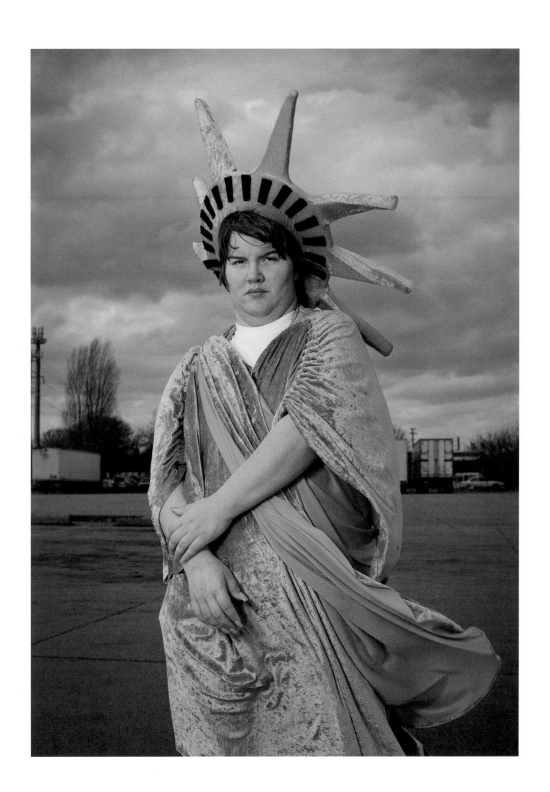

Greta Pratt
Christine Sweeney, 2009
From the series *Liberty*
Archival Pigment Print

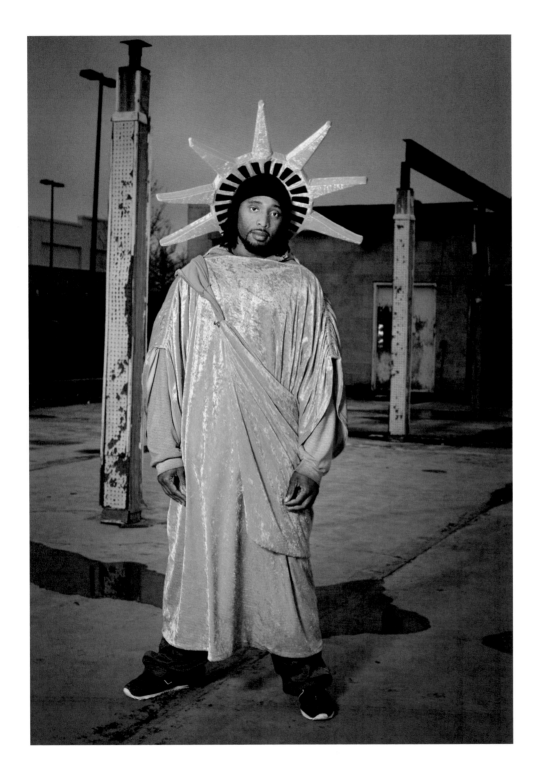

Greta Pratt
Ramone Williams, 2009
From the series *Liberty*
Archival Pigment Print

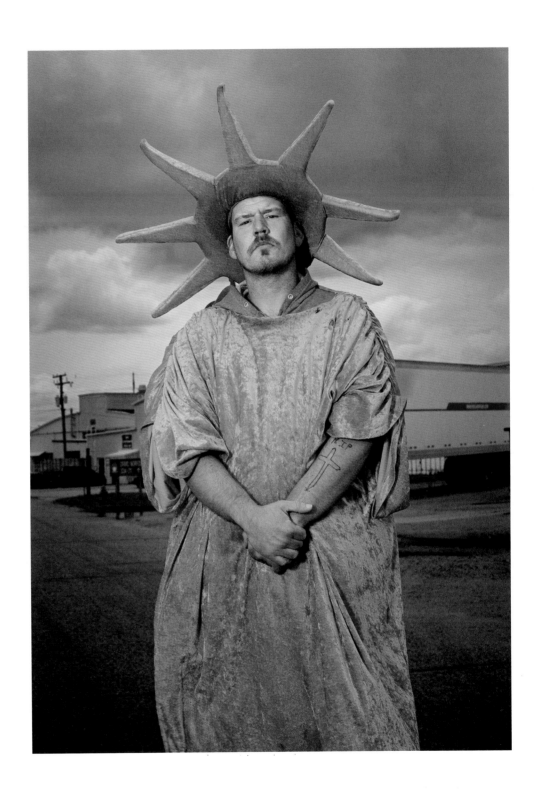

Greta Pratt
Joe Lachwa, 2009
From the series *Liberty*
Archival Pigment Print

Eirik Johnson

153

Eirik Johnson

Erin Rieman along the Siuslaw River, Oregon, 2006

From the series *Sawdust Mountain*

Archival Pigment Print

Courtesy of G. Gibson Gallery, Seattle and

Rena Bransten Gallery, San Francisco

Eirik Johnson

Arlington, Washington, 2006

From the series *Sawdust Mountain*

Archival Pigment Print

Courtesy of G. Gibson Gallery, Seattle and

Rena Bransten Gallery, San Francisco

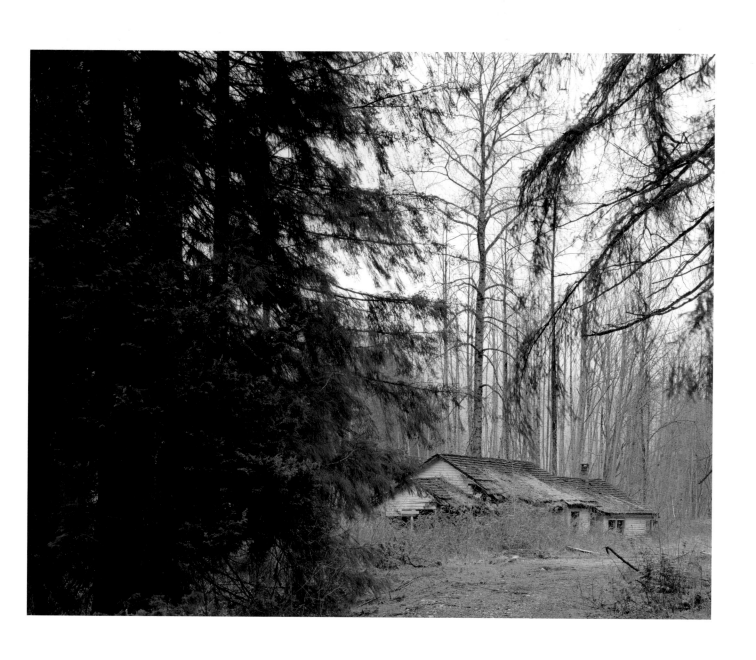

Myra Greene

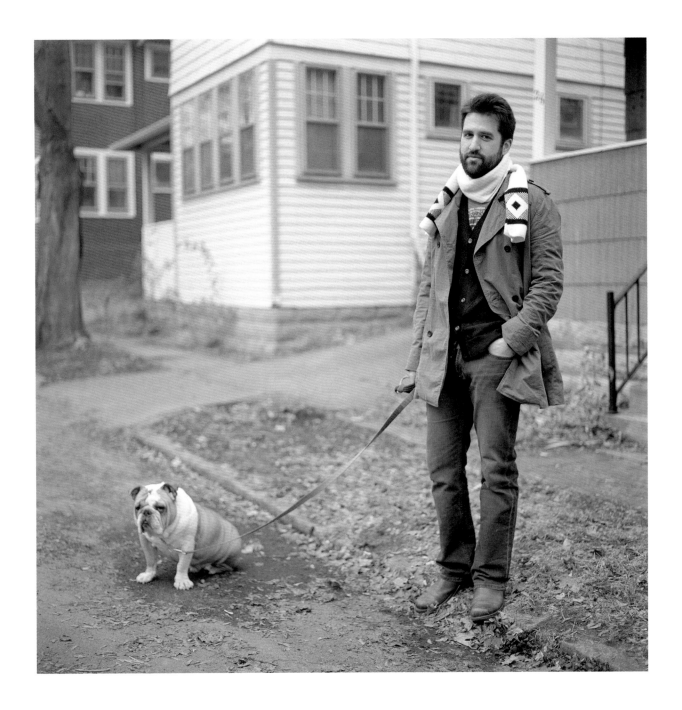

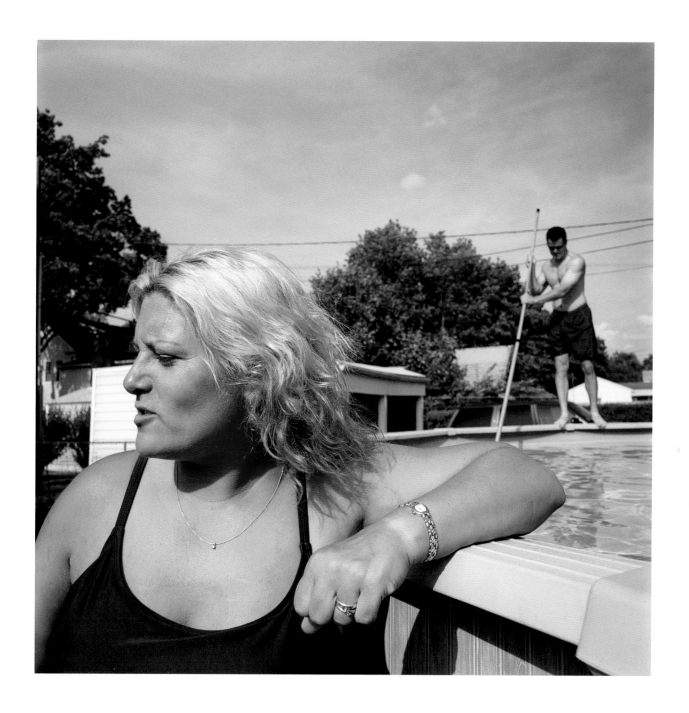

Myra Greene

T.S. Rochester, NY, 2009

From the series

My White Friends

Inkjet Print

Myra Greene

A.G. and K.G.

Rochester NY, 2007

From the series

My White Friends

Inkjet Print

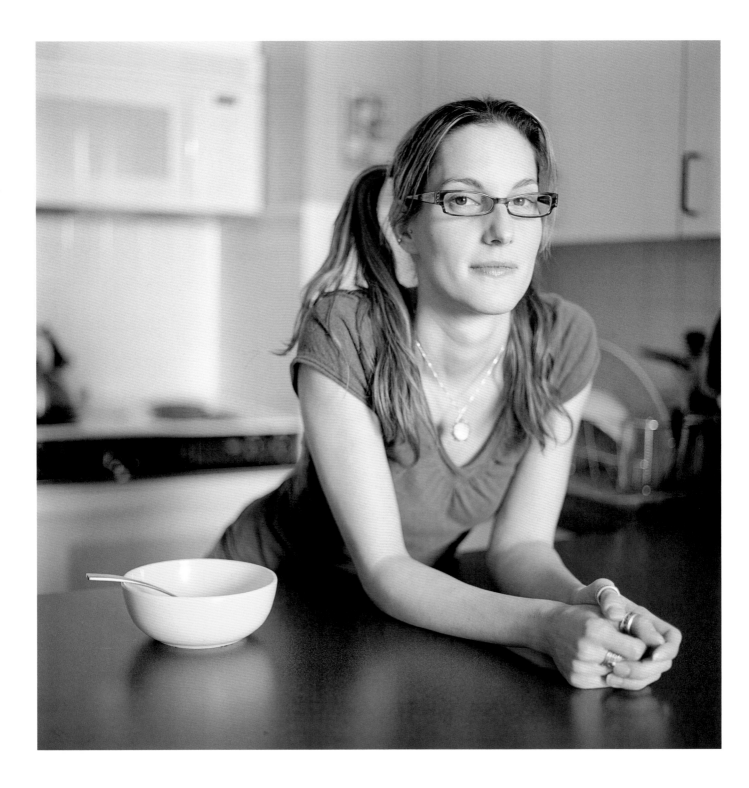

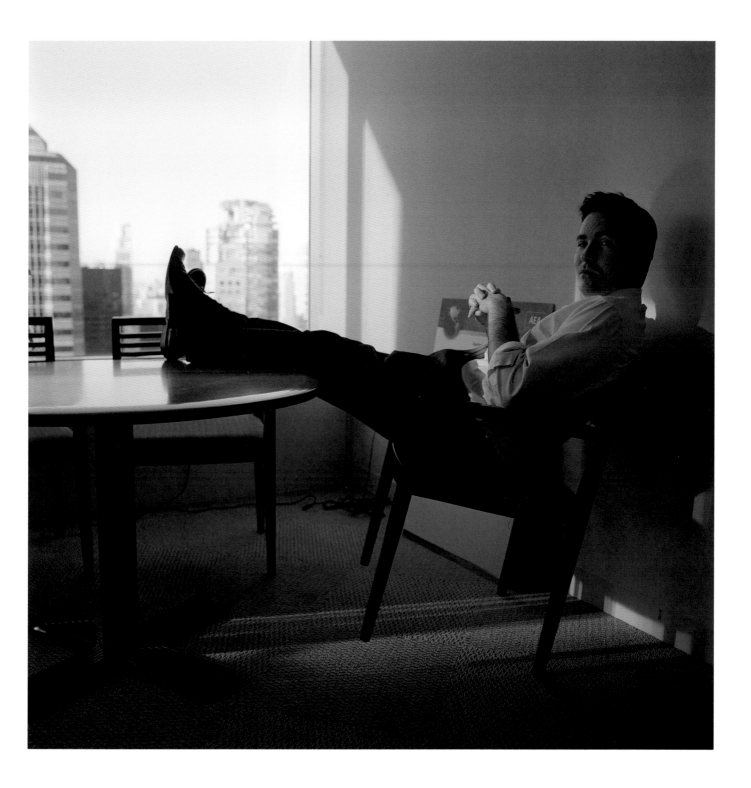

LEFT

Myra Greene

J.E. Chicago, IL, 2008

From the series *My White Friends*

Inkjet Print

RIGHT

Myra Greene

J.S. New York, NY, 2008

From the series *My White Friends*

Inkjet Print

159

Sheila Pree Bright

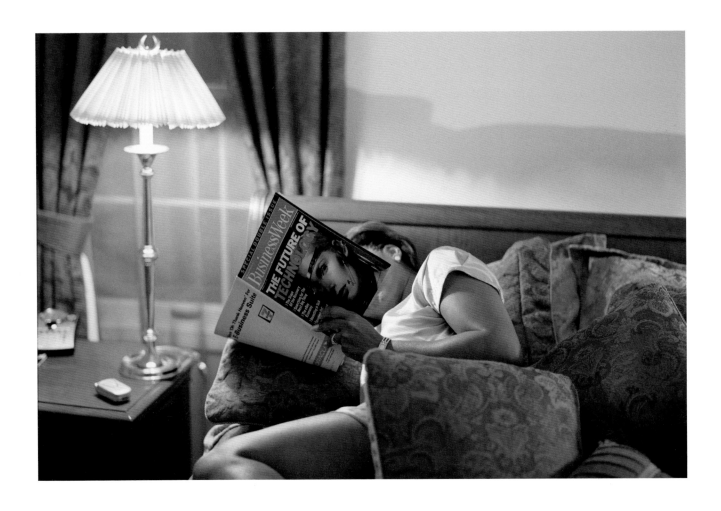

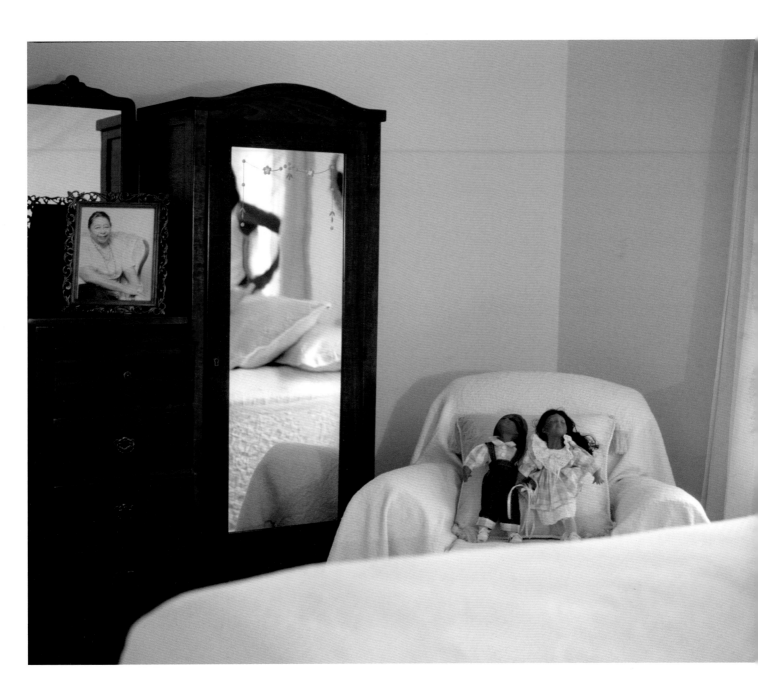

Sheila Pree Bright
Untitled #11, 2006
From the series **Suburbia**
Chromogenic Print

Sheila Pree Bright
Untitled #29, 2006
From the series *Suburbia*
Chromogenic Print

163

Jeff Brouws

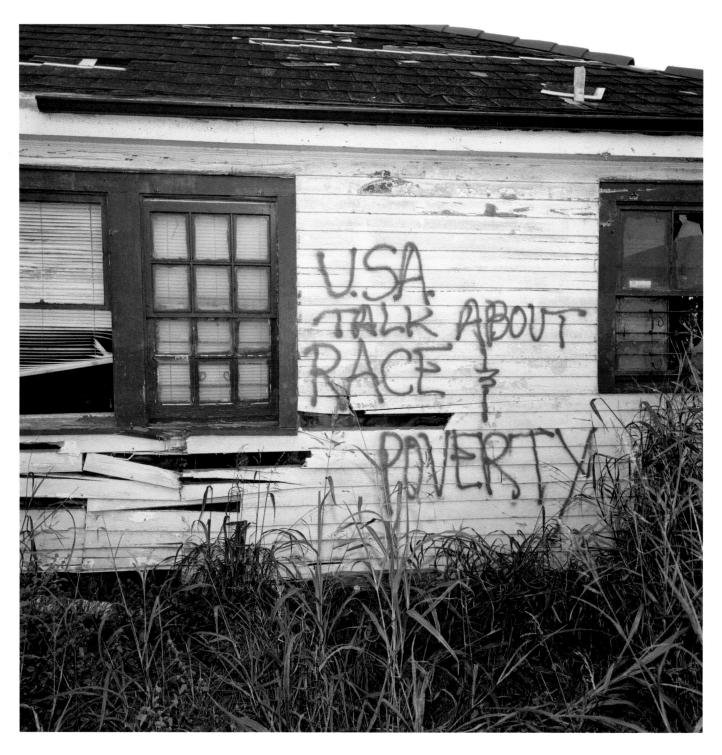

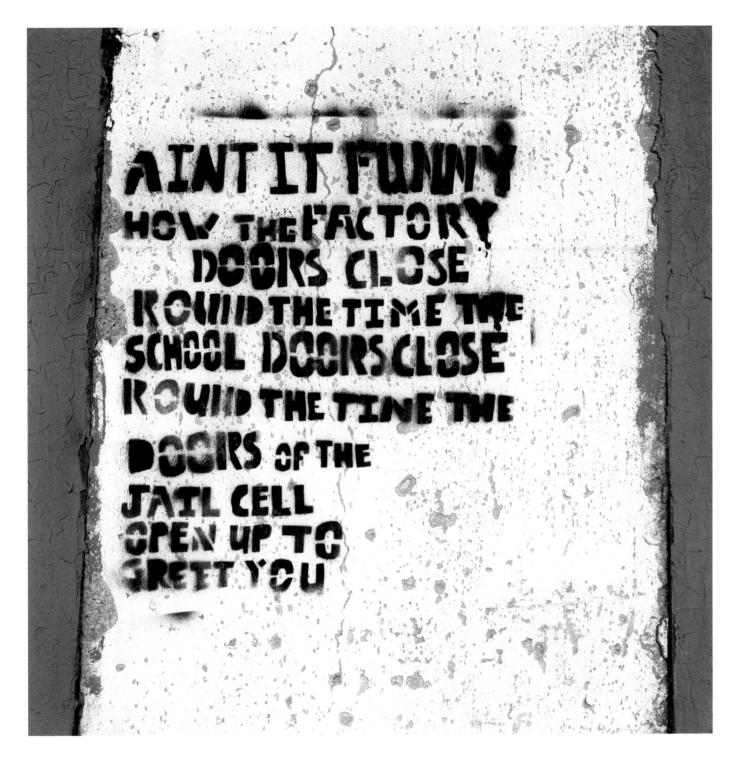

AINT IT FUNNY
HOW THE FACTORY
DOORS CLOSE
ROUND THE TIME THE
SCHOOL DOORS CLOSE
ROUND THE TIME THE
DOORS OF THE
JAIL CELL
OPEN UP TO
GREET YOU

LEFT

Jeff Brouws

USA Talk about Race and Poverty, 2006

From the series *Language of the Unheard, Lower Ninth Ward, New Orleans*

Archival Inkjet Print, Courtesy of the Artist and Robert Mann Gallery, New York

RIGHT

Jeff Brouws

Ain't It Funny, 2008

From the series *Language of the Unheard, Detroit, Michigan*

Archival Inkjet Print, Courtesy of the Artist and Robert Mann Gallery, New York

165

An-My Lê

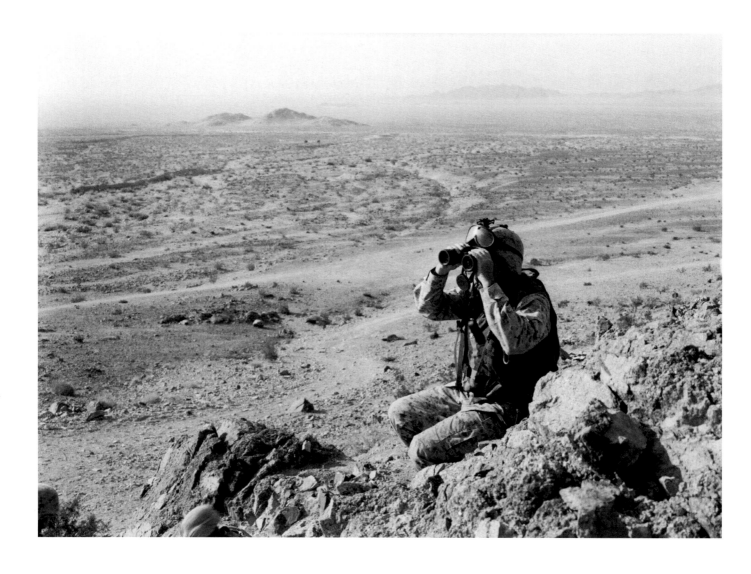

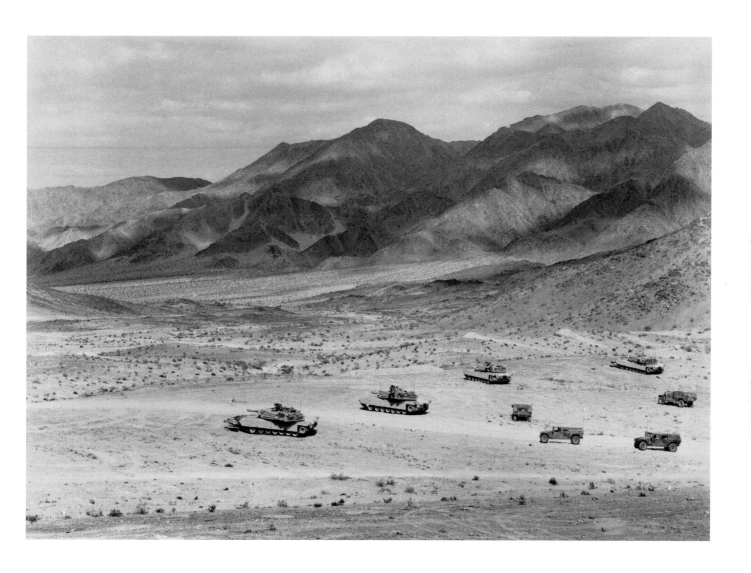

LEFT

An-My Lê

29 Palms: Colonel Greenwood, 2003–04

Silver Gelatin Print

Courtesy of the Lannan Foundation, Santa Fe

RIGHT

An-My Lê

29 Palms: Mechanized Assault, 2003–04

Silver Gelatin Print

Courtesy of the Museum of Contemporary

Photography at Columbia College Chicago

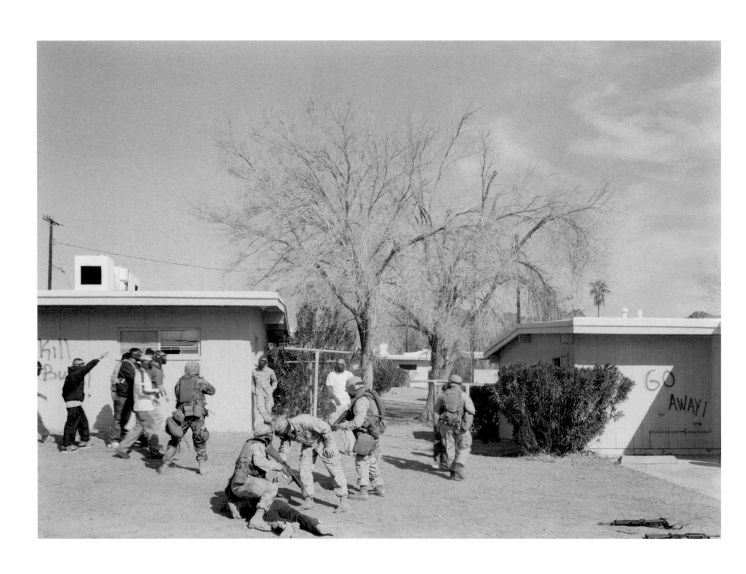

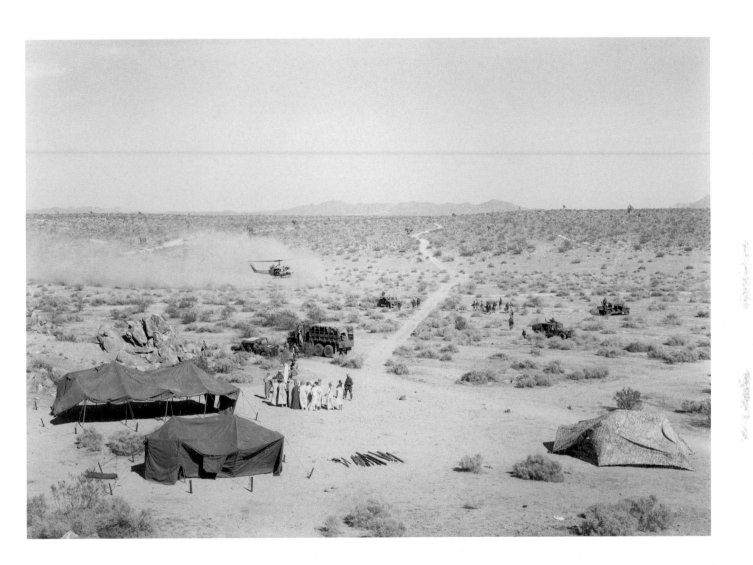

169

David Oresick

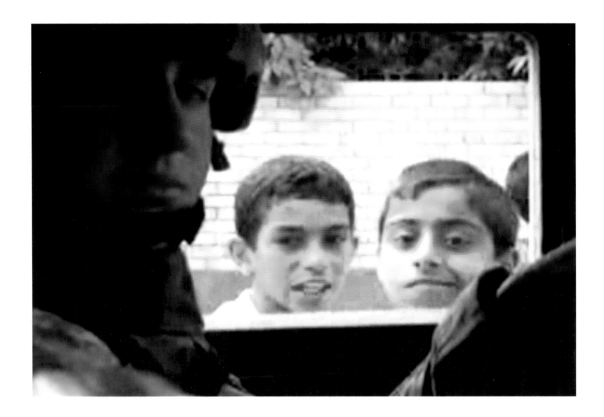

David Oresick
Soldiers in Their Youth, 2009
Video Still

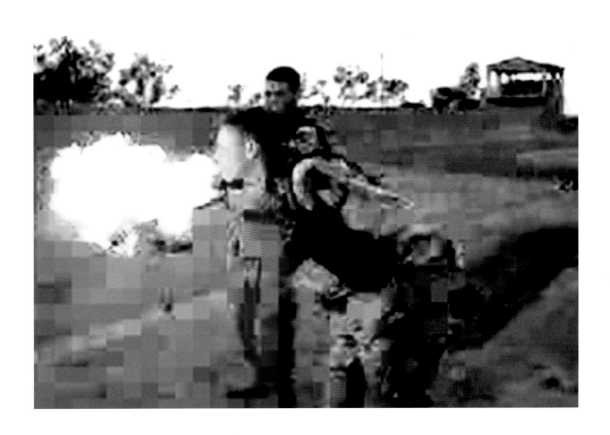

David Oresick
Soldiers in Their Youth, 2009
Video Still

David Oresick

Soldiers in Their Youth, 2009

Video Still

David Oresick
After the War, 2009
Video Still

Jeff Brouws

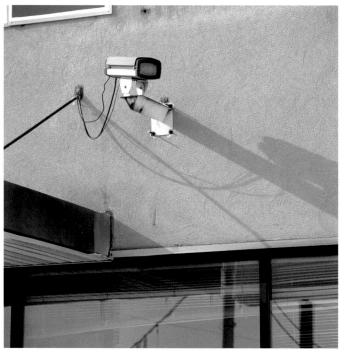

Jeff Brouws

Surveillance Cameras, 2003

From the series *Surveillance*

Archival Pigment Print

Courtesy of the Artist and Robert Mann Gallery, New York

Trevor Paglen

Trevor Paglen
P35-12 Military Meterological Spacecraft Near Alpha Persei (OPS 8389), 2007
From the series *The Other Night Sky*
Chromogenic Print
Courtesy of Altman Siegel Gallery, San Francisco

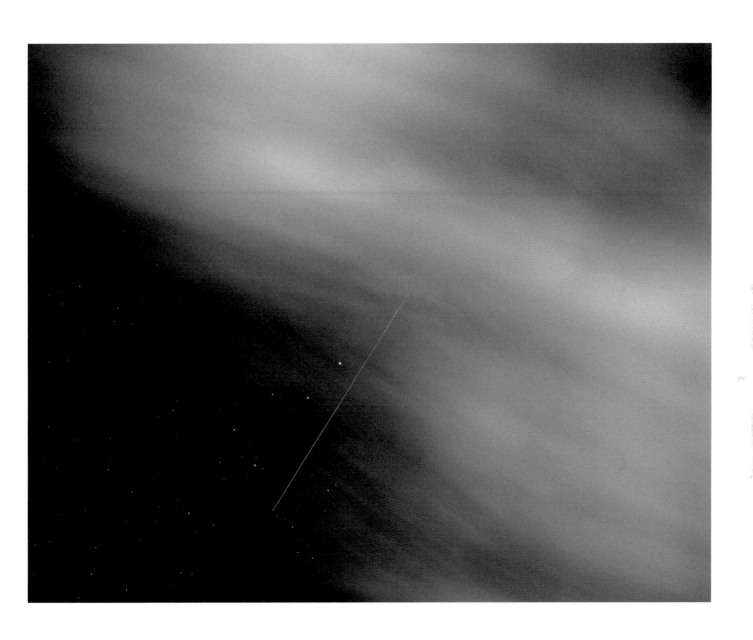

Trevor Paglen
LACROSSE / ONYX IV Near Alfirk (Radar Imaging Reconnaissance Satellite), 2008
From the series *The Other Night Sky*
Chromogenic Print
Courtesy Altman Siegel Gallery, San Francisco

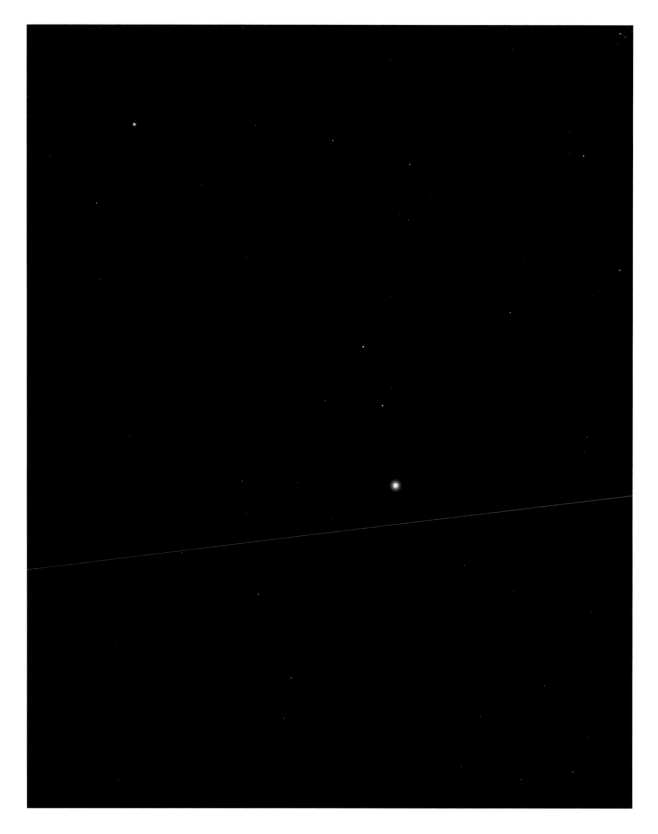

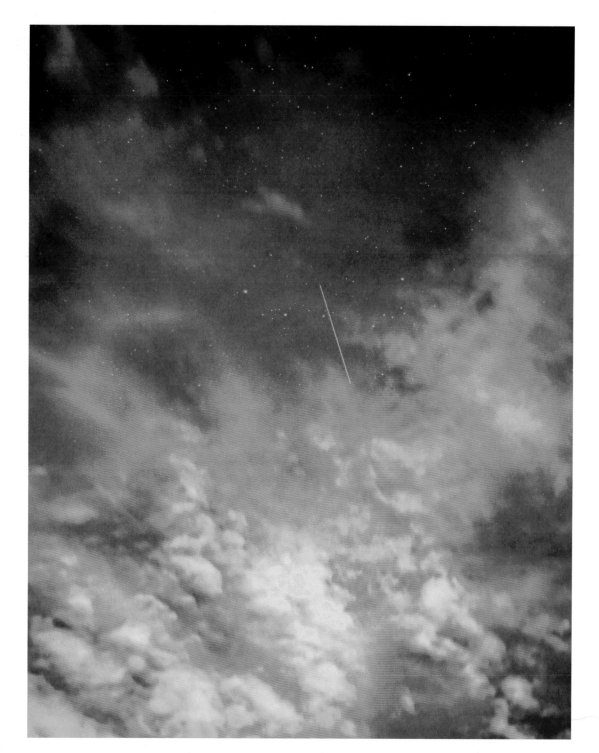

Trevor Paglen
USA 193 Near Alioth (Code
Name Unknown), 2007
From the series
The Other Night Sky
Chromogenic Print
Courtesy of Altman Siegel
Gallery, San Francisco

Trevor Paglen
KEYHOLE/IMPROVED
CRYSTAL Optical
Reconnaissance Satellite
Near Scorpio (USA 129), 2007
From the series
The Other Night Sky
Courtesy of Altman Siegel
Gallery, San Francisco

Paul Shambroom

Paul Shambroom

Hawk air defense missile, First Baptist Church, Covington, Ohio, 2008

From the series *Shrines: Public Weapons in America*

Archival Pigment Print

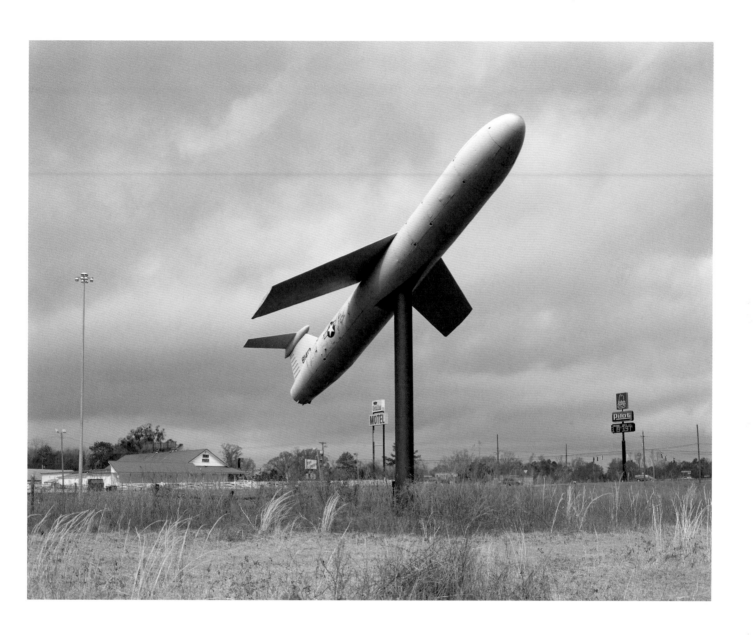

Paul Shambroom

Martin Mace Cruise missile, Interstate 75 Exit 146, Centerville, Georgia, 2008

From the series *Shrines: Public Weapons in America*

Archival Pigment Print

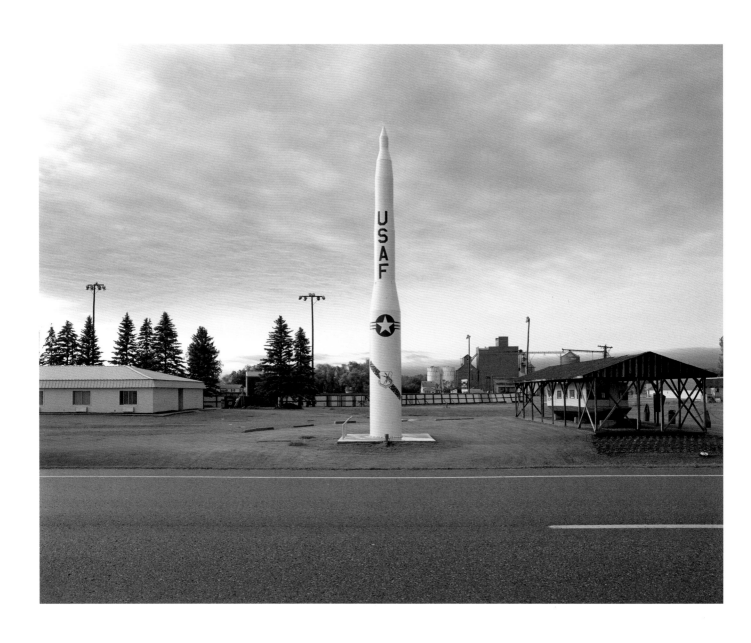

Paul Shambroom
Minuteman I nuclear armed intercontinental ballistic missile,
ND Highway 13, Lamoure, North Dakota, 2008
From the series *Shrines: Public Weapons in America*
Archival Pigment Print

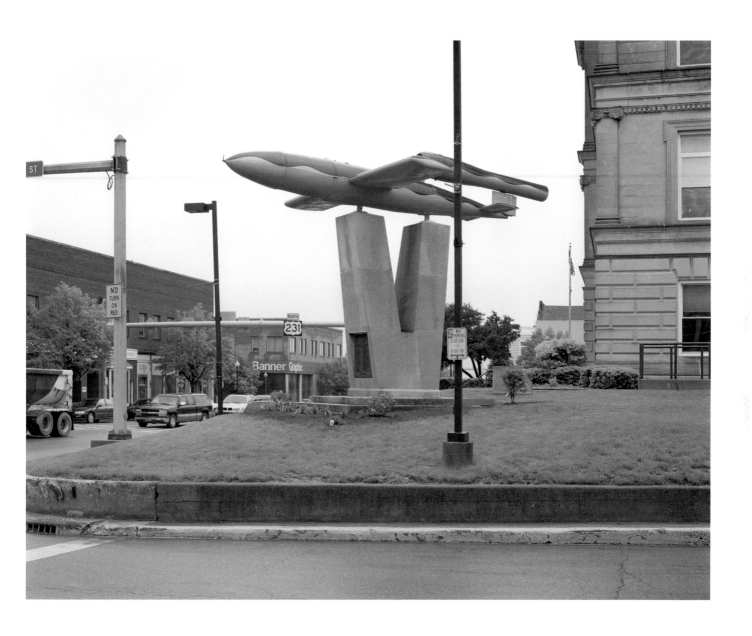

Paul Shambroom

German V-1 "buzz bomb", Putnam County Courthouse,
Greencastle, Indiana, 2008
From the series *Shrines: Public Weapons in America*
Archival Pigment Print

Erika Larsen

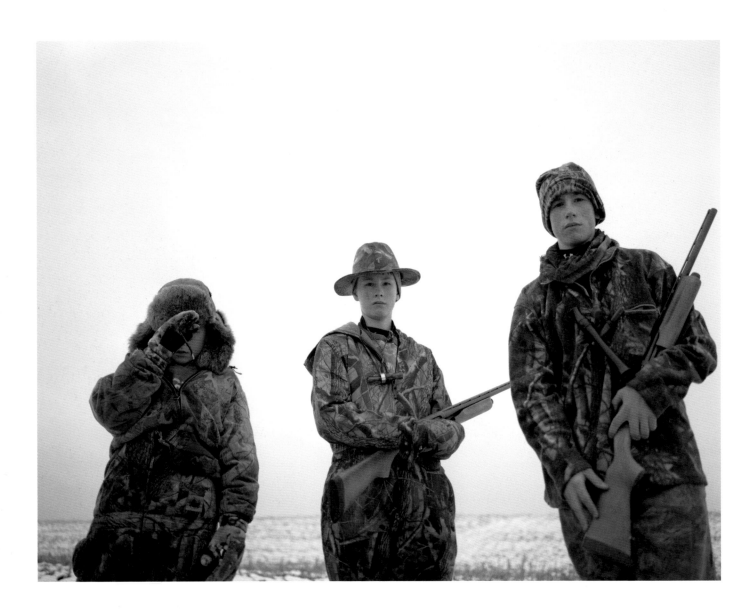

LEFT
Erika Larsen
Brothers, 2007
From the series *Young Blood*
Chromogenic Print

RIGHT
Erika Larsen
Ruthie's First Kill, 2007
From the series *Young Blood*
Chromogenic Print

Erika Larsen

Pheasant Hunter, 2007

From the series *Young Blood*

Chromogenic Print

Erika Larsen
The Clearing, 2007
From the series *Young Blood*
Chromogenic Print

Greg Stimac

Greg Stimac
Untitled Recoil, 2005
Archival Inkjet Print

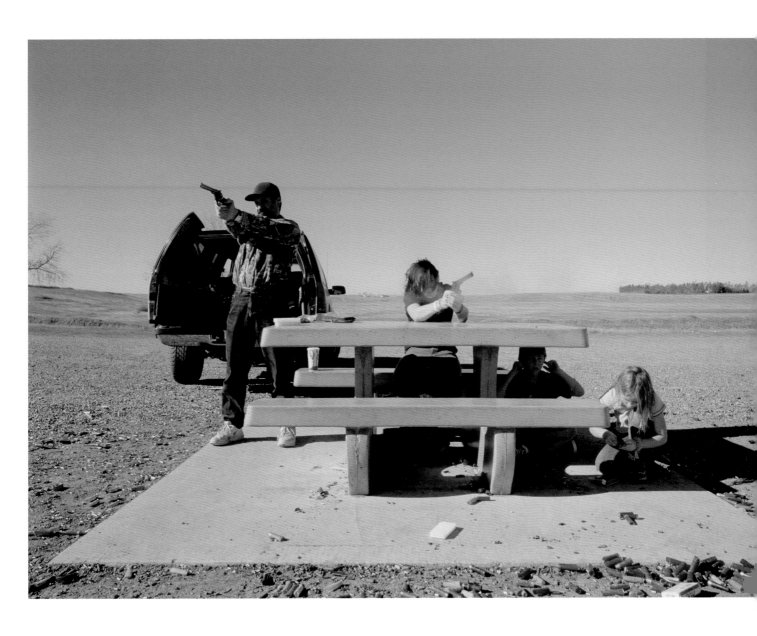

Greg Stimac
Untitled Recoil, 2005
Archival Inkjet Print

189

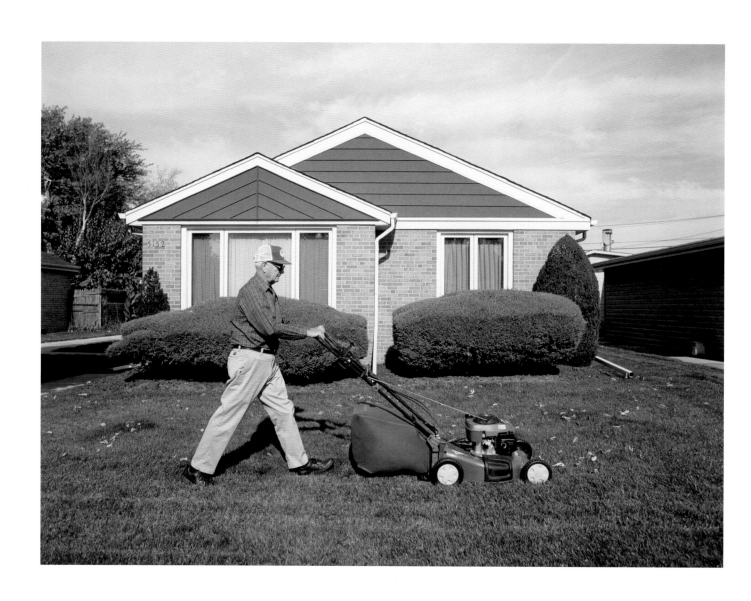

LEFT

Greg Stimac
Oak Lawn, Illinois
(Mowing the Lawn), 2006
Archival Inkjet Print
Courtesy of the Museum of
Contemporary Photography at
Columbia College Chicago

RIGHT

Greg Stimac
Concord, Vermont,
(Mowing the Lawn), 2006
Archival Inkjet Print
Courtesy of the Museum of
Contemporary Photography at
Columbia College Chicago

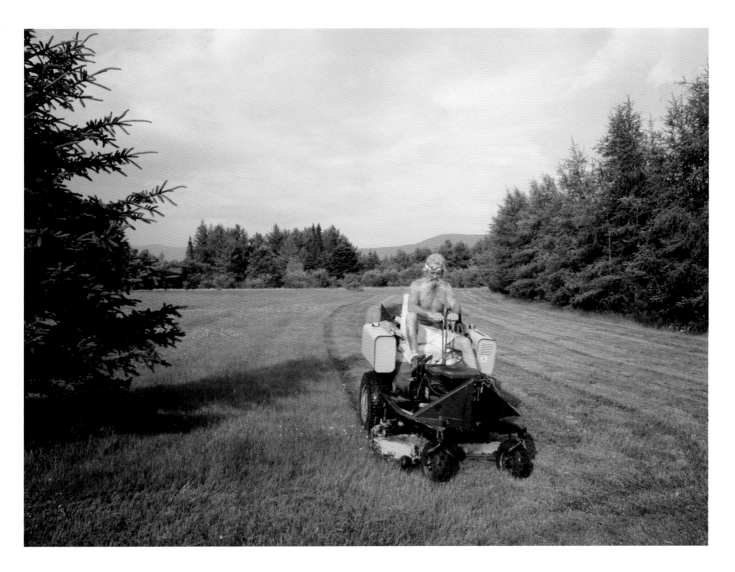

Nic Nicosia

Nic Nicosia

9 ½ *Hours to Santa Fe,* 2003/2004
Video Still
Courtesy of the Artist; Dunn and Brown Contemporary, Dallas;
James Kelly Contemporary, Santa Fe

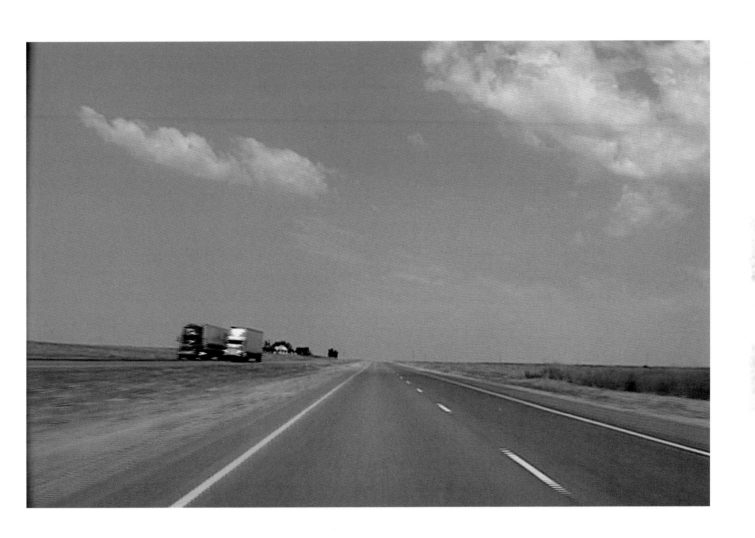

Nic Nicosia

9 ½ Hours to Santa Fe, 2003/2004

Video Still

Courtesy of the Artist; Dunn and Brown Contemporary, Dallas;

James Kelly Contemporary, Santa Fe

Nic Nicosia

9 ½ Hours to Santa Fe, 2003/2004

Video Still

Courtesy of the Artist; Dunn and Brown Contemporary, Dallas;

James Kelly Contemporary, Santa Fe

Nic Nicosia

9 ½ Hours to Santa Fe, 2003/2004
Video Still
Courtesy of the Artist; Dunn and Brown Contemporary, Dallas;
James Kelly Contemporary, Santa Fe

Victoria Sambunaris

Victoria Sambunaris
Untitled (Copper mine),
Bingham Canyon, UT, 2002
Chromogenic Print
Private Collection

Victoria Sambunaris
Untitled (Pipeline),
Dalton Highway, Mile 298, AK, 2003
Chromogenic Print
Collection Lannan Foundation,
Santa Fe

Christina Seely

Christina Seely
Metropolis 42° 22' N 71° 2' W (Boston)
From the series *Lux*, 2005–2010
Digital C-Print

Christina Seely
Metropolis 36° 10' N 115° 8' W (Las Vegas)
From the series *Lux,* 2005–2010
Digital C-Print

Christina Seely
Metropolis 29°40'N 95°18'W (Houston)
From the series *Lux,* 2005–2010
Digital C-Print

Jason Lazarus

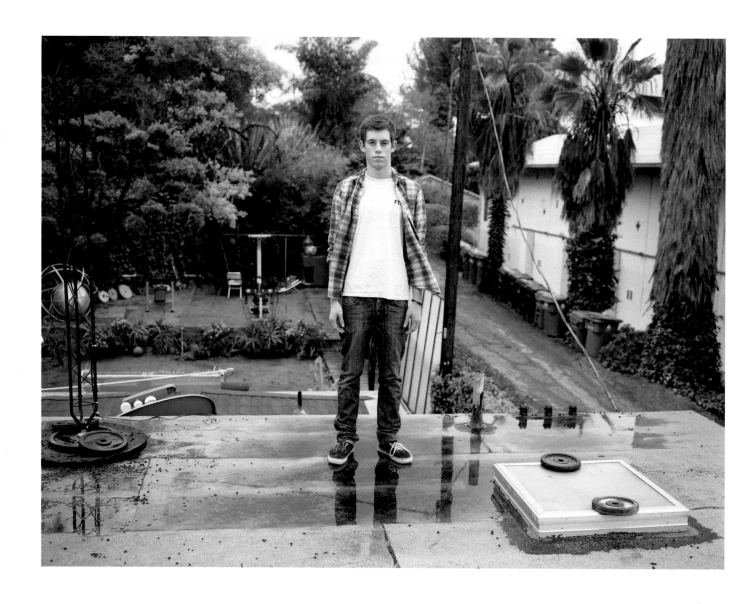

Jason Lazarus

Spencer Elden in his last year of
high school (January 2008), 2008
From the series *2004–present*
Spencer originally appeared as a naked baby
on the cover of Nirvana's *Nevermind* record
Archival Inkjet Print
Courtesy of the Artist and
Andrew Rafacz Gallery, Chicago

Jason Lazarus

The entire three minute duration of the
'America's Answer' fireworks package,
$99.95, Independence Day 2007, 2008
From the series *2004–present*
Archival Inkjet Print
Courtesy of the Artist and
Andrew Rafacz Gallery, Chicago

"What did I have on me today? I think I had Lil Wayne, "I'm Me." I think I had that on there"
- Michael Phelps
8/12/08

★

Last year they had the Grammys and left me in Miami
Sleeping on a nigga like I'm wrapping in my jammies
Mel Gibson flow, Lethal Weapon
Danxie'm Danny
I'm a monster I tell you - monster Wayne
I have just swallowed the key to the house of pain
Now I'm stuck here to deal with the houses pain
Fuck w. me i will peel like the house's paint
Lets go niggas doubt won't see me cause I'm
Getter and bold / The only time i wear
depends is when I'm 70 yrs old
That's when I can't hold my shit within,
so I shit on myself
cause I'm so sick & tired
of shitting on everybody else
I'm tryna tell ya,
like I'm sayin' sumthin

I'm from the dirty like
the bottom of my pants cuffs
And there ain't nothin'
you stop me so just
envy it. Hey I'll
accept a friendly grit

★ HOOK ★
the hottest under the sun (?)
Ain't nobody fuckin' with me man
Ay ay my ay U already know pimpin'
CASH $ records where dreams come true
FUCK up my DREAMS somebody gon die 2nite
(Ay) U already know that's pimpin'
YO it's cash $ records man, a lawless game

the hottest
under the sun (who dat)
Ain't nobody fuckin' with me man

Ay ay, U already know that pimpin' [YA]
ay ay,
CASH MONEY RECORDS, where dreams come TRUE
FUCK up my dreams, somebody gon die 2 nite
- Ay it's $ money Records man. low ass game
Ay ay U already know that pimpin'
aya

Un fuckin believable Lil' Wayne the President
Fuck'em fuck'em fuck'em, even if they celibate
I know the game is crazy, its more crazy than
to that it's ever
I'm married crazy Bitch, cost me Kevin Federlin been
It's obvious that he'll be cash $ till the death of him
the ground shall break when they bury him Bury him
I KNOW ONE DAY they gotta bury him

BETTER LOCK
MY CASKET TIGHT BABY, so i don't let the devil in
Nigga, it's just me and my guitar, yea Bitch I'm heavy metalin
You can get that fuckin led Zepplin
Niggas is bitches, Bitches, i think they full of estrogen
And we hold court and take your life for a settlement / Yes I'm the best!
And no i ain't positive positive. I'm definate I know the game like I'm
This is reffin it
The Carter, The Carter 3,
the new Testament
And I'm the god and this is what i bless'em with

HOOK:
Bitch I'm me, I'm me
I'm me I'm me
Baby I'm me so who you?
You're not me you're not me
And I Know THAT AIN'T FAIR
But i don't care
I'm a mutha fuckin CASH $ Millionaire
I know that ain't fair, but i don't care
I'm a mutha fuckin cash $ millionaire, YEA

U mean... brr
It's cash $ over everything it's in my blood I feel't running in every vein
I'm from the mud, I am a missle like a scud
Wuts really good? I'm about that Ruckers like Fudd
And i stay on my floor at cash $ like a rug / tied to the
Fuckin Birdman like a lug / And dear Mr. Ronald Williams
To you i shall forever give thanks like a grudling
CASH $ million, heir to the throne / Going at they
heads like hair in a comb. Sitting by the
window i just stare at the stolen
know i'll make it thru like hair in a comb
Yo / Bitches, my niggas trust my senses
And i will take on that shit as the
Lord as my witness. And you all
have witnessed. but i have not
finished. So keep your mouth
closed and let your
eyes listen
- HOOK ★

Michael Robinson

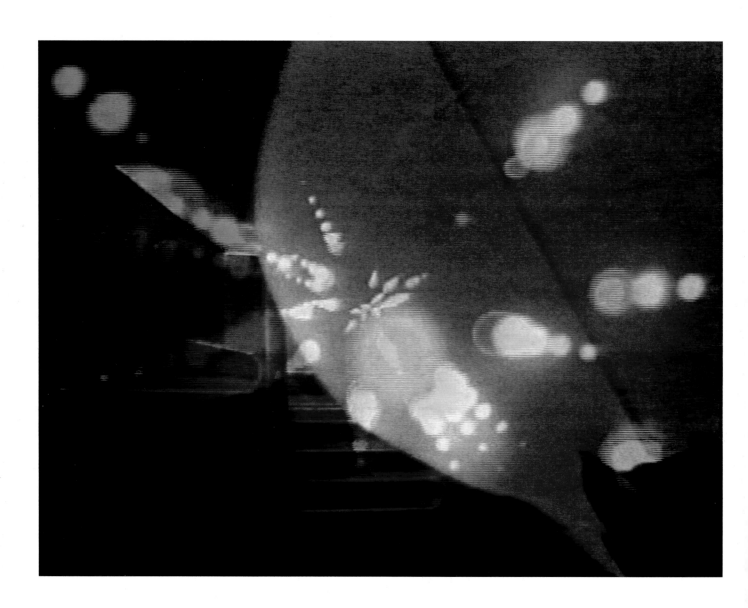

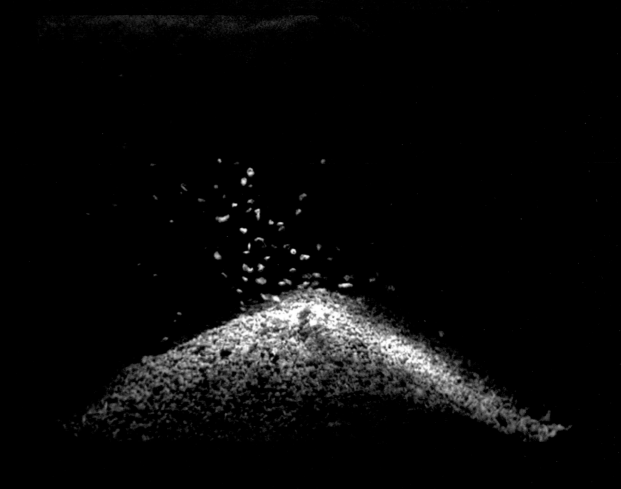

LEFT
Michael Robinson
Victory Over the Sun, 2007
Film Still

RIGHT
Michael Robinson
Victory Over the Sun, 2007
Film Still

Greg Stimac

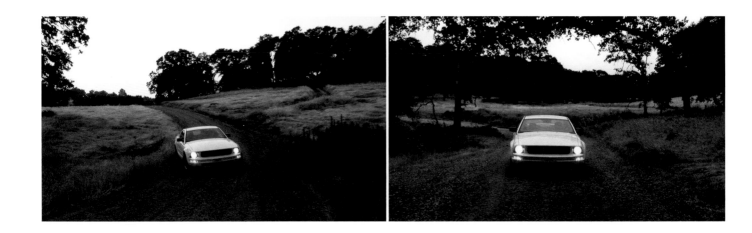

Greg Stimac

Untitled *(White Mustangs)*, 2008

Three Channel Video Projection

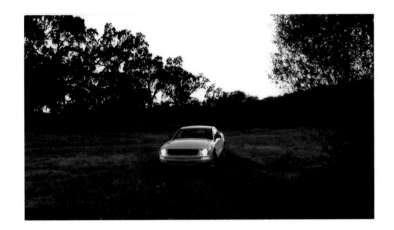

Medianation: Performing for the Screen

GILBERT VICARIO

EMILIO CHAPELA

SANDRA VALENZUELA

LAUREL NAKADATE

KALUP LINZY

LESLIE HALL

SUSANNE JIRKUFF

ADRIÀ JULIÀ

DANIEL JOSEPH
MARTINEZ

Medianation: Performing for the Screen

GILBERT VICARIO

"I have been obsessed with performance art for over a decade—ever since the Mexican performance artist Guillermo Gómez Peña came to visit my class at Cal Arts summer school. I finally took the plunge and experimented with the form myself when I signed on to appear on 20 episodes of "General Hospital" as the bad boy artist Franco, just Franco."
—**James Franco,** American actor, director, screenwriter, film producer, and artist [1]

"The line between art and life should be kept as fluid, and perhaps indistinct, as possible."
—**Allan Kaprow,** artist

Performance art, it seems, continues to rely on the frame (photographic and monitor) to deliver its message while the medium has undergone a radical shift from analog to digital, from still to moving images. What seems different now is that more artists are beginning to embrace the commercial dimensions of television and the internet as a radical strategy against traditional video and new media art. Ironically, David Antin articulated over thirty years ago that, "it is with television that we have to begin to consider video, because if anything has defined the formal and technical properties of the video medium, it is the television industry." [2] As Antin goes on to explain, the essentially post-World War II phenomenon of commercial television was patterned on the government-protected, private monopolies of the radio networks. Coupled with their relationship to the electronics industry, both television and radio made it economically impossible for anything but corporate ownership to be in control of information reception and transmission. How has this flow of information impacted our faith in the veracity of images?

Today, television has all but been replaced by the personal computer, the telephone has been absorbed by the Internet, and the ability to perform in and out of elegantly discrete or not so discrete portals of digital communication continues to shape and distort our conception of the individual. *Medianation* explores the interrelationship between the digital image and the flows of information that shape contemporary art discourse. Taking the media as a starting point and as an undeniable (though not unique) American phenomenon, the artists in MEDIANATION explore political, sexual, and cultural issues in a moment when the mutation of "traditional" forms of communication—radio, television, film, and photography—are giving way to an explosion of digitally based forms of social

1
James Franco. "A Star, A Soap and the Meaning of Art," The Wall Street Journal, December 4, 2009 (WSJ.com).
2
David Antin, "Video: The Distinctive Features of the Medium," in *Culture: A Critical Investigation,* edited by Jon Handardt (New York: Visual Studies Workshop Press, 1986), p. 149

interaction. The work in MEDIANATION is informed, but not limited by, this ongoing technological shift.

Recent developments in social networking have given artists new possibilities for exploring how performance art can reside in the collective imagination. No longer bound by the traditional limitations of the single-channel video camera that served to "document" an action nor by prescribed institutional spaces such as galleries or theatrical stages, artists have taken to exploring the new avenues of distribution and contextualization made available through the Internet or through other more commercially viable platforms. The historical roots of this technology date back to the mid-1960s with the advent of the Sony portable video recorder known as the Portapak. Nam June Paik is generally regarded as the pioneer of this medium through his groundbreaking video work where he collaborated with the classical cellist Charlotte Moorman, among others. The ability to be relatively mobile with video recording equipment meant that artists could record extemporaneously in a variety of conditions or contexts, effectively moving toward the idea of real-time interaction. Artist-made videos challenged the preponderant stranglehold of the transmitted television signal by fighting against its easily digestible narrative conventions. This challenge manifested itself formally by dramatically digressing from the time-segmented structure of the programming and advertisements of commercial television. Structurally and politically, this was of primary interest to video makers anxious to invert the phenomenological relationship between artist and television, monitor and viewer. Martha Rosler's brilliant *Semiotics of the Kitchen* (1975), is one of the few, early precursors to performance art that parodied the structure of commercial television. Now it seems it is those very structural limitations of television and the internet that are of increasing interest to contemporary artists along with a healthy disinterest in the formal attributes of new technologies.

As Christiane Paul explains in her 2003 book *Digital Art*, "The terminology for technological art forms has always been extremely fluid, and what is now known as digital art has undergone several name changes since it first emerged: once referred to as 'computer art' (since the 1970s) and then as 'multimedia art,' digital art now takes its place under the umbrella term 'new media art,' which at the end of the twentieth century was used mostly for film and video, as well as sound art and other hybrid forms. The qualifier of choice here—'new'—points to the fleeting nature of the terminology. But the claim of novelty also begs the question, what exactly is supposed to be considered 'new' about the digital medium?"[3]

According to the author, what is in fact new about "new" technologies are the new possibilities for the creation and experience of art. Yet for contemporary artists, digital apparatuses merely afford the possibility of containing their ideas or allowing them to be projected within a multiplicity of venues, both virtual and physical. What seems to be emerging as a new strategy invariably consists of the establishment of a critical distance from the utopian miasma that usually accompanies new media terminology,[4] along with a tacit rejection of all of the technological hardware that becomes outdated or obsolete seconds after its

3
Christiane Paul, *Digital Art* (London: Thames and Hudson, 2003), 7.
4
This include cyborgs, cybernetics, artificial life and intelligence, telepresence, telerobotics, database aesthetics, mapping, data visualization, and tactical media, to name a few.

unveiling. The strategy of "critical remove" becomes a viable avenue of discourse when we try to address our relationship to these tendencies. In other instances, a self-conscious willingness to contend or compete with the lowest common denominator, television, remains an appealing and perhaps intellectually unexpected strategy that many artists employ and embrace. A perhaps more radical tactic that some artists use is the approach offered by the return to the analog and the question of whether this enables one to arrive at an essential truth in the construction of images.

An objective knowledge bank through his own discursive performance, Emilio Chapela's project *According to Google* (2008) is a forty-volume encyclopedia that contains thousands of images extracted from the Internet using the Google image search engine. Every volume of the encyclopedia corresponds to a concept or idea such as "beauty," "capitalism," "communism," "money," "art," or "abstraction" that reflects a digital collective unconsciousness blindly attempting to express itself. *Language* (2007), on the other hand, examines the inherent shortcomings of Internet technology when faced with the extremely difficult, and inherently human, act of translation.

In the work of Emilio Chapela, criticality is deployed through the interrogation of information and how it lives on the Internet.[5] He investigates the phenomenon of the Google search engine as Chapela's discursive performance began when the artist set out to try to translate a sentence that seems to self-referentially speak of communication: *A language is a system used to facilitate communication among higher animals and/or computers, but it's not limited to communication*. This is, in fact, a definition of the word *language* by the information website Wikipedia. This phrase was successively translated by Google's translation function from English into Portuguese, Portuguese back to English, English into German, German back to English, English into Spanish, Spanish back to English, English into Dutch, and Dutch back to English, yielding the sentence: *By language the communication to guarantee is which is higher used by the system between by animal and one is more computer, but that one no communication will be which not limited*. Aside from displaying the weaknesses of the programs of search engines and their inability to grasp subtleties in semantics that determine literal and cultural meaning, Chapela's project underscores the rapid rate at which misinformation gets circulated, absorbed, and recycled. To paraphrase Wikipedia itself on the subject, "Translation must take into account constraints that include context, the rules of grammar of the two languages, their writing conventions, and their idioms. A common misconception is that there exists a simple word-for-word correspondence between any two languages, and that translation is a straightforward mechanical process; such a word-for-word translation, however, cannot take into account context, grammar, conventions, and idioms."[6]

Reverting back to the early modern history of performance and photography, Sandra Valenzuela's *X-boyfriends* (2007) project came about as a result of an identity crisis that the artist faced while living in New York. Through the staging of a sequence of narrative

5
"In 1962, a nuclear confrontation seemed imminent. The United States (US) and the Union of Soviet Socialist Republics (USSR) were embroiled in the Cuban missile crisis. Both the US and the USSR were in the process of building hair-trigger nuclear ballistic missile systems. Each country pondered post-nuclear attack scenarios. US authorities considered ways to communicate in the aftermath of a nuclear attack. How could any sort of 'command and control network' survive? Paul Baran, a researcher at RAND, offered a solution: design a more robust communications network using 'redundancy' and 'digital' technology. At the time, naysayers dismissed Baran's idea as unfeasible. But working with colleagues at RAND, Baran persisted. This effort would eventually become the foundation for the World Wide Web." http://www.rand.org/about/history/baran.html (December 13, 2009).
6
http://en.wikipedia.org/wiki/Translation.

stills based on the personality of each of her ex-boyfriends, Valenzuela has tried to make sense of her own identity as both an individual and girlfriend. *X-boyfriends Alias Fake Memories (Paco)* (2007) documents her relationship with an ex-boyfriend whom Valenzuela characterized as being smart, cultured, and self-assured; he was somebody who grew up among females and was very close to his feminine and manipulative side. She decided to shoot the project in Prospect Park in Brooklyn and chose the decade of the 1920s to supply the symbolic tenor of this failed relationship. Valenzuela then decided to reverse roles with her ex-boyfriend by having him dress up as a "respectable" lady and herself as a little boy. Valenzuela staged this performance in the 1920s to coincide with the decade most associated with the Dadaist movement; in her imagination, "the twenties provided a poignant window because what began with such fervor ended with a tragic crisis."[7] Her haircut in the photographs was inspired by that of the Romanian and French avant-garde poet and performance artist Tristan Tzara, pictured in a *Vogue* magazine of the period. Tzara himself had explained that his self-chosen name was a pun in Romanian (*trist în țară*, meaning "sad in the country"), which may explain why Valenzuela chose it in the first place, having just moved to New York from Mexico. The time period in the artist's series also alludes to the legacy of the French artist, photographer, and writer Claude Cahun.[8] Cahun's work is generally regarded as marked by a sense of role reversal, and her public identity mirrored the general public's notions of sexuality, gender, beauty, and logic.

Like Valenzuela, artist Laurel Nakadate, who grew up in Ames, Iowa, performs in front of the camera along with a cast of amateur actors in an uncomfortable pairing of documentary photography and tabloid television. Locations shift from dingy, claustrophobic motel rooms to the majestic open spaces of the American West. Her *Lucky Tiger* series, for example, comprises small snapshots in which she appears in suggestive poses inspired by 1950s-style cheesecake and camera club photos. These snapshots were taken during a performance in which the artist and various anonymous middle-aged men, enlisted via Craigslist.com, covered their hands with fingerprinting ink and touched the photographs together. Nakadate's videos continue her performative exploits with a variety of middle-aged men, seemingly playing out different roles and scenarios that tread uncomfortably close to dark psychological territories that seem completely at odds with the politically correct attitudes one might ascribe to age-appropriate male/female relationships. But as she has said, "I also like the idea of turning the tables—the idea of them thinking that they're in charge or that they're in power and they're asking me for something and then I turn it on them, where I'm the director and the world is really my world.[9] Nakadate's work seems to rise out of an increasing tendency in popular culture to embrace the utter banality of reality and tabloid television. Rather than shrinking away from it, Nakadate employs it as a platform for the exploration of her own identity in the face of a long history of women's exploitation in film, television, and photography. The powerfully seductive video *American Gothic* (2006) shows Nakadate performing a pole dance on the porch of the Gothic Revival cottage that Grant Wood used for his famous painting. The soundtrack is Neil Young's "Heart of Gold," which plays as Nakadate writhes and swings awkwardly

7
Sandra Valenzuela, Artist's Statement, *X-boyfriends Alias Fake Memories (Paco)* (2007). Sent via e-mail to Gilbert Vicario, 9/9/2009

8
Born Lucy Renee Mathilde Schwob, Claude Cahun (1895–1954) adopted her pseudonym because of its sexual ambiguity, and her androgynous self-portraits display a feminist stance by playing with her audience's understanding of photography as a documentation of reality. Where most Surrealist artists were men, and their primary images were of women as isolated symbols of eroticism, Cahun epitomized the chameleonlike and multiple possibilities of the female identity.

9
Laurel Nakadate, quoted in interview with Scott Indrisek, *Believer* (October 2006), http://www.believermag.com/issues/200610/?read=interview_nakadate (December 13, 2009).

around the whitewashed pole. In the artist's first feature-length film, *Stay the Same, Never Change* (2008), much of her preoccupation with violence, isolation, and personal relationships finds expression among a circle of teenage girls in Kansas City. One of the girls acts out an imaginary wedding night with a stand-in teddy bear, while another teen writes a letter to Oprah Winfrey in the hopes that the television star will adopt her. In another scenario, a girl swimming with two older men asks them to drown her. Some of the eyes of the men that inhabit Nakadate's world are inexplicably blacked out, yet the implication that they are wearing blinders further complicates the relationship between the older men and the much younger girls. Is she protecting them or marking them? As *Variety* film critic Ronnie Scheib notes, "the favored instrument of teen interaction, the internet, is strangely absent.... In many ways, [her] camera mediates the zone between private and public spheres increasingly fudged in cyberspace."[10]

Adrià Julià's video and photo installation *La Reunion* (2008) considers the spiritual limitations of performance by conflating the history of the socialist utopian community formed in 1855 by French, Belgian, and Swiss colonists in Dallas with the present-day architecture of the now defunct Reunion Arena and the rallying cries of a present-day Dallas Stars hockey team cheerleader. Victor Prosper Considérant, the founder of La Reunion, was inspired by the utopian thought of the French philosopher and socialist Francois Marie Charles Fourier, most notable for his having originated the word *féminisme* in 1837 and for his belief that extending liberty to women was the principle of all social progress. Fourier's primary concern was to liberate every man, woman, and child through education and the liberation of human passion. He conceived of utopian communities, called "phalanxes," which were based around *Phalanstéres*, or grand hotels where individuals where situated based on their economic status; this was determined by one's job, which was assigned based on one's interests and desires (jobs people would not enjoy received higher pay). An ideal phalanx would have exactly 1,620 people based on 810 types of character rooted in twelve common passions. Fourier's ideas strangely took root in America, with his followers starting these utopian communities throughout the country including one in Utopia, Ohio. The colony near present-day Dallas was incorporated into the emerging city of Dallas around 1860, ending the original social experiment. As Débora Antscherl has written, "Adrià Julià has found in Fourier's legacy a chaotic yet exact system of symbols, language and psychological exploration.... The introduction of the Fourierist possibility into Julià's discourse is in line with his most recent work, *A Means of Passing the Time*, for example, in that he continues to contemplate and address new aspects of representation, architecture and landscape."[11] In Julià's installation, images of the resolutely capitalist architecture of Reunion Arena (1980–2008) and Reunion Tower (1978) stand symbolically in place for what has long disappeared since the height of Considérant's community. The fervent passion of Considérant, known for his sermons about "America the Great" is here transmogrified into the passionate cheerleading of Cameron Hughes, who is striving to get an entire stadium crowd on its feet, a subject that Julià has deconstructed in both photography and slow motion film. In the humble yet charismatic Hughes, a correlation is made back to Considérant, an attempt by the artist to see the forces of human persuasion as universal.

10
Ronnie Scheib, "Stay the Same Never Change," *Variety* (March 24, 2009), http://www.variety.com/review/VE1117939933.html?categoryid=31&cs=1 (December 13, 2009).

11
Débora Antscherl, Adrià Julià: Indications for Another Place, Montehermoso, Vol. V, p. 102

One of the most powerful forms of television communication in the last thirty years has been its video-based outlets for music, such as MTV and VH1. As a result, many artists have begun to unapologetically and successfully cross over between performance artist and musical performer. Kalup Linzy has been at the forefront of this hybridization of commercial and creative endeavors. His *SweetBerry Sonnet (Remixed)* (2008) is a remixed version of a recent video anthology created to accompany the songs on his 2008 album *SweetBerry Sonnet*. Performing as his recurring characters (including Taiwan, Labisha, Katonya, Nucuavia, and Jada), Linzy created a music video for each R&B-inspired song on the album, including "Dirty Trade," "Edge of My Couch," and "Chewing Gum," to name a few. Linzy's *Melody Set Me Free* (2007) is a bittersweet story about a small-town contestant in an American Idol-style talent show competition and her quest for fame and stardom. Writes Linzy, "Vying to win a recording contest, they must take a Whitney Houston song and make it their own." Every stock Hollywood character, from the wide-eyed ingénue to the conniving nemesis, is featured in the video. In Linzy's *Conversations Wit de Churen: As da Art World Might Turn* (2006), the artist has taken a funny and melodramatic look at the current state of the art world through the filter of his own recent success. Originally from a small town in Florida, Linzy in this work has assimilated various guises and social codes taken from his humble upbringing where folks always had the television on to watch their favorite soap operas. Linzy's work is, in fact, inspired by his family's favorite television shows along with various traditions of black performers in the south.

Ames, Iowa, native Leslie Hall is a video artist and lead singer to her band Leslie and the Ly's, and a connoisseur of the decorative and decidedly lowbrow fashion accessory known as the gem sweater. Hall began collecting gem sweaters in 2000 and has since amassed over 400 different kinds. A graduate of the School of the Museum of Fine Arts, Boston, she has created significant interest through her various commercial endeavors, including Midwest Diva stretchy pants, "gay wedding in Iowa" packages, and tour information for her wildly popular band. In 2005 her band released their first album, *Gold Pants*, and in 2006 Hall followed up with a second self-released solo record, *Door Man's Daughter*, and toured the globe in support of it. She was also featured on a VH1 special called *40 Greatest Internet Superstars*. Hall's videos are readily available on YouTube and usually accompany songs off her albums. *How We Go Out* (2007) features the artist in her trademark "Jiffy-Pop" hairdo, gold lamé outfit with octopus-like epaulets, and oversized glasses, accompanied by her two backup singers. The spirited rap song features the artist in a variety of middle American settings including a supermarket, a video store, and a discount clothing store, dancing around with a variety of characters. Hall's charmingly low-tech videos are alternately hilarious yet touching vignettes that celebrate life in the Midwest and her aspirations towards becoming a pop superstar. Her latest video, *Gravel in My Shoe* (2009), is a mordant view into the lives of a polygamist community in which Hall plays one of the harried wives; it pushes Hall's work in a stronger narrative direction even as it remains firmly planted in a local American vernacular.

The Austrian-born artist Susanne Jirkuff, on the other hand, has created an overtly political work with *Feel It* (2004), completed in the same year Bush successfully won reelection against Senator John Kerry and a year after he ordered the invasion of Iraq. Known for her drawings and videos, Jirkuff has created a humorous, comics-like portrait of the forty-third president of the United States at a moment when a growing insurgency in Iraq began to deepen the country's political instability. Set in the Oval Office at the White House, it brings together G. W. Bush, C. Rice, and C. Powell in an animated rap video set to the music of Timbaland and Magoo:

> *Ooh Snap!*
> *My head throbbin*
> *As I ride in my 3-4-8 mobbin*
> *Listen to the buddha brothers*
> *6 to 10 there aint no other*
> *Playin my favorite jams*
> *On 1-0-3 Jams*
> *I got my man Big D, Big Rodney*
> *In case somebody want to rob me*
> *We going to Military Circle [echo Circle]*
> *Virginia's tight that's why they gotta keep a curfew [echo curfew]*
> *It's time to get something to eat*
> *Oh snap, there's my man Kumbalee*
> *And my girl Missy*
> *Who she role wit? Who she be wit? Who she role wit? Who she be wit?*
> *Total, Da Brat, Lil Kim, Lil Cease and Puffy*
> *Can I get a ride?*
> *Tonight, tonight*
> *Can I get a ride?*
> *Tonight, tonight* [12]

With humor and cynicism, Jirkuff has presented the personages of the Bush administration in the form of a music video that is as much an affirmation of the political potency of the rap music industry as it is of the powers that it reduces or elevates to the status of pop culture icons.

Unlike Jirkuff, Daniel Joseph Martinez's approach to politics and popular culture resides in an analytic deconstruction of hierarchies along with a conflation of social and cultural histories. Martinez's relationship to performance has always been profoundly rooted in the tradition of social protest and political action and has manifested itself in various guises and manifestations. Language and text are of primary interest to his work and reflect a pedagogical kinship with conceptual practitioners of the 1960s. Martinez's Alaskan pipeline project documents the entire 800-mile length of the Trans-Alaska pipeline from Valdez, the nearest pack ice-free port in the state, to Prudhoe Bay, where oil was discovered in 1968. Through text and image. Martinez is motivated by the history of the pipeline, present-day politics, and the skeptical relationship between received knowledge (via the media) of the region and the subjectivity of his own experience. Martinez's project is entitled: *Those who wish for peace should prepare for war! / Old Sasquatch Proverb / She could see Russia from her house! / (In search of the Tribe Called Sasquatch, or who really built the Alaskan Oil Pipeline) / 16 – Communiqués and found photographs from traveling the length and*

12
"Feel It," Timbaland and Magoo, Welcome to Our World, album released, 11/11/1997

break of Alaska during the month of August, 2009. The piece consists of a mail-art performance enacted while traveling the length of the pipeline. Martinez purchased tourist postcards he found throughout his route, adding phrases and text related to either the date or a particular feeling he wanted to convey. The first postcard, for example, was purchased in Valdez and featured an image of the bay. On the back, Martinez added, "Azimuth 53 degrees, 5:39am, Watts Riots, August 11, 1965, DJM, Mountain Sky Hotel, Valdez, Alaska." Another postcard dated August 13 features an image of a North Pacific Fur Fish, and the text Martinez added reads, "Firey the angels fell deep thunder rolled around their shores burning with the fires of orion moon beams point the way, DJM." And still another postcard dated August 21 features an image of a monument in the town of Delta Junction where the Alaska Highway and the Richardson Highway come together. On the back the text reads, "A man who fights for no flag. A man loyal to no country. DJM." While Martinez's project recalls the history of mail art and its most famous practitioner, On Kawara, we are reminded of its obsolescence in the face of current digital communications. The mail-art process thus becomes the perfect analog to Internet communication, which conversely is causing the slow demise of the postal system. Martinez's aim is not so much to comment on systems of communication and their imminent death, although that is an important aspect. His aim instead centers on his suspicion of the photographic image's ability to convey an absolute truth. By combining a photographic record with a subjective impression, Martinez's project becomes less about a personal account than about the fallacy of such a pursuit. In Martinez's mind, photography becomes complicit in the fabrication of a perceived reality, which in turn gets perpetuated through the media. His project also attempts to deconstruct the very notion of photography and the passive viewer by creating an installation where the viewer is positioned between the postcards and distorted mirrors thereby creating a palimpsestic structure that paradoxically collapses mass-produced images, objectivity, and personal testimony. In Martinez's mind, the refractive instability of the eye perfectly distorts the current political climate and thereby suggests that a strategy of distortion is perhaps the most interesting position an artist can take at this moment.

What may seem as innocuous as a musical performance, or as controversial as a video capturing the World Trade Center burning to the ground, Martinez and the other artists in MEDIANATION, merely act as morally neutral mirrors, reflecting a society seduced and corrupted by the power of the media in all of its manifestations. While the work reflects the instability of the digitally generated image; it is through this instability that artists are beginning to navigate their way around the inherent difficulties of presenting performance-based work via new modes of digital communication. As James Franco's career aspirations attest and Allan Kaprow has reminded us all along, keeping that line fluid and indistinct can perhaps yield the most interesting and unexpected results thereby suggesting that the most interesting performance may be happening whether we know it or not. Photography and its biological offspring may have a hard time keeping up.

GILBERT VICARIO
CURATOR, DES MOINES ART CENTER, DES MOINES, IOWA

Emilio Chapela

Emilio Chapela
According to Google, 2008
40 digital offset books
Courtesy of the Artist and
EDS Galería, México City

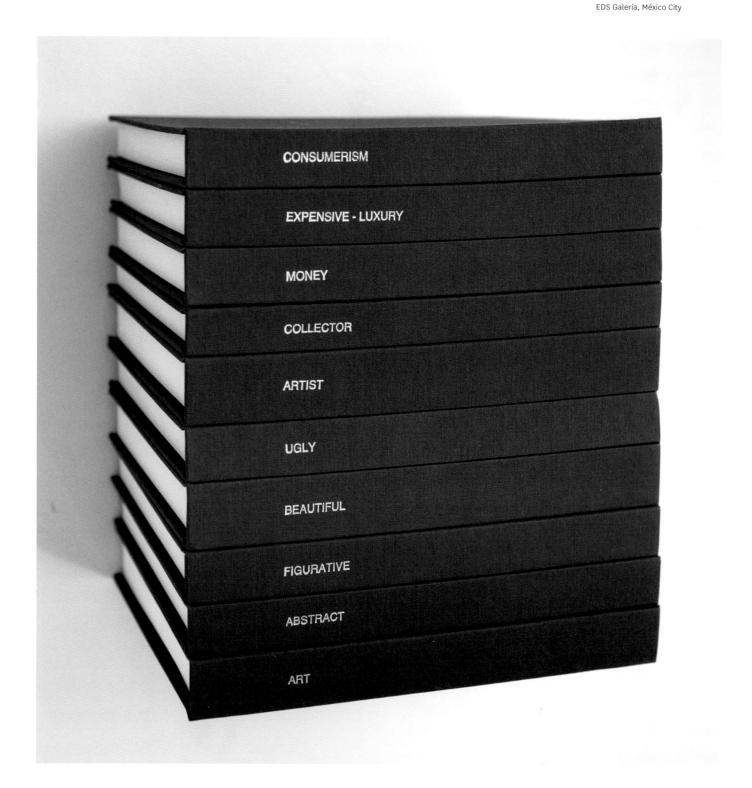

CONSUMERISM

EXPENSIVE - LUXURY

MONEY

COLLECTOR

ARTIST

UGLY

BEAUTIFUL

FIGURATIVE

ABSTRACT

ART

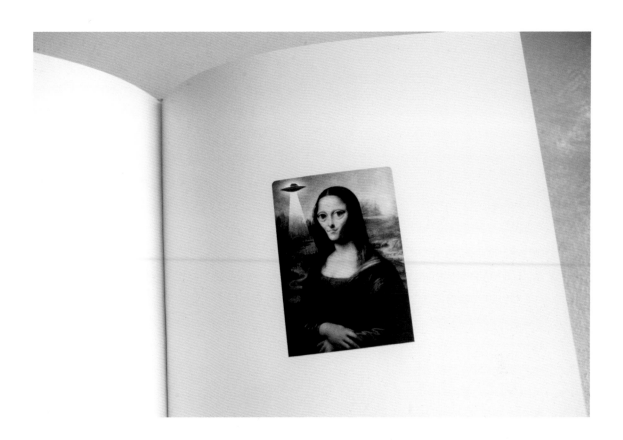

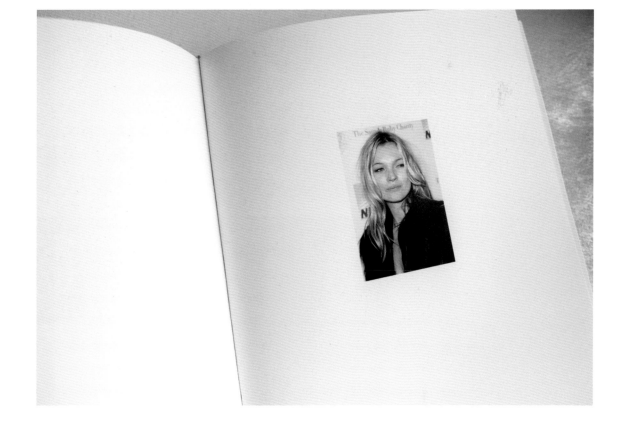

Emilio Chapela

Digital Degradation, 2009

Inkjet on archival paper

Courtesy of the Artist and

EDS Galería, México City

Sandra Valenzuela

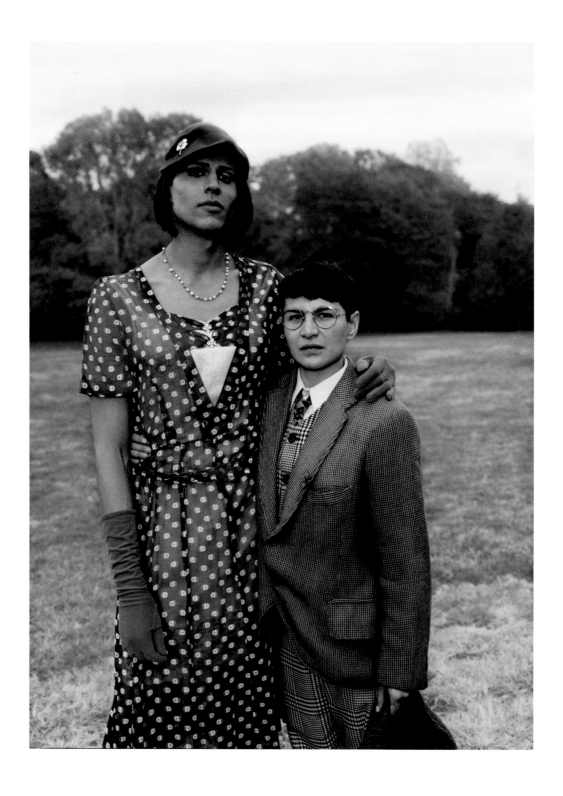

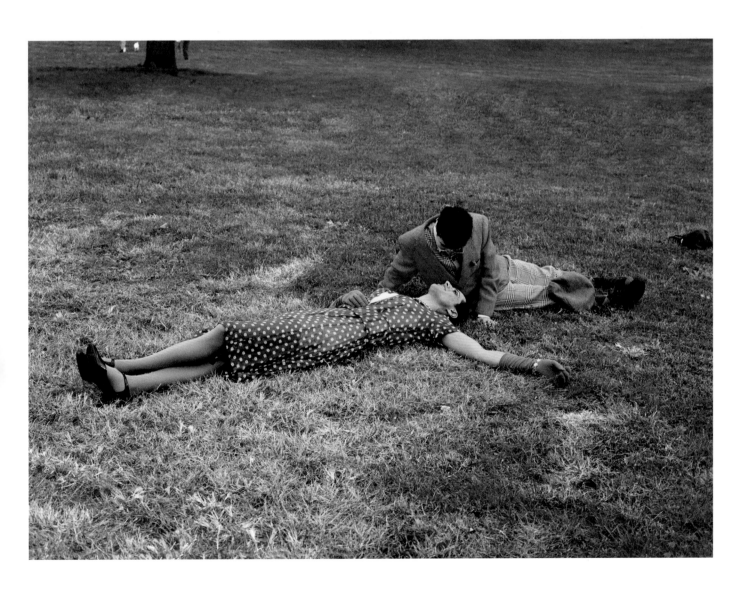

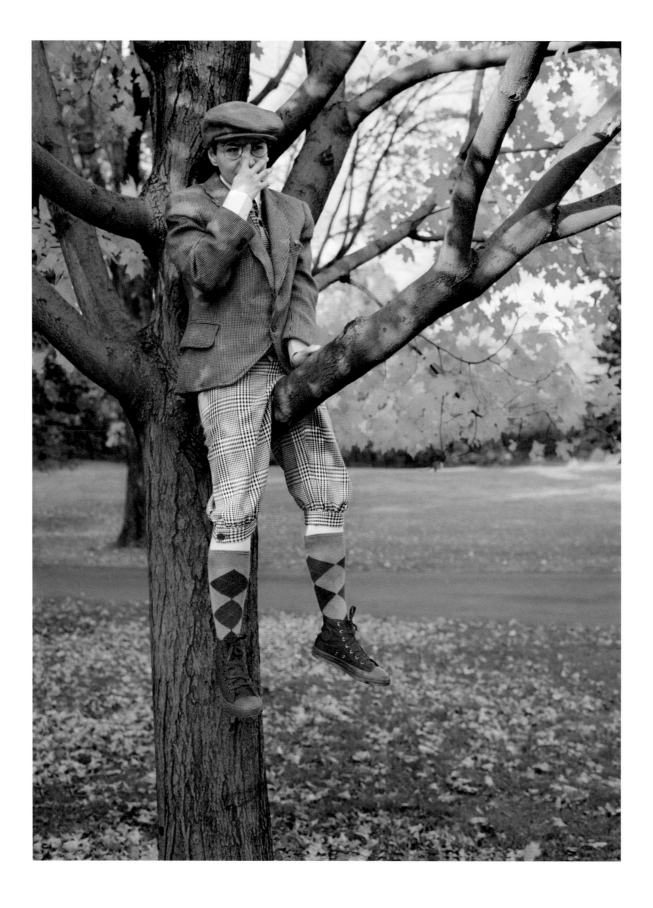

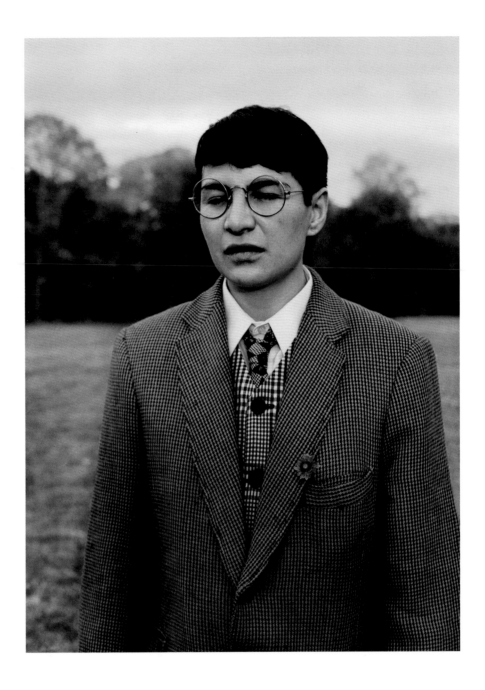

LEFT
Sandra Valenzuela
Untitled, 2007
From the series *X-boyfriend Alias*
Fake Memories (Paco)
Inkjet Print
Courtesy of the Artist and
EDS Galería, México City

RIGHT
Sandra Valenzuela
Untitled, 2007
From the series *X-boyfriend*
Alias Fake Memories (Paco)
Inkjet Print
Courtesy of the Artist and
EDS Galería, México City

Laurel Nakadate

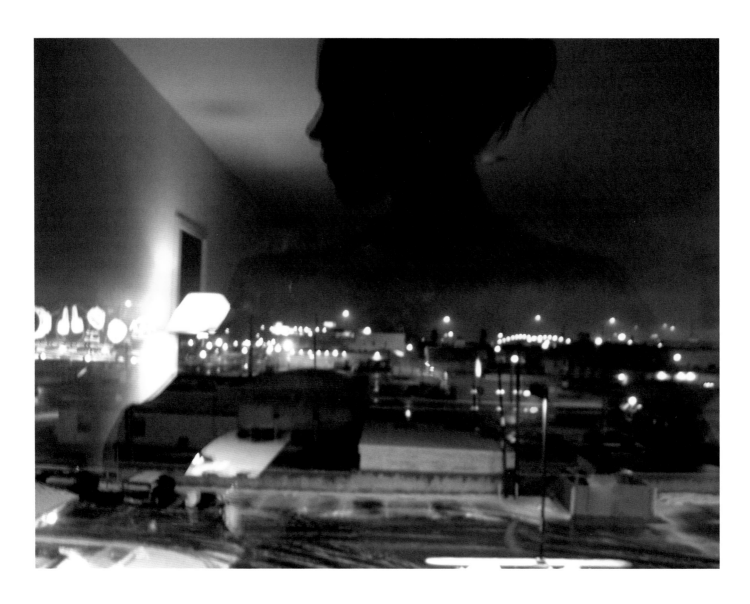

LEFT
Laurel Nakadate
Fever Dreams at the
Crystal Motel, 2009
Chromogenic Print
Courtesy of the Artist and
Leslie Tonkonow Artworks + Projects, New York

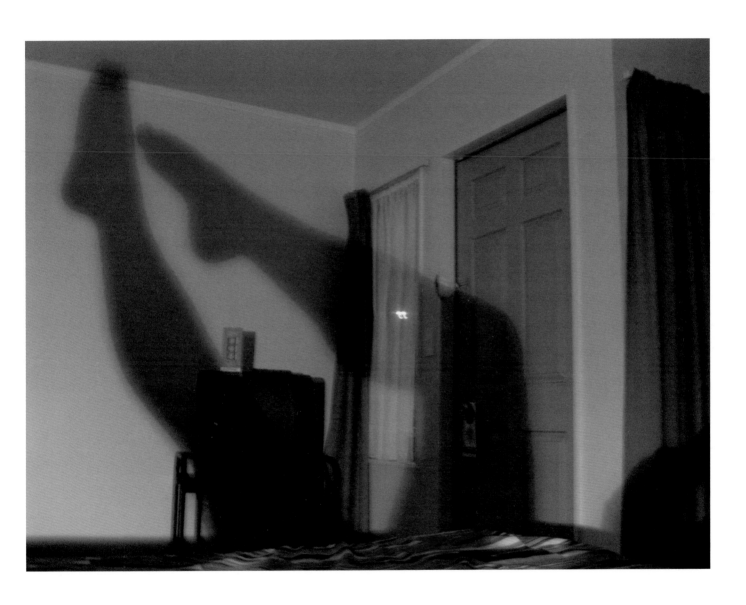

RIGHT

Laurel Nakadate

***Farther From Home than
I'd Ever Been,*** 2007

Chromogenic Print

Courtesy of the Artist and

Leslie Tonkonow Artworks + Projects, New York

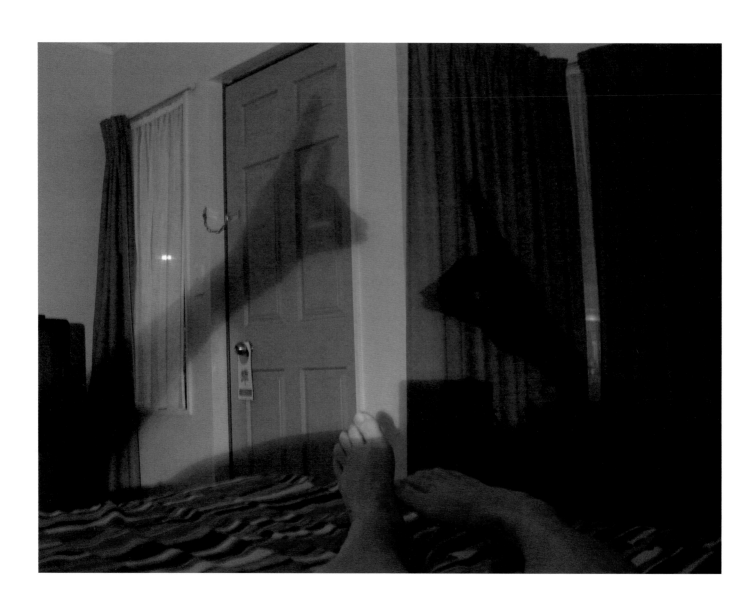

Laurel Nakadate
We Can Be Anyone Now
(for D.D.), 2007
Chromogenic Print
Courtesy of the Artist and
Leslie Tonkonow Artworks + Projects, New York

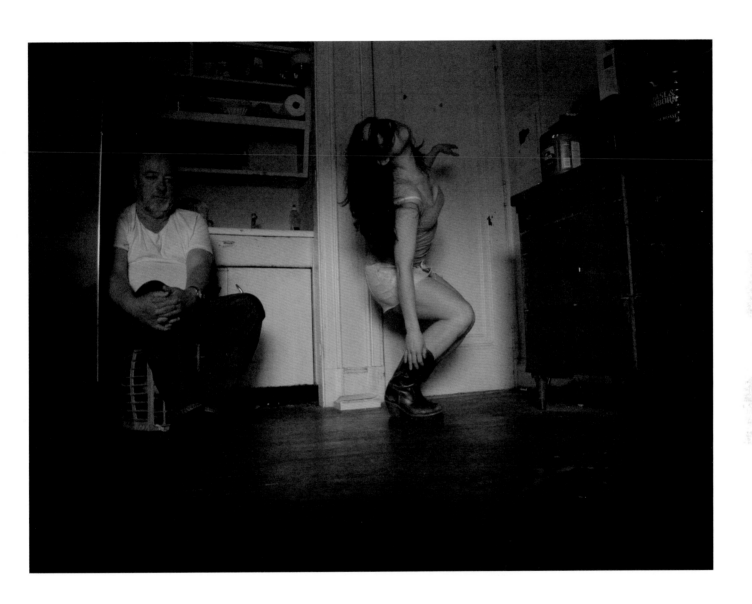

Laurel Nakadate

Exorcism in January, 2009

Chromogenic Print

Courtesy of the Artist and

Leslie Tonkonow Artworks + Projects, New York

Kalup Linzy

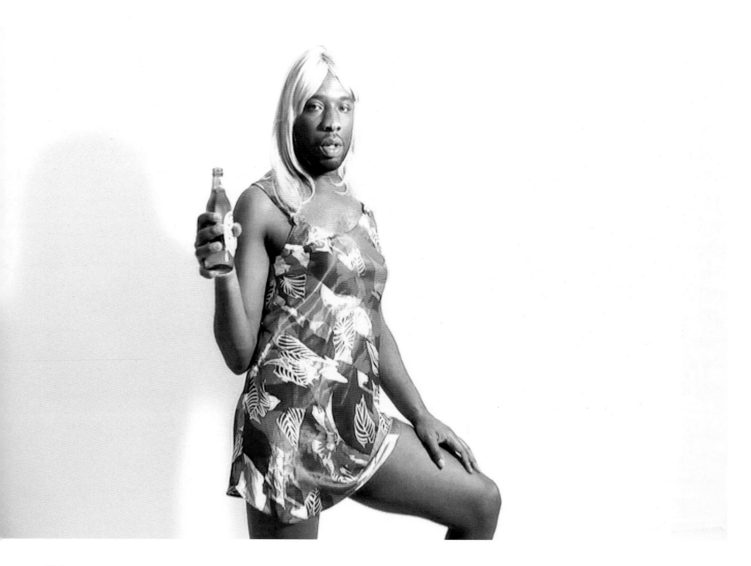

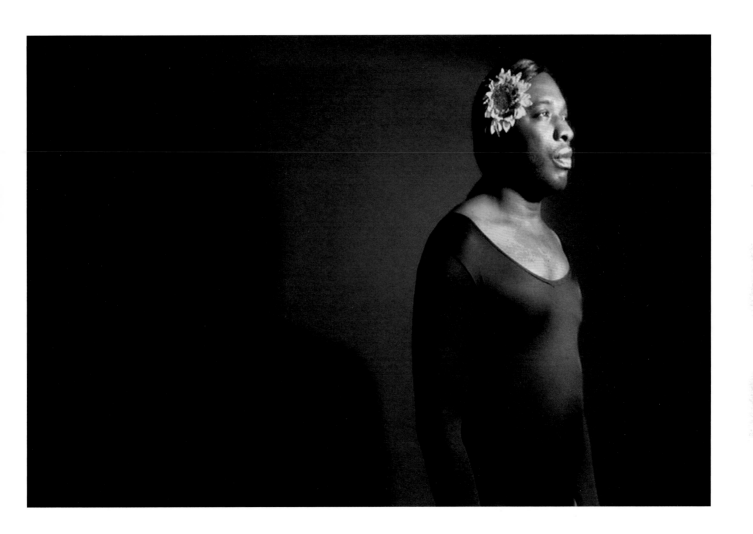

LEFT
Kalup Linzy
*Sweetberry Sonnet
(Remixed),* 2008
Digital video still
Courtesy Electronic Arts
Intermix and Taxter and
Spengemann Gallery, New York

RIGHT
Kalup Linzy
*Sweetberry Sonnet
(Remixed),* 2008
Digital video still
Courtesy Electronic Arts
Intermix and Taxter and
Spengemann Gallery, New York

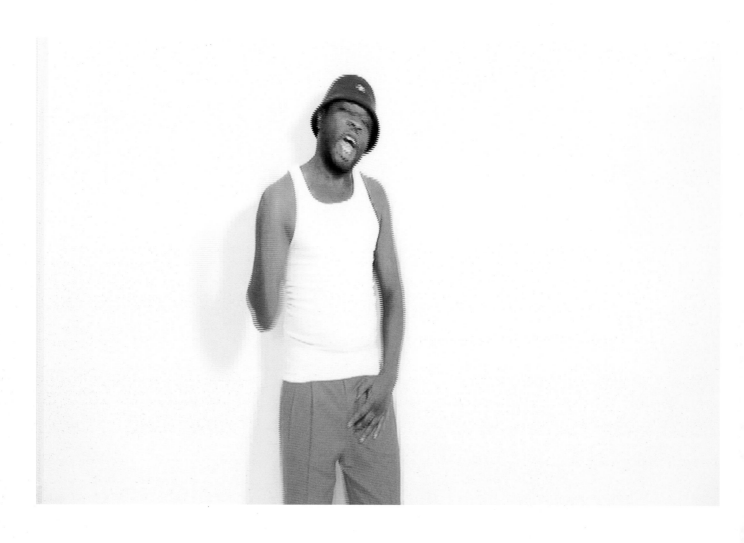

LEFT

Kalup Linzy

Sweetberry Sonnet
(Remixed), 2008

Digital video still

Courtesy Electronic Arts

Intermix and Taxter and

Spengemann Gallery, New York

RIGHT

Kalup Linzy

Sweetberry Sonnet
(Remixed), 2008

Digital video still

Courtesy Electronic Arts

Intermix and Taxter and

Spengemann Gallery, New York

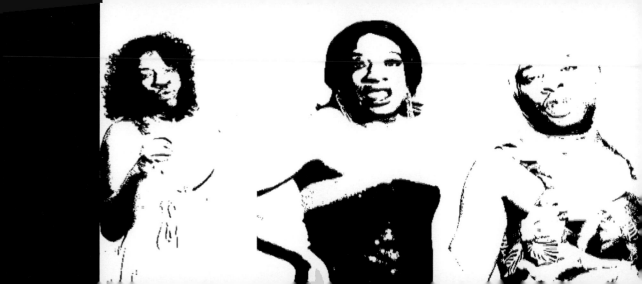

Leslie Hall

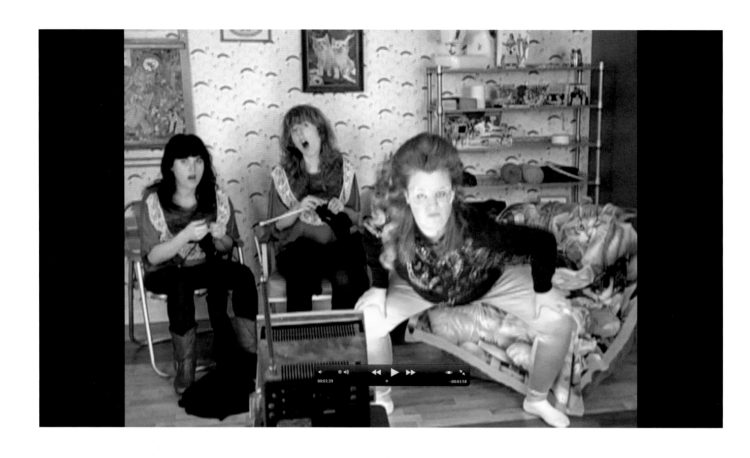

Leslie Hall
Craft Talk, 2007
Video still

Leslie Hall

How We Go Out Version 2, 2007

Video still

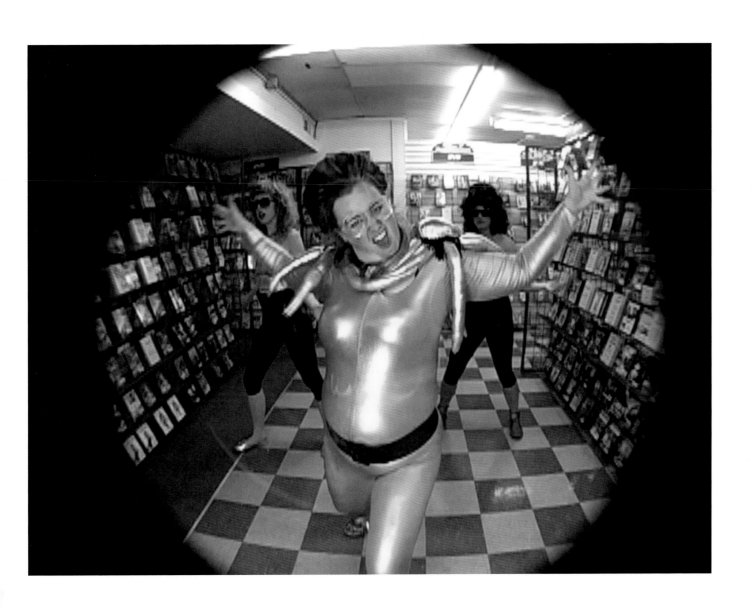

Leslie Hall
How We Go Out Version 2, 2007
Video still

Susanne Jirkuff

Susanne Jirkuff
Feel It, 2004
Video still
Courtesy of Espaivisor-Galería Visor, Valencia and
the Collection of Bernardino Arocha, Houston

Susanne Jirkuff

Feel It, 2004

Video still

Courtesy of Espaivisor-Galería Visor, Valencia and

the Collection of Bernardino Arocha, Houston

245

Susanne Jirkuff

Feel It, 2004

Video still

Courtesy of Espaivisor-Galería Visor, Valencia and

the Collection of Bernardino Arocha, Houston

246

Susanne Jirkuff
Feel It, 2004
Video still
Courtesy of Espaivisor-Galería Visor, Valencia and
the Collection of Bernardino Arocha, Houston

Adrià Julià

LEFT
Adrià Julià
Untitled (La Réunion Tower), 2008
Photograph
Courtesy of Espaivisor-Galería Visor,
Valencia and the Collection of
Bernardino Arocha, Houston

RIGHT
Adrià Julià
Untitled (La Réunion Tower), 2008
Photograph
Courtesy of Espaivisor-Galería Visor,
Valencia and the Collection of
Bernardino Arocha, Houston

Adrià Julià

La Réunion, 2008

Video still

Courtesy of Espaivisor-Galería Visor,

Valencia and the Collection of

Bernardino Arocha, Houston

TOP
Adrià Julià
Untitled (La Réunion Arena), 2008
Photograph
Courtesy of Espaivisor-Galería Visor, Valencia and the Collection of Bernardino Arocha, Houston

BOTTOM
Adrià Julià
La Réunion, 2008
Video still
Courtesy of Espaivisor-Galería Visor, Valencia and the Collection of Bernardino Arocha, Houston

251

Daniel Joseph Martinez

North Pacific Fur Fish
Valdez, Alaska

Those who wish for peace should prepare for war!
—Old Sasquatch Proverb

She could see Russia from her house!

(In search of the Tribe Called Sasquatch,
or who really built the Alaskan Oil Pipeline)

16 — Communiqués and found photographs
from traveling the length and breath of Alaska
during the month of August, 2009.

NORTH PACIFIC FUR FISH

A popular attraction in the Valdez Hotel in the 1950s and 60s, this fur fish, reportedly caught in the frigid waters of Alaska's Prince William Sound, is prominently displayed in the Valdez Museum.

FIREY THE ANGELS FELL

DEEP THUNDER ROLLED

AROUND THEIR SHORES

BURNING WITH THE

FIRES OF ORION

MOON BEAMS

POINT THE WAY DJM

AUG 1 3 2009

© The Valdez Museum and Historical Archive Valdez, AK 99686

Des Moines Art center gilBert Vicario 4700 Grand Ave Des moines, iowA 9 - 50312

LEFT & RIGHT PAGES
Daniel Joseph Martinez
Detail from *Those who wish for peace should prepare for war:*
Old Sasquatch Proverb, Communiqués and found photographs
from traveling in Alaska for the month of August 2009, 2009
Photo and mixed media installation
Courtesy of the Artist and Simon Preston Gallery, New York

253

ALASKA
H I G H W A Y

ALASKA HIGHWAY

Monument in the town of Delta Junction where the Alaska Highway
and the Richardson Highway come together.

Photo © Fred Hirschmann/Ken Graham Agency

AUG 2 1 2009

ACE-1264

© ARCTIC CIRCLE ENTERPRISES®, ANCHORAGE, ALASKA

A MAN WHO FIGHTS FOR NO FLAG. A MAN LOYAL TO

NO COUNTRY

7 23731 1000 4

DJM

USA 28

Post Card

Des Moines art
Center
Gilbert Vicario
4700 Grand ave
Des Moines, iowA
50312

LEFT & RIGHT PAGES

Daniel Joseph Martinez

Detail from *Those who wish for peace should prepare for war:
Old Sasquatch Proverb, Communiqués and found photographs from
traveling in Alaska for the month of August 2009,* 2009

Photo and mixed media installation

Courtesy of the Artist and Simon Preston Gallery, New York

255

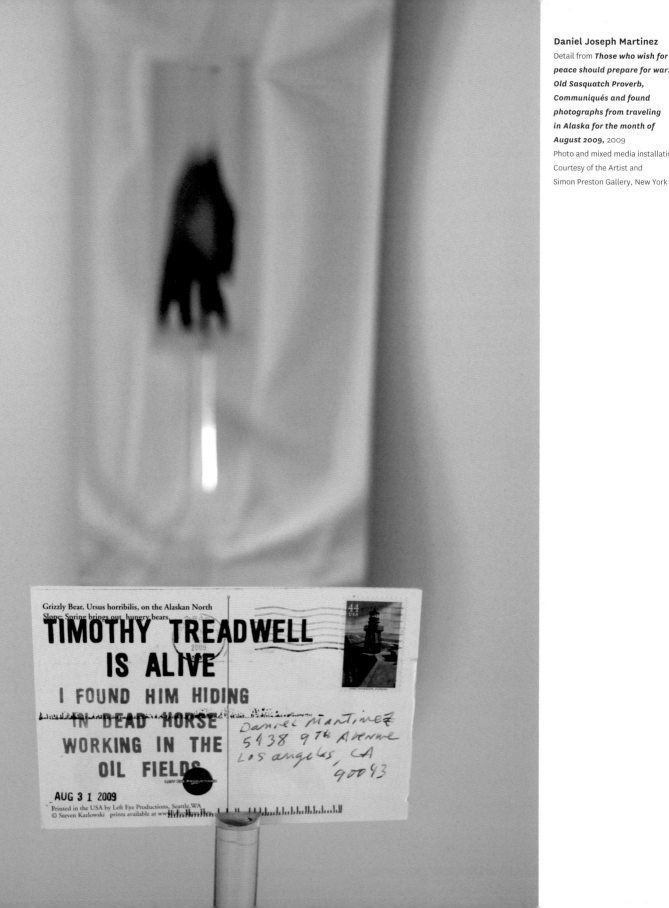

Daniel Joseph Martinez
Detail from *Those who wish for peace should prepare for war: Old Sasquatch Proverb, Communiqués and found photographs from traveling in Alaska for the month of August 2009,* 2009
Photo and mixed media installation
Courtesy of the Artist and Simon Preston Gallery, New York

Film Programs

THE MUSEUM OF FINE ARTS, HOUSTON

SOUTHWEST ALTERNATE MEDIA PROJECT (SWAMP)

Visual Acoustics: The Modernism of Julius Shulman

DIRECTED BY ERIC BRICKER

In cooperation with FotoFest and FotoFest 2010 Biennial, the Museum of Fine Arts, Houston is presenting three films on photographic artists who have been seminal figures in modern U.S. photography.

Julius Shulman (1910–2009) was, many experts say, the world's greatest architectural photographer. Narrated by Dustin Hoffman, the film Visual Acoustics celebrates the life and career of this artist and highlights not only the iconic images he made, but also the magnetic character behind these images.

Julius Shulman captured the work of virtually every modern U.S. architect since the 1930s, including Frank Lloyd Wright, Richard Neutra, John Lautner, and Frank Gehry. His work epitomized the singular beauty of southern California's modernist movement, which ushered modern architecture into the American mainstream. This film is a testament both to the evolution of modern architecture and to the individual who many described as "a joyful and whip-smart gentleman."

From the Museum of Fine Arts, Houston Film Department

A selection of photographs by Julius Shulman will be on view next to the Brown Auditorium Theater. Presented in collaboration with Rice Design Alliance and the American Institute of Architects–Houston.

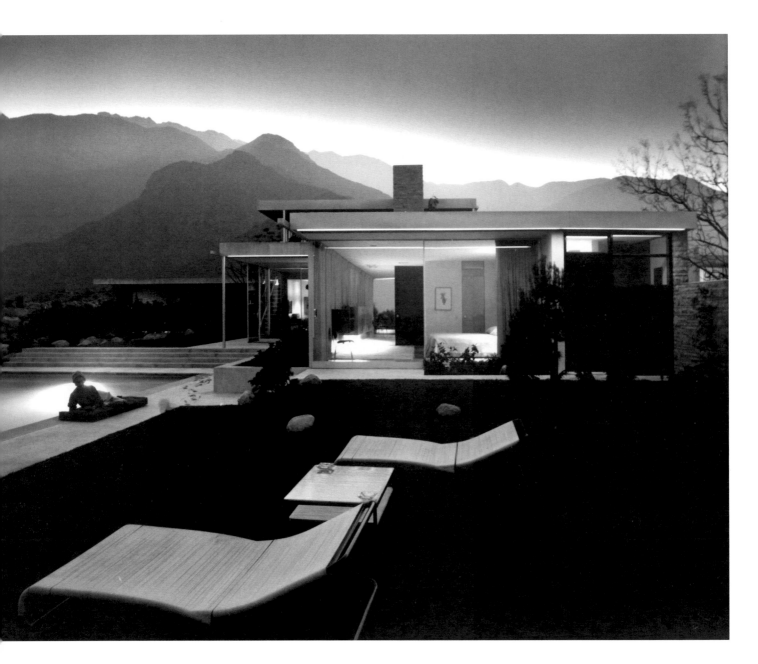

Kaufmann House
photographed by Julius Shulman (1947)
from *VISUAL ACOUSTICS,* an Arthouse
Films release, 2009
Film Still
Copyright J. Paul Getty Trust

Fire in the East: A Portrait of Robert Frank

DIRECTED BY PHILIP BROOKMAN AND AMY BROOKMAN

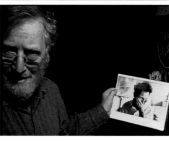

Images from *AN AMERICAN JOURNEY*
Courtesy of Lorber Films

This award-winning and rarely screened documentary was coproduced by the Museum of Fine Arts, Houston, Film Department, and Houston PBS on the occasion of the museum's 1986 exhibition New York to Nova Scotia, curated by Anne Wilkes Tucker. The film was presented by the museum at the first FotoFest Biennial, FOTOFEST1986.

Fire in the East presents an intimate view of four decades of Robert Frank's life and work. His extraordinary career is detailed in photographs, film excerpts, and interviews with many of his collaborators and contemporaries, including Emile de Antonio, Allen Ginsberg, Walter Gutman, June Leaf, Jonas Mekas, Duane Michals, John Szarkowski, and Rudy Wurlitzer.

An American Journey

DIRECTED BY PHILIPPE SÉCLIER

More than fifty years ago, Robert Frank's seminal book, *The Americans* (Paris: Delpire, 1958), was published to great acclaim—as well as to negative reviews faulting his vision of a nation awash in poverty, racism, and postwar jingoism. Today it is impossible to overstate the influence of Frank's groundbreaking work. The documentary *An American Journey* travels back to the small towns and rural communities the photographer immortalized—exploring the world as Frank saw it and as it survives today. Artist Edward Ruscha, publisher Barney Rosset, photographers John Cohen and Raymond Depardon, and curators/critics Vicki Goldberg, Sarah Greenough, and Peter Galassi explore the feelings of anger and alienation that fueled the Swiss-born Frank in his earlier American journey.

www.filmforum.org

The American Dream 2010:
Visions of 21st-Century Life in the Americas from North to South

In cooperation with FotoFest 2010 and the theme of Contemporary U.S. Photography, the Southwest Alternate Media Project (SWAMP), a thirty-three-year-old nonprofit media arts organization for independent filmmakers, has held an open call for submissions of short films (10 minutes) on the theme of *The American Dream 2010: Visions of 21st-Century Life in the Americas from North to South*.

The call for submissions is a juried competition inspired by the focus of FotoFest 2010. Texas filmmakers are challenged to produce a short film exploring the possibilities and challenges of twenty-first-century life in the Americas. A distinguished panel of jurors chooses the best films from those submitted. The selected shorts are screened during the FotoFest 2010 Biennial, and all the shorts are considered for inclusion in the thirty-fourth season of The Territory, SWAMP's short film television series broadcast on Texas PBS stations.

MARY M. LAMPE, DIRECTOR, SOUTHWEST ALTERNATE MEDIA CENTER

BIOGRAPHIES

Contemporary U.S. Photography [Artists]

NICOLE BELLE

Nicole Belle was born in 1977 in Dayton, Ohio. She received her B.A. in French literature from New York University, a B.F.A. in fine art photography from the Rochester Institute of Technology, and her M.F.A. in visual art at the University of California, Riverside. In New York she studied at the School for Visual Arts and worked in the Associated Press photography department. Her work has been shown in the Los Angeles area at Sandroni.Rey, High Energy Constructs, Torrance Art Museum, the New Wight Gallery at University California, Los Angeles, the Riverside Art Museum; also in California the Brand Gallery, Glendale; the Millard Sheets Gallery, Pomona; Sweeney Art Gallery, Riverside and the California State University, Long Beach Galleries, as well as in various group shows in Rochester, New York, and Minneapolis, Minnesota. Belle currently lives and works in Los Angeles.

MATTHEW BRANDT

Matthew Brandt was born in Los Angeles in 1982. His father is a California-based advertising photographer and his mother is an emigrant from Hong Kong. He worked with his father as a photo-assistant in his early adolescence. As a young man, Brandt briefly abandoned photography turning to painting. While studying at Cooper Union in New York he fully embraced photography as his medium of choice. Following college, Brandt worked for two years for architectural photographer Robert Polidori. In 2008 he returned to Los Angeles to complete his M.F.A in photography at the University of California, Los Angeles. There he rekindled his passion for the hands-on processes of the darkroom. His first solo exhibition was held the following year at Cardwell Jimmerson Gallery, Los Angeles. Brandt continues to live and work in Los Angeles.

SHEILA PREE BRIGHT

Sheila Pree Bright, born 1967, is a fine art photographer base in Atlanta. Her large-scale works combine a wide-ranging knowledge of contemporary culture, while challenging perceptions of identity. Bright received national attention after winning the "Santa Fe Prize" from the Santa Fe Center for Photography in 2006 for her body of work The *Suburbia Series*. The project takes aim at the American media's projection of the *typical* African-American community and depicts a more realistic and common ideology of African-American life. The series also explore the variations and similarities of an existence that subverts lifestyle and culture, particularly as it relates to Americanism. As a result, Bright has emerged as a new voice in contemporary photography with her edgy portrayals of urban and suburban themes, as well as her provocative commentary about American beauty standards. Recently, Bright has embarked on one of her most ambitious projects to date called the *Young Americans* which premiered at The High Museum of Art Atlanta in May 2008 and now is working on her new anticipated series *In High Definition: The Globalization of Hip Hop Culture*.

JEFF BROUWS

Jeff Brouws, born in 1955 in San Francisco, is a self-taught photographer who has spent the last twenty-five years tirelessly exploring and documenting the American cultural landscape. He has lectured at the Society for Photographic Education; School of Visual Arts, New York; International Center for Photography, New York; Rochester Institute of Technology, New York and the University of Nottingham, United Kingdom. His work is represented by galleries worldwide including Robert Mann, New York; Robert Klein, Boston; Robert Koch, San Francisco; Craig Krull, Los Angeles; and Toni Tapies, Barcelona. His work is found in the collections of the Whitney Museum of American Art, New York; the J. Paul Getty Museum, Los Angeles; the Fogg Museum, Cambridge, Massachusetts; the Princeton University Art Museum, New Jersey; the Los Angeles County Museum of Art; and the San Francisco Museum of Modern Art. Publications include *Approaching Nowhere* (New York: W.W. Norton, 2006) *Readymades: American Roadside Artifacts* (San Francisco: Chronicle Books, 2003), *Highway: America's Endless Dream* (New York: Stewart, Tabori & Chang, 1997), and *Twentysix Abandoned Gasoline Stations* (Santa Barbara, California: Gas-N-Go Publications, 1992).

EMILIO CHAPELA

Emilio Chapela is a conceptual artist from Mexico City. Because of his academic background in mathematics and communications, his work usually relates to scientific notions, methodological thinking and with a constant research towards abstraction. He has participated in several collective and solo shows both in galleries and museum including: EDS Galeria, Mexico City (2008); the MARTE Museum, San Salvador, El Salvador (2008); the Museo de Arte Abstracto Manuel Felguerez, Zacatecas, Mexico (2009); the Ilmin Museum in Seoul, Korea (2009); and the Museo de Castellón de la Plana, Spain. He was selected for the XIV Bienal Rufino Tamayo, Mexico City (2008) and for the X Bienal de Fotografía de Mexico (2002). Perez has been honored for his work through the 2008 PULSE Miami Award; the Feria México Arte Contemporáneo (FEMACO) best emerging artist; and an artist-in-residence at the International Studio and Curatorial Program (ISCP), New York (2007). In 2009 he published his first monographic catalogue with funds provided by the National Fund for Culture and Arts Mexico (FONCA). He is represented by EDS Galeria, Mexico City.

TIM DAVIS

Tim Davis (born, Malawi, 1969) is an artist and writer living in Tivoli, New York, and teaching photography at Bard College and Yale University. His latest show, *The New Antiquity* was exhibited at Greenberg Van Doren Gallery in New York, September to October, 2009. He is the author of five books of photographs: *The New Antiquity* (Bologna: Damiani, 2009), *My Life in Politics* (New York: Aperture, 2006), *Illuminations* (New York: Greenberg Van Doren Gallery, 2006), *Permanent Collection* (Portland: Nazraeli Press, 2005), and *Lots* (Paris: Coromandel Express, 2002). He is also the author of two books of poems: *American Whatever* (Washington, D.C.: Edge Books, 2004), and *Dailies* (Great Barrington, Massachusetts: The Figures, 2000). In New York, is photographs are in the collections of the Guggenheim, the Metropolitan Museum of Art, and the Whitney Museum of American Art, as well as the Hirshhorn, Washington D.C; Walker Art Center, Minneapolis; and the High

Museum, Atlanta and many other museums. He has had solo exhibitions in New York, London, Los Angeles, Chicago, Brussels, Geneva, Atlanta, and Miami. Davis was a Discovery Award finalist at the 2004 Arles Photography Festival and was the Joseph H. Hazen Rome Prize Fellow in residence at the American Academy in Rome in 2007-2008. He is represented by Greenberg Van Doren Gallery (NY). See *www.davistim.com* for more information.

MYRA GREENE

Myra Greene was born in New York. She received her B.F.A. from Washington University in St. Louis in 1997 and her M.F.A. in photography from the University of New Mexico in 2002. Her work has been exhibited in galleries and museums including: Museum of the African Diaspora, San Francisco; Spelman College Museum of Fine Art, Atlanta; and Sculpture Center; New York. Greene is the recipient of the 2009 Illinois Arts Council fellowship in photography and has completed residencies in New York at Light Work, Syracuse and the Center for Photography at Woodstock. She currently lives in Chicago and is an assistant professor of photography at Columbia College Chicago.

LESLIE HALL

Leslie Hall initially caught the hearts and eyes of America's children when she began uploading images of her world famous gem sweater collection on the internet. Through word of mouth interest in her site quickly grew and within one month the site received over two million unique hits, which left her with an $800 bill for exceeding her bandwidth. To raise money to pay back her mother, who paid the bill, Hall did what any 200 lb. plus girl from Iowa would do. She became a rapper. Hall's star has risen quickly with such viral video music hits a *Gold Pants, Beatdazzler, Zombie Killer,* and *How We Go Out.* She has performed at Los Angeles's Hammer Museum, Museum of Fine Arts Boston, and sold out shows supporting the Scissor Sisters at New York City's infamous Bowery Ballroom.

TODD HIDO

Todd Hido is a San Francisco Bay area-based artist whose work has been featured in *Artforum, The New York Times Magazine, Eyemazing, Metropolis, The Face, I-D,* and *Vanity Fair.* His photographs are in the permanent collections of the Whitney Museum of American Art, New York; Guggenheim Museum, New York; San Francisco Museum of Modern Art; and the Los Angeles County Museum of Art, as well as in many other public and private collections. He is an adjunct professor at the California College of Art, San Francisco, California.

PETER HOLZHAUER

Peter Holzhauer lives and works in Los Angeles. He studied at Pratt Institute, New York and Massachusetts College of Art and Design, Boston before receiving his B.F.A. from the Art Institute of Boston, and his M.F.A. from the University of California, Los Angeles. His photographs are in the permanent collections of the Boston Public Library, the Boston Athenaeum, and the George Eastman House, Rochester, New York. Holzhauer is a recipient of D'Arcy Hayman Award, Bill Muster Foundation Award, and Hoyt Scholarship. He is currently an instructor of photography at Cerritos College, Norwalk. His work has been in recent group exhibitions at the New York Photo Festival in Brooklyn; Piero Gallery in Orange, New

Jersey; Phantom Gallery in Pasadena, California; and the Portland Museum of Art, in Maine.

WHITNEY HUBBS

Whitney Hubbs was born in Los Angeles in 1977. She received her B.F.A. from the California College of the Arts, San Francisco and her M.F.A. from the University of California, Los Angeles. Her photographs of found and applied textual elements sited in an ordinary residence, draw a heightened attention to the ways meaning becomes inscribed to the conditions of our everyday lives. She currently resides and works in Los Angeles.

SUSANNE JIRKUFF

Viennese artist and videographer, Susanne Jirkuff, has exhibited her work internationally: *Populism*, was shown at the Contemporary Art Centre, Vilnius, Lithuania; Stedelijk, Amsterdam; and Frankfurter Kunstverein (2005); *Huérfanos del vacío—Orphans of the Void*, was exhibited at Sala Rekalde, Bilbao, Spain; in Vienna at Lives and Works and Kunsthalle Wien (2005); in Spain *Històries animades* was shown at Fundació La Caixa, Barcelona, and Sala Rekalde, Bilbao (2006); *Traurig sicher, im Training*, Grazer Kunstverein, Graz; *Momentary Momentum*, Parasol Unit, London (2007) and Kettle's Yard, Cambridge (2008); *Sound of Silence*, Townhouse Gallery, Cairo (2007); *Playback, Musée d'Art Moderne* Paris (2007) and Videorama, Kunsthalle Wien (2009). Her videos are shown at film festivals world wide, including European Media Art Festival, Osnabrück, Germany; Media Art Friesland, The Netherlands; Tricky Women, Vienna; Kasseler Dokumentarfilm and Videofest, Germany; Satellite of Love, Rotterdam Filmfestival; and Platform Garanti Contemporary Art Center, Istanbul. She had residencies in Los Angeles at MAK Center for Art and Architecture at the Schindler House and at Taipei Artist Village, Taiwan. Jirkuff was awarded the Hilde Goldschmidt Preis 2006 and the Staatsstipendium Bildende Kunst, 2007. Currently, she working with animation and drawing, and is a member of RAIN, on site specific projects in Los Angeles, Vienna, Havana and Houston.

EIRIK JOHNSON

Boston-based photographer Eirik Johnson is an assistant professor of photography at the Massachusetts College of Art and Design, Boston. His work has been exhibited at spaces including the Museum of Contemporary Photography in Chicago; the Henry Art Gallery in Seattle; and the Aperture Foundation in New York. He has received numerous awards including the "Santa Fe Prize" from the Santa Fe Center for Photography in 2005 and a William J. Fulbright Grant for travel to Peru in 2000. His work is in the permanent collections of the San Francisco Museum of Modern Art, the Seattle Art Museum, and the George Eastman House, Rochester, New York. His first monograph *Borderlands*, published by Twin Palms Press, was named one of the best books of 2005 by Photo Eye magazine. His second monograph, *Sawdust Mountain*, was published by Aperture in 2009. Johnson is represented by Rena Bransten Gallery in San Francisco and G. Gibson Gallery in Seattle. Please visit *www.eirikjohnson.com* for further information.

ADRIÀ JULIÀ

Adrià Julià has been exhibiting his work for the past ten years. His most recent solo exhibitions have been hosted by Orange County Museum of Art, Newport Beach, California; LA><ART, Los Angeles; Insa Art Space, Seoul; Galería Soledad Lorenzo, Madrid, Spain; The Room Gallery, Irvine, California; Artists Space, New York,; Sala Rekalde, Bilbao, Spain; Associates, London; Palau de la Virreina, Barcelona, Spain. He has also been part of group exhibitions at Centro Cultural Montehermoso, Vitoria, Spain; Generali Foundation, Vienna, Austria; 2007 Lyon Biennale, Lyon, France; New Langton Arts, San Francisco, California; O.K. Centrum, Linz, Austria; Städtische Galerie, Bremen, Germany; Museo Nacional Centro de Arte Reina Sofia, Madrid, Spain; Akademie der Künste, Berlin, Germany; Edith-Ruß-Haus, Oldenburg, Germany. Adrià Julià has received grants from Art Matters, American Center Foundation, Fundación Arte y Derecho-Vegap, Institut Ramon Llull and EDAC, "La Caixa" Fellowship program and in 2002 he was awarded the Altadis Prize. He is currently preparing an exhibition for Museo Tamayo, Mexico City.

ERIKA LARSEN

Erika Larsen's (American, born 1976) most notable bodies of work, *Young Blood* and *The Hunt* look intimately at hunting culture in North America, its connection with nature and its role in the cycle of life and death. These solo shows have been exhibited internationally. She has been recognized by World Press Photo, American Society of Magazine Editors, American Photography, Society of Photographers, and New Jersey State Council of the Arts. Her work is included in the 2009-2010 Outwin Boochever Portrait Competition National Portrait Gallery, Smithsonian Institution. Larsen is currently on a Fulbright Fellowship in the Scandinavian Arctic working on her latest project *Sami, The People*.

AN-MY LĚ

An-My Lě was born in Saigon, Vietnam in 1960 and came to the United States in 1975 as a refugee. She holds a B.A.S. (1981) and M.S. (1985) from Stanford University, Stanford, California and a M.F.A. from Yale University School of Art, Yale University School of Art (1993). Recent solo exhibitions of her work include *29 Palms* at Murray Guy, New York; *Small Wars* at PS1/MOMA Contemporary Art Center, Long Island City, New York; and *Vietnam* at Scott Nichols Gallery, San Francisco. She is the recipient of a John Simon Guggenheim Memorial Foundation fellowship (1997), and her work is held in the collections of the Whitney Museum of American Art, New York; Museum of Modern Art, New York; San Francisco Museum of Modern Art, New York; Metropolitan Museum of Art, New York, Bibliotheque Nationale, Paris; and Sackler Gallery, The Smithsonian, Washington DC.

KALUP LINZY

Kalup Linzy is a video and performance artist based in Brooklyn, New York. Born in Stuckey, Florida in 1977, Linzy received his M.F.A. from the University of South Florida, Tampa in 2003 and also attended the Skowhegan School of Painting and Sculpture in Maine. Linzy has been the recipient of numerous awards including a grant from the Louis Comfort Tiffany Foundation in 2005, a fellowship from the John Simon Guggenheim Memorial Foundation in 2007, and most recently, a 2008 Creative Capital Foundation grant, a Jerome Foundation Fellowship, and an Art Matters Grant. Linzy's best-known work is a series of politically charged videos that satirize the conventions of the television soap opera. His works have been included in exhibitions as far ranging as *Black Alphabet* at The Zacheta National Museum in Warsaw Poland, and *Frequency*, Thelma Golden's survey of new art by emerging artists of color at the Studio Museum in Harlem. In 2008, Linzy's work was included in Prospect.1 New Orleans, New Orleans curated by Dan Cameron; *Modern Mondays: An Evening with Kalup Linzy* at the Museum of Modern Art, New York; Glasgow International: Festival of Contemporary Visual Art, Glasgow, Scotland, and *30 Americans*, Rubell Family Collection, Miami.

MATT LIPPS

Matt Lipps was born in northern California in 1975 and was brought up there. He received his B.F.A. from California State University, Long Beach and his M.F.A. in studio art from the University of California, Irvine, in 2004. Lipps currently lives in Los Angeles where he is the photography lab supervisor for the department of art at the University of California, Los Angeles. His photographs and sculptural works have been included in such recent solo and group exhibitions as *Living History II: Asad Faulwell & Matt Lipps*, Marc Selwyn Fine Art in Los Angeles; *Photography Unbound*, California State University, San Bernardino; *Log Cabin*, Jeffrey Uslip, Curator, Artists Space, New York; *Tainted Love*, presented by Visual AIDS, La Mama La Galleria, New York; *BUMP: Recent + Rarely Seen Explicit Videos from Southern California Artists*, Los Angeles Contemporary Exhibitions; *The Banality of Good*, Claremont Graduate University Gallery, Claremont, California; *Rendering Gender*, Truman State University Art Gallery, Kirksville, Missouri; The Office, Huntington Beach, California; and in Athens, Greece at The Apartment, and the Athens Photo Festival 2008, Hellenic Centre for Photography.

CRAIG MAMMANO

Artist and photographer, Craig Mammano was born in 1975 in New Jersey. He studied at Hunter College, The City University of New York and received a B.A. in art studio. Later, he worked in the archives of the Black Star Photo Agency in New York and assisting documentary photographer Joseph Rodriguez. His photographs have been featured on Tiny Vices, an online gallery and image archive; The Sunday Times, London; *Hamburger Eyes Photo Magazine*, issue 013; and *Kaugummi* magazine # 5. He has exhibited at the Association of Photographers Gallery, London; Home Space Gallery, New Orleans; and Permanent Gallery, Brighton, United Kingdom.

DANIEL JOSEPH MARTINEZ

For over thirty years Daniel Joseph Martinez has engaged in an investigation of social, political, and cultural mores through artworks that have been characterized as "nonlinear multidimensional propositions." He has exhibited in the United States and internationally since 1978, most recently, *The Fully Enlightened Earth Radiates Disaster Triumphant: Daniel Joseph Martinez: United States Pavilion*, 10th International Cairo Biennale 2006, Museum of Fine Arts, Houston (2006); the 2008 Whitney Biennial Exhibition, New York; and *the west bank is missing, I am not dead yet, am I?*, Amie and Tony James Gallery at City University of New York (2009). Recent publications include *Daniel Joseph Martinez: A Life of Disobedience* (Stuttgart, Germany: Hatje Cantz, 2009), including essays by Arthur C. Danto, David Levi Strauss, Michael Brenson, and Hakim Bey. Martinez has been teaching since 1990 at the University of California, Irvine, and is currently professor of theory, practice, and mediation of contemporary art in the graduate studies program and new genres department.

JOEY LEHMAN MORRIS

Joey Lehman Morris was born and raised in Los Angeles, California, where he currently lives and works. He earned his B.F.A. at the University of Southern California, Los Angeles (2004) and his M.F.A. from the University of California, Irvine (2008). Working primarily with photography, he employs, in his sculptural concerns for the medium, an examination of he said is "the sway of time and language on landscape." His recent solo and group projects include *Landlot*, Galería Perdida/Project Row Houses, Houston; *Infrastructure*, Wignall Museum, Rancho Cucamonga, California; *Wreckers, Records and Redeemers*, LA>< Art, Los Angeles; *Alternative Places*, Los Angeles International Airport; Oranges and Paper: *MFA Thesis Exhibition*, University of California, Irvine; *The Doubt Can Just Roll off the Tongue, Shotgun Space*, Los Angeles; and *A Face in the Crowd*, in collaboration with Marcus Civin, Catalyst Gallery, Irvine.

RICHARD MOSSE

New York-based artist Richard Mosse was born in Ireland in 1980. He is the recipient of a Leonore Annenberg Fellowship in the performing and visual arts, this fellowship is currently permitting him to extensively travel. Mosse's work has been exhibited at Tate Modern, London; Akademie der Künste, Berlin; Barbican Art Gallery, London; Museu de Mataró, Barcelona; and Musée de l'Élysée, Lausanne. His images were published in *reGeneration: 50 Photographers of Tomorrow* (New York: Thames and Hudson, 2005), *El Dorado* (Bielefeld, Germany: Kerber Verlag, 2009), and *Aesthetics of Terror* (New York: Charta, 2009). Mosse received an M.F.A. in photography from Yale, New Haven, Connecticut (2008), a postgraduate diploma in fine art from Goldsmiths College, London (2005), a Master of Research in cultural studies from the London Consortium (2003), and a first class B.A. in English literature from Kings College London (2001). Mosse is represented by Jack Shainman Gallery in New York.

LAUREL NAKADATE

Laurel Nakadate was born in 1975 in Austin, Texas and raised in Ames, Iowa she received a B.F.A. from the School of the Museum of Fine Arts and Tufts University, Boston in 1998 and completed her M.F.A at Yale University, New Have Connecticut in 2001. She currently lives and works in New York. Nakadate has had nine solo exhibitions and participated in group shows at numerous galleries and museums throughout the world, including the Museo Nacional Reina Sofía in Madrid; the Berkeley Art Museum, California; P.S.1 Contemporary Art Center, Long Island City; the Getty Center, Los Angeles; the Asia Society, New York; and the Yerba Buena Center for the Arts, San Francisco; among other institutions. Her first feature-length film, *Stay the Same Never Change*, premiered in January 2009 at the Sundance Film Festival and was subsequently screened at the 2009 New Directors/New Films series at The Museum of Modern Art and Lincoln Center in New York; the Museum of Fine Arts, Boston; the San Francisco Art Institute, and other venues worldwide. Nakadate has been the subject of numerous articles and reviews in the art press and general interest publications throughout the world. Her work is included in the collections of The Museum of Modern Art, New York; the Princeton University Art Museum, Princeton, New Jersey; and the Yale University Art Gallery, New Haven, Connecticut. She is represented by Leslie Tonkonow Artworks + Projects, New York.

NIC NICOSIA

Nic Nicosia has exhibited his staged photographs internationally since 1980. He has been selected for the Whitney Biennials of 1983 and 2000, The Guggenheim Exxon Show in 1983 and Documenta IX, Kassel, Germany in 1992. Nicosia has had over seventy solo exhibitions and his work has been shown in galleries and museums throughout the United States, Canada, and Europe. In New York, his work is included in the permanent collections of the Museum of Modern Art, Solomon R. Guggenheim Museum, Whitney Museum of American Art , as well as the Los Angeles County Museum of Art; the Museum of Contemporary Art, Chicago; the Art Gallery of Ontario, Toronto; the San Francisco Museum of Modern Art, The Museum of Fine Art, Houston and the Dallas Museum of Art. In 1999 a twenty-year retrospective of Nicosia's work was shown at the Contemporary Arts Museum Houston and traveled to several venues. Centro de Arte de Salamanca, Spain mounted a retrospective in 2003 and both originating museums produced comprehensive catalogs.

DAVID ORESICK

David Oresick was born in Pittsburgh, Pennsylvania in 1984. He earned his B.F.A. in photography at the Rochester Institute of Technology, New York in 2007. Oresick is a student at Columbia College Chicago and will complete his M.F.A. program in 2010. He has exhibited at the Newspace Center for Photography in Portland, Oregon and The Guggenheim Gallery at Chapman University in Orange, California. He is also the recipient of an Albert P. Weisman Project Grant. He lives and works in Chicago, Illinois.

TREVOR PAGLEN

Trevor Paglen, born in 1974 and currently working in the western United States, is an internationally acclaimed artist and geographer. Paglen's photographs point to the limits of visibility, imposed both by the realities of physical distance and by informational obfuscation. He has been featured in numerous exhibitions including: *Universal Code*, The Power Plant, Toronto; *Experimental Geography*, Independent Curators International, New York; the 2009 Istanbul Biennial; the 2009 Havana Biennial; San Francisco Museum of Modern Art; The Berkeley Art Museum; *Conspire*, Transmediale.08, Berlin; and *Crimes of Omission*, Institute of Contemporary Art, Philadelphia. In 2010 his work will be featured in a solo exhibition at Secession, Vienna. Trevor Paglen is represented by Altman Siegel Gallery, San Francisco, and Galerie Thomas Zander, Cologne. Paglen has published three books, the latest being *Blank Spots on the Map: The Dark Geography of the Pentagon's Secret World* (New York: Dutton, 2009).

GRETA PRATT

Greta Pratt is the author of two monographs, *Using History* (London: Steidl, 2005). and *In Search of the Corn Queen* (Washington DC: Smithsonian American Art Museum, 1994). Pratt's works are represented in major public and private collections, including The Smithsonian American Art Museum, The Museum of Contemporary Photography and The Museum of Fine Arts, Houston. Pratt was nominated for a Pulitzer Prize, served as photography bureau chief of Reuters International in New York City, and her photographs have been featured in *The New York Times Magazine* and *The New Yorker*. She is a recipient of a New Jersey State Council on the Arts Artist Fellowship. Pratt is currently an assistant professor of photography at Old Dominion University, Norfolk, Virginia.

MICHAEL ROBINSON

Michael Robinson was born in Plattsburgh, NY in 1981. Since 2000 he has created a body of film, video, and photography work exploring the poetics of loss and the dangers of mediated experience. His work has screened in both solo and group shows at a variety of festivals, avant-garde movie houses and galleries including: The New York Film Festival; Anthology Film Archives, New York; Sundance, Park City, Utah; CinemaTexas, Austin; The Wexner Center for the Arts, Columbus, Ohio; Media City, Windsor, Ontario; Chicago Filmmakers, The Yerba Buena Center for the Arts, San Francisco; Viennale, Vienna; Tate Modern, London; The London Film Festival; International Film Festival Rotterdam; Oberhausen International Short Film Festival, Germany; and Hong Kong International Film Festival. Robinson's films have been awarded at numerous festivals, and have been discussed in publications such as *Cinema Scope*, *Art Papers*, *The San Francisco Chronicle*, *The Village Voice* and *Time Out New York*. Robinson l holds a B.F.A. from Ithaca College, New York, and a M.F.A. from the University of Illinois at Chicago. He was a visiting assistant professor of cinema at the State University of New York–Binghamton for 2008-2009, and was awarded a residency at the Headlands Center for the Arts for the fall of 2009.

VICTORIA SAMBUNARIS

Crossing the American landscape in her car for up to five months each year, Victoria Sambunaris structures her life around project-based photographic journeys. Working with a 5x7 view camera to produce large-scale color photographs, her subject matter revolves around the vast transformation of the landscape through the intersection of geophysical occurrences and human manipulation. Sambunaris received her M.F.A. in photography from Yale University in 1999. She is the recipient of fellowships from the Center for Land Use Interpretation, Culver City, California; the Lannan Foundation, Santa Fe; and the Rema Hort Mann Foundation, New York. She was a lecturer at the Yale University School of Architecture and instructor at Sarah Lawrence College. Her work is represented by Yancey Richardson Gallery

ASHA SCHECHTER

Asha Schechter lives and works in Los Angeles. He received his B.F.A. from the California College of Art, San Francisco (2001) and his M.F.A. from University of California, Los Angeles (2009). His work has been shown at a number of exhibition spaces including Marvelli Gallery and Spencer Brownstone Gallery, both in New York; The San Francisco Arts Commission; and the Wight Gallery in Los Angeles.

MICHAEL SCHMELLING

Michael Schmelling is the author of three photo books, *Shut Up Truth* (New York: J+L Books, 2002), *The Week Of No Computer* (New York: TV Books, 2008), and *The Plan* (New York: J+L Books, 2009). Schmelling was also the principal photographer of *The Wilco Book* (New York: Picturebox, 2004). *The Plan* (New York: J+L Books, 2009) which Schmelling also designed, was a book award finalist at both Photo Espana, Madrid and Rencontres d'Arles, France in 2009. His newest book, about hip hop in Atlanta, will be published by Chronicle Books in 2010. Schmelling's work has been included in numerous group shows internationally. He lives and works in New York.

CHRISTINA SEELY

Christina Seely is a photographer and professor based in the San Francisco Bay area. Her work has been exhibited nationally and internationally and is a part of many private and public collections including: The West Collection, Oaks, Pennsylvania; Walker Art Center, Minneapolis; Yale University, New Haven, Connecticut; Museum of Contemporary Photography, Chicago; and The National Museum of Women in the Arts, Washington, DC. She received her B.A. from Carleton College, Northfield, Minnesota (1998) and her M.F.A. in photography from Rhode Island School of Design, Providence (2003). Seely is a member of the faculty of the California College of the Arts in Oakland/San Francisco in the photography department. She is also a principal member of Civil Twilight, a design collective whose Lunar Resonant Streetlights (streetlights that dim and brighten in correlation with the moon phases) won *Metropolis Magazine*'s, 2007 "Next Generation Design Competition".

PAUL SHAMBROOM

Paul Shambroom is a photographer who explores American power and culture. For over twenty years he has documented subjects ranging from industrial and office environments, the U.S. nuclear arsenal, small town council meetings, and post-9/11 "Homeland Security" preparations. His current project is *Shrines: Public Weapons in America*, images of retired weapons "that are not scrapped often are given second lives in the public sphere, mounted in places of honor in communities across the United States ." Shambroom's work is in the collections of the Whitney Museum of American Art, Museum of Modern Art, both in New York; San Francisco Museum of Modern Art; Art Institute of Chicago; Walker Art Center, Minneapolis; and many others. His photographs were included in the 1997 Whitney Biennial and he has had solo exhibitions at many institutions including the Walker Art Center, the Museum of Contemporary Photography in Chicago, and galleries in NY, Chicago, San Francisco and London. His work has been published in three monographs: *Paul Shambroom: Picturing Power*

(Minneapolis: Weisman Art Museum, 2008), *Meetings* (London: Chris Boot,2004) and *Face to Face with the Bomb: Nuclear Reality After the Cold War* (Baltimore: Johns Hopkins University, 2003). Shambroom received fellowships from the Guggenheim Foundation and the Creative Capital Foundation, among others. He was born in Teaneck, NJ and lives in Minneapolis.

RJ SHAUGHNESSY

RJ Shaughnessy is a thirty-year old Los Angeles-based photographer whose blend of documentary and fashion has bought him to the attention of numerous publications and garnered jobs working for clients such as Adidas, Nike, Sony PlayStation, and Microsoft. Since graduating from the Art Center College of Design in Pasadena California, he has built a reputation for capturing the anarchic, spontaneous, and often playful nature of the youth experience. Although they feature a departure from his normal people oriented subject matter, Shaughnessy's books are a means of accessing a different language with which to approach contemporary life in the city. These pictures are a result of life lived in Los Angeles amid the many thoughts of perfection (and its opposite) that only "the city of angels" can evoke.

TEMA STAUFFER

Tema Stauffer is a photographer based in Brooklyn. She graduated from Oberlin College, Ohio in 1995 and received a M.F.A. in photography from The University of Illinois at Chicago in 1998. Her series, *American Stills*, was shown in a solo exhibition at Jen Bekman Gallery, New York in 2004, where she has also participated in seven group shows. The Museum of Contemporary Photography at Columbia College selected fifteen images from this body of work for the Midwest Photographers Project. She was a finalist for The McKnight Photography Fellowship in 2005 and nominated for the KLM Paul Huf Award in 2008. Tema Stauffer teaches at The School of the International Center of Photography, New York and William Paterson University of Wayne, New Jersey. Her work is represented by Daniel Cooney Fine Art Gallery in New York.

WILL STEACY

Will Steacy is an American photographer and writer. He was born in 1980. Before becoming a photographer, he worked as a union laborer. His photographs have been exhibited in numerous galleries and museums across the country and are included in many private and public collections. In 2006, Steacy was named *25 Under 25: Up-and-Coming American Photographers* by powerHouse Books and The Center for Documentary Studies. He is a recipient of the 2008 Tierney Fellowship and The Aperture New York City Green Cart Photography Commission for 2009 to 2001. His work has been featured on *CNN*, in *Harper's*, *Newsweek*, *New York Magazine*, *The Paris Review*, among others, and published in various books. Steacy lives and works in New York.

GREG STIMAC

Greg Stimac explores the American ideologies found in mowing suburban lawns, campfires, snowmen, roadside memorials erected after automobile accidents, discarded urine-filled plastic bottles, and gunplay at unregulated outdoor firing ranges spread throughout the United States. Stimac's photographic series, *Recoil*, is comprised of images of recreational sport shooters at ranges found

in Missouri and California firing their weapons toward the viewer. Photographing gun flash, gun smoke, and shell ejection approaches America's love of and identity with firearms. In 2005, Stimac received his B.F.A. in photography from Columbia College, Chicago, and was awarded an Albert P. Weisman Memorial Fellowship. His photographs have been shown at Carnegie Museum of Art, Pittsburgh; Crocker Art Museum, Sacramento; Museum of Contemporary Art, Chicago; Museum of Contemporary Photography, Chicago; and the Walker Art Center, Minneapolis. Stimac was born in Euclid, Ohio in 1976. He currently lives and works in Chicago.

JANE TAM

Fine art photographer, Jane Tam was born in Brooklyn in 1986. She currently lives and works in New York City. Her parents immigrated to New York in the mid-1970s from Guangdong, China and took blue-collar jobs truck driving and working in sweatshops of Chinatown. Most of her work explores the weaving of Chinese and American cultures and how it defines many offspring of working-class immigrants. Tam has exhibited in venues including the Griffin Museum of Photography in Winchester, Massachusetts; Sasha Wolf Gallery in New York City; Daniel Cooney Fine Art in New York City; and the Pingyao International Photography Festival, China where was awarded the "Emerging Photographer Award." Tam earned her B.F.A. in photography from Syracuse University, New York. She is also a member of Nymphoto, a women's photography collective in New York.

HANK WILLIS THOMAS

Hank Willis Thomas, winner of the first Aperture West Book Prize for his monograph *Pitch Blackness* (New York: Aperture, 2008), received his B.F.A. from New York University's Tisch School of the Arts and his M.F.A. in photography—along with a M.A. in visual criticism—from the California College of the Arts, San Francisco. His work was featured in the exhibition and accompanying catalog, *25 under 25: Up-and-Coming American*. He has exhibited in galleries and museums throughout the United States and abroad including: Galway 126, Galway, Ireland; Annarumma 404, Milan, Italy; Studio Museum in Harlem; P.S. 1 Contemporary Art Center, New York; the International Center of Photography, New York; Yerba Buena Center for the Arts, San Francisco; Wadsworth Atheneum, Hartford, Connecticut; The High Museum of Art, Atlanta; Museum of Fine Art, Houston; Jamaica Center for Arts and Learning, Jamaica, New York; Artists Space, New York; Leica Gallery, New York; Bronfman Center for Jewish Life at New York University Oakland Museum of California; and the Smithsonian Institution's, Anacostia Museum, National Museum of American History, and National Portrait Gallery, all in Washington, D.C. among others.

BRIAN ULRICH

Brian Ulrich was born 1971 in Northport, New York. He earned his M.F.A. in photography at Columbia College, Chicago and his B.F.A. in photography at the University of Akron. His work has been included in many group exhibitions: Art Institute of Chicago; the Museum of Contemporary Photography, Chicago; Galerie f5.6, Munich; Krannert Art Museum, Champaign, Illinois; Cleveland Museum of Art; the Walker Art Center, Minneapolis; and Carnegie Museum of Art, Pittsburgh. Ulrich has had solo exhibitions at the Museum of Contemporary Art, Chicago; Nerman Museum of Con-

temporary Art, Overland Park, Kansas; Museum of Contemporary Art, San Diego; Rhona Hoffman Gallery, Chicago; Julie Saul Gallery, New York; and the Robert Koch Gallery, San Francisco. His photographs portraying contemporary consumer culture are in the collections of the Art Institute of Chicago, the Cleveland Museum of Art, the Museum of Fine Arts Houston, the Museum of Contemporary Art San Diego, and the Museum of Contemporary Photography, Chicago. His first monograph, *Copia* was published in 2006 by Aperture as a part of the MP3: Midwest Photographers Project. In 2009 he was awarded a John Simon Guggenheim Memorial Fellowship. His work has been recently featured in several magazines including: *New York Times Magazine, Orion, Vice, Mother Jones, Artforum, Harper's, Leica World, Yvi Magazine* and as a frequent contributor to *Adbusters*.

SANDRA VALENZUELA

Sandra Valenzuela was born in Mexico City in 1980.She earned her B.F.A in visual arts at the School of Painting and Sculpture: La Esmeralda-INBA, Mexico City and a M.F.A from the Pratt Institute, New York. She has had solo exhibitions in Italy, the United States, Mexico, and Spain. Her work has also been exhibited in collective shows at The Rubin Center for The Visual Arts, El Paso, Texas; Museo del Barrio; New York; Instituto Cervantes, New York; Centro de la Imagen, Mexico City; Galería Centro Nacional de las Artes, Mexico City; and Museo Universitario de Ciencias y Arte Roma, Mexico City. Valenzuela has received grants from: Fulbright/García Robles, El Fondo Nacional para la Cultura y las Artes—Programa de Apoyo para Estudios en el Extranjero (FONCA-PAEE), La Colección Jumex, Unidad Latina Foundation and National Council on Science and Technology of Mexico (CONACyT). Her work is included in private collections as well as the collection of El Museo del Barrio, New York and has been reviewed in *The New York Times, Village Voice,* and *The New Yorker* among others. She is currently working towards a degree in Chinese studies at El Colegio de México, Mexico City.

AUGUSTA WOOD

Augusta Wood received her B.F.A. from Cooper Union, New York and her M.F.A. from the California Institute of the Arts, Los Angeles. Wood has exhibited at China Art Objects, Los Angeles; Anton Kern Gallery, New York; and The Armory Center for the Arts, Pasadena, California. Her work has been featured in *Artweek, The Los Angeles Times,* and *Black Clock*. Her upcoming group exhibitions include *I Am Not So Different* at Art Palace in Austin, Texas; *Baker's Dozen* at the Torrance Art Museum, Torrance, California; and a solo exhibition at Cherry and Martin, Los Angeles, in 2010. Wood lives and works in Los Angeles.

Contemporary U.S. Photography [Curators]

CHARLOTTE COTTON

Charlotte Cotton is the creative director for the London location of the United Kingdom's National Media Museum. Presenting new points of view on both the history and the contemporary issues of

film, photography, television, animation, and the Web, this space is due to open in Central London in 2012. Previously, Cotton was the head and curator of the Wallis Annenberg Department of Photography at the Los Angeles County Museum of Art (LACMA). During her two-year tenure in Los Angeles, she created a dynamic program of exhibitions, commissions, publications, and live events for LACMA, including the artist's book *The Sun as Error* by Shannon Ebner (Los Angeles: LACMA, 2009), *The Machine Project Field Guide to LACMA* (Los Angeles: LACMA, 2009), and the yearlong, online and live discussion forum *Words Without Pictures*. Previously in London, Cotton was the curator of photographs at the Victoria and Albert Museum (1993–2004) and head of programming at The Photographers' Gallery (2004-5). She is the author of *Imperfect Beauty* (London: Victoria and Albert Museum, 2000), *Then Things Went Quiet* (London: MW Projects, ca. 2003), and *The Photograph as Contemporary Art* (London and New York: Thames and Hudson, 2004), which has recently been updated and is part of the publisher's World of Art series. Her recent writings have been published in monographs and catalogues on Isa Genzken, Larry Sultan and Mike Mandel, Lise Sarfati, Nick Knight, and Paul Graham.

NATASHA EGAN

Natasha Egan is associate director and curator at the Museum of Contemporary Photography, Chicago. Egan has organized numerous international and national exhibitions, such as *Alienation and Assimilation: Contemporary Images and Installations from the Republic of Korea* (1998); *Andrea Robbins and Max Becher: The Transportation of Place* (2003); *Consuming Nature: Naoya Hatakeyama, Dan Holdsworth, Mark Ruwedel and Toshio Shibata* (2003); *Manufactured Self* (2005), featuring photographs about how we identify ourselves through what we consume by international artists from Africa, Asia, Europe, and the United States; *Made in China* (2006), focusing on the global impact of manufacturing in China through photography, video, and installation; *Loaded Landscapes* (2007), looking at historical and contemporary sites of trauma and conflict; *The Edge of Intent* (2009), examining the utopian aspirations of urban planners and how their visions adapt to changing environments; and *Reversed Images: Representations of Shanghai and Its Contemporary Material Culture* (2009). Egan has contributed essays to such publications as *Shimon Attie: The History of Another* (Santa Fe: Twin Palms, 2004); *Contemporary* magazine (2004); *Brian Ulrich: Copia* (New York: Aperture, 2006); *Beate Gütschow LS / S* (New York: Aperture, 2007); *Michael Wolf: The Transparent City* (New York: Aperture, 2008); *Placing Memory: A Photographic Exploration of Japanese American Internment* (Norman: University of Oklahoma Press, 2008); *Stacia Yeapanis* (New York: Aperture, 2009); and Michael Wolf's *Hong Kong Inside/Outside* (Berlin: Peperoni Press, 2009). Egan teaches in the photography and humanities departments at Columbia College, Chicago, and juries local and national exhibitions. She holds a M.A. in museum studies, a M.F.A. in fine art photography, and a B.A. in Asian studies.

EDWARD ROBINSON

Edward Robinson is the associate curator of the Wallis Annenberg Photography Department at the Los Angeles County Museum of Art (LACMA). He curated the LACMA presentation of *New Topo-*

graphics: Photographs of a Man-Altered Landscape (2009), co-curated *The Sum of Myself: Photographic Self-Portraits from the Audrey and Sydney Collection* (2009), and is working on the upcoming exhibition *William Eggleston: Democratic Camera* (fall, 2010). He earned his Ph.D. at Oxford University, United Kingdom, in the history of art and photography and his B.A. in art history at Brown University, Providence, Rhode Island. Formerly the Beaumont and Newhall Curatorial fellow in the department of photography at the Museum of Modern Art, New York, he initiated and organized, over four years, a number of exhibitions and programs. He has collaborated with such artists as Reneke Dijkstra, Nan Goldin, Stuart Klipper, Boris Mihailov, Vik Muniz, Mark Steinmetz, and Beat Streuli. He has served as the editor of *Blind Spot* magazine, has published a number of articles on photographic history, and has taught at New York University and Yale University.

AARON SCHUMAN

Aaron Schuman is an American photographer, editor, writer, and curator currently based in the United Kingdom. Born and raised in Northampton, Massachusetts, he earned a B.F.A. in photography and art history at New York University's Tisch School of the Arts in 1999, and a M.A. in humanities and cultural studies at the University of London's London Consortium in 2003. After working for various photographers—most notably, Annie Leibovitz and Wolfgang Tillmans—in 2000 Schuman began to work as a freelance photographer. Since then, he has exhibited his work internationally, and has contributed photography, articles, essays, and interviews to publications such as: *Aperture, FOAM, Photoworks, ArtReview, Modern Painters, HotShoe International, The British Journal of Photography, SPOT, 1000Words, The Face, Dazed & Confused, The Guardian, The Observer,* and *The Sunday Times.* In 2004, Schuman established and became editor of the online photography journal *SeeSaw Magazine* (www.seesawmagazine. com), and more recently he was invited to guest edit issue no. 13 of *Ojodepez,* "This Land Was Made for You and Me" (Summer 2008). He is also currently a research fellow and senior lecturer in photography at the Arts University College at Bournemouth and a lecturer in photography at the University of Brighton. For more information, please visit: *www.aaronschuman.com*

GILBERT VICARIO

Gilbert Vicario was appointed curator of the Des Moines Art Center in August 2009. From 2004 to 2009, Vicario was assistant curator of Latin American and Latino art at the Museum of Fine Arts, Houston (MFAH). His exhibitions there included *Alfredo Jaar: The Eyes of Gutete Emerita* (2005); *Indelible Images (trafficking between life and death)* (2005-6), featuring the work of Felix Gonzalez-Torres, Teresa Margolles, Daniel Joseph Martinez, Oscar Muñoz, and Regina Silveira; *Constructing a Poetic Universe: The Diane and Bruce Halle Collection* (2007); and *Tunga: Lezart* (2009). In 2006, Vicario was named commissioner for the International Cairo Biennale by the U.S. Department of State and curated the exhibition *Daniel Joseph Martinez: The Fully Enlightened Earth Radiates Disaster Triumphant.* Prior to joining the MFAH, Vicario worked at the Institute of Contemporary Art/ Boston, where he organized *Nikki S. Lee: Projects* (2001); *Chen Zhen: Inner Body Landscapes* (2002), which traveled to P.S. 1

Contemporary Art Center, Queens, New York; and *Made in Mexico* (2004), which traveled to the Hammer Museum at the University of California, Los Angeles. His recent publications include *Daniel Joseph Martinez: A Life of Disobedience* (Stuttgart: Hatje Cantz, 2009), with Hakim Bey, David Levi-Strauss, and Arthur C. Danto. Vicario is a graduate of the Center for Curatorial Studies at Bard College, Annandale-on-Hudson, New York (M.A., 1996), and the University of California, San Diego (B.A., 1989).

SARAH BAY WILLIAMS

Sarah Bay Williams is the Ralph M. Parsons fellow of the Wallis Annenberg Photography Department at the Los Angeles County Museum of Art (LACMA). There she contributed curatorially and programmatically to the exhibition *New Topographics: Photographs of a Man-Altered Landscape* (2009), including the production of recorded talks by the exhibiting artists creating an innovative self-guided, artist-led audio tour. For this show, Bay Williams also produced a series of video interviews of the exhibiting Los Angeles-based photographers for the museum's website. She served as picture editor for LACMA's virtual exhibition and print-on-demand book, *Celebrating Urban Light (www.lacma. org/urbanlight/exh/Urban Light/home.html).* She is also the author of *The Digital Shoebox: How to Organize, Find and Share Your Digital Photos* (Berkeley: Peachpit, 2009). Previously, Bay Williams served as head of the communications photography department at the Academy of Motion Picture Arts and Sciences in Los Angeles. She plans to begin her doctoral studies in the history of photography in the fall of 2010.

Film

MUSEUM OF FINE ARTS, HOUSTON FILM DEPARTMENT

The Museum of Fine Arts, Houston presents the best of classic and contemporary world cinema throughout the year in its landmark Brown Auditorium Theater, designed by Mies van der Rohe. A highlight of the schedule is collaborative programming presented in response to community-wide events such as FotoFest. *www.mfah.org/film*

SOUTHWEST ALTERNATE MEDIA PROJECT

Southwest Alternate Media Project (SWAMP) is a thirty-three year-old non-profit media arts organization for independent filmmakers based in Houston, Texas. Its mission is to promote the creation and appreciation of film, video, and new media as art forms of a multicultural community. It is the first non-profit of its kind in Texas and one of the oldest in the United States. SWAMP evolved from programs originally organized at the University of St. Thomas and later at Rice University Media Center through the vision of the internationally acclaimed filmmaker and educator James Blue. Houston philanthropists, John and Dominique de Menil, lent initial financial support to the program that became an independent non-profit under the direction of Ed Hugetz. Among SWAMP's current programs are professional development work-

shops for adults, digital filmmaking for youth and teens, the Media Literacy Institute for educators, special film screenings, the Emerging Filmmakers Fellowship Program in collaboration with Universidad Iberoamericana, Mexico City, and *The Territory*, the longest running short film showcase series in the country, broadcast on Texas Public Broadcasting Service (PBS) stations.

ROBERT FRANK

Born in Switzerland in 1924, photographer and filmmaker Robert Frank emigrated to the United States after World War II and has since lived in New York and Nova Scotia. Among his career highlights are the groundbreaking series of photographs and accompanying book, *The Americans* (1958), and the films *Pull My Daisy* (1959) co-directed by Alfred Leslie and narrated by Jack Kerouac and adapted from his play, *The Beat Generation*, and *Cocksucker Blues*, a chronicle of the Rolling Stone's 1972 North American tour. The most recent of his numerous awards is the Grand Prix Design of the Swiss Confederation, bestowed in 2009 to honor his astonishing accomplishments over seven decades.

JULIUS SHULMAN

American photographer, Julius Shulman was arguably the world's greatest architectural photographer. He captured the work of nearly every major modern and progressive architect since the 1930s, including Frank Lloyd Wright, Richard Neutra, John Lautner, Eero Saarinen, and Frank Gehry, among others. His images epitomized the singular beauty of southern California's modernist movement and brought its iconic structures to the attention of the general public. His photographs are included in many major publications about modernist architecture and provide a history and legacy for innumerable buildings that are no longer standing.

Creative Direction

FREDERICK BALDWIN

Co-founder of FotoFest in 1983, Frederick Baldwin has been a photographer for many years. He has been President and Chairman of FotoFest since 1984. As a photographer, worked around the world, and his photographs have been published in *Esquire, National Geographic, Life, The New York Times, Newsweek,* and *Geo,* as well as many other national and international publications. Baldwin taught photography at the University of Texas and the University of Houston. He was a Peace Corps director in Borneo during the 1960s. Baldwin has published two books on his photographs of the Civil Rights Movement in Savannah, GA – *Freedom's March* (Savannah, Ga: Telfair Books. 2008) and *We Ain't What We Used to Be* (Savannah, Ga.: Telfair Academy of Arts and Sciences, 1983). He is coauthor of the books *Looking at the U.S. 1957-1986* (Amsterdam, The Netherlands: Schilt Publishing, 2009) and *Coming to Terms: The German Hill Country of Texas* (College Station: Texas A&M University Press, 1991). He is the recipient of a Humanities Fellowship from The Rockefeller Foundation. His photographic work is represented in many public collections, including those of the Bibliothèque Nationale de Paris, the Museum of Fine Arts, Houston, and the Harry Ransom

Humanities Research Center of The University of Texas at Austin. Baldwin was born in Lausanne, Switzerland, and served as a U.S. Marine in the Korean War, where he was wounded and decorated. He was born in Lausanne, Switzerland.

JENNIFER WARD

Jennifer Ward joined FotoFest in 2003 as the Assistant Exhibitions Coordinator and was elevated to Exhibitions Coordinator later that year. She has coordinated FotoFest exhibitions and the Biennial Participating Spaces programs for the FotoFest 2010 – *Contemporary U.S. Photography*; FotoFest 2008 – *CHINA*, FotoFest 2006 – *The Earth* and *Artists Responding to Violence*, and FotoFest 2004 – *WATER* Biennials as well as the FotoFest Inter-Biennial programs since 2004. She co-curated and co-conceived, with Wendy Watriss, *Home & Garden* (2004), the first exhibition of FotoFest's ongoing *Talent in Texas* exhibition series and in 2006, Ms. Ward was lead curator for *Native Sons*, the series' second exhibition. In fall 2009, the *POKE! Artists and Online Social Media* exhibition marked her debut as a solo curator. Ms. Ward organizes educational outreach and student tours for all FotoFest exhibitions and coordinates collaborative programs with organizations in Houston and abroad. She has coordinated and supervised the Participating Spaces sections of the FotoFest Biennial Catalogues and has been senior editor for the FotoFest Biennial Map and Calendar since 2004. Ms. Ward has reviewed artists' portfolios for the Houston Center for Photo-graphy; Photolucida in Portland, Oregon; Critical Mass, Portland, Oregon; Mois de la Photo in Montreal, Quebec; Mesiac Fotografie in Bratislava, Slovakia.

WENDY WATRISS

Co-founder of FotoFest in 1983. Wendy Watriss worked as a freelance photographer, writer, curator, newspaper reporter, and producer of television documentaries from 1965 to 1993. Since 1991, she has been Artistic Director and Senior Curator for FotoFest, curating and organizing international exhibitions on photography from China (1934-2008), Latin American photography, U.S. Latino photography, Central European photography, the global environment, new media, water, artists responding to violence, and Guantánamo, among other themes. She conceived and produced the award-winning book *Image and Memory: Photography from Latin America 1865-1994* (Austin: University of Texas Press, 1998). Her photo-documentary essays have been published in national and international publications such as *Stern Life, Geo, The Smithsonian, Newsweek, The New York Times,* and many others. She is the recipient of numerous awards, including the World Press Photo Feature of the Year, the Oskar Barnack Prize, the Mid-Atlantic Arts Alliance/National Endowment for the Arts Award, and a Humanities Fellowship from the Rockefeller Foundation. She is coauthor of *Looking at the U.S. 1957-1986* (Amsterdam, The Netherlands: Schilt Publishing, 2009) and *Coming to Terms: The German Hill Country of Texas* (College Station: Texas A&M University Press, 1991). She was born in San Francisco.

Acknowledgments
FotoFest 2010

FOTOFEST 2010 EVENT PUBLICATIONS

Wendy Watriss, *Co-coordinator, FotoFest 2010 Publications*

Jennifer Ward, *Co-coordinator, FotoFest 2010 Publications*

HvADESIGN, New York (Henk van Assen, Anna Zhang, Savi Lopez Negrete), *Designers, FotoFest 2010 Publications*

Rattaya Nagorski, *Publications Assistant, 2010 Map and Calendar*

Earthcolor, Jim Walker, *Printing, Biennial Map/Calendar and Invitations*

Masterpiece Litho, David Tarnowski Sr., David Tarnowski Jr., *Printing, 2010 Auction Catalogue*

FOTOFEST 2010 BIENNIAL EXHIBITION PROGRAM

Wendy Watriss, *Artistic Director and Senior Curator, FotoFest*

Frederick Baldwin, *Creative Director, FotoFest*

Jennifer Ward, *2010 Exhibitions Coordinator, FotoFest*

CURATORS, CONTEMPORARY U.S. PHOTOGRAPHY EXHIBITIONS

Natasha Egan, *Associate Director and Curator, Museum of Contemporary Photography at Columbia College Chicago*

Aaron Schuman, *Photographer, Writer, Editor, Curator, and Founder of SeeSaw Magazine*

Charlotte Cotton, *Creative Director, National Media Museum, Bradford, U.K. and former Head of the Wallis Annenberg Photography Department at the Los Angeles County Museum of Art (LACMA)*

Edward Robinson, *Associate Curator of the Wallis Annenberg Photography Department at the Los Angeles County Museum of Art (LACMA)*

Sarah Bay Williams, *Ralph M. Parsons fellow of the Wallis Annenberg Photography Department at the Los Angeles County Museum of Art (LACMA)*

Gilbert Vicario, *Curator, Des Moines Art Center, Des Moines, Iowa; Former Assistant Curator of Latin American Art and Latino Art, Museum of Fine Arts, Houston*

Annick Dekiouk, *2010 Exhibitions Assistant, FotoFest*

ROMA, Tony Gareri, *2010 Exhibition and Auction Frames*

Kanan Construction, Jim Kanan, *2010 Biennial Production*

Keith Hollingsworth, *2010 Exhibition Matting/Framing, Hollingsworth Art Services*

George Neykov, *2010 Program Associate, FotoFest*

Mark Larsen, *Supervisor, 2010 Biennial Exhibition Installation, Facets*

David Zenteno, *2010 Biennial Exhibition Lighting*

Eric Hester, *Photographer, Photography Services*

Lorranie Houthoofd, *Exhibition Support, Village Frame Shoppe, Houston*

Vickie Russell, *Exhibition Support, Village Frame Shoppe, Houston*

Alexandra Yoder, *Exhibition Support*

Sally Sprout, *FotoFest Exhibition Space, Williams Tower Gallery*

Armando Palacios and Cinda Ward, *FotoFest Exhibition Space, New World Museum*

Joanna Chain, *FotoFest Exhibition Spaces, Allen Centers One, Two and Three*

Jon Deal, *FotoFest Exhibition Space, Winter Street Studios*

Vanessa Perez McCalla and Sarah Schellenberg, *FotoFest Exhibition Space, Art League Houston*

Kerry Inman, *FotoFest Exhibition Space, Isabella Court*

Roy Murray, *FotoFest Gallery, Vine Street Studios*

Barrie Scardino and Mat Wolff, *FotoFest Collaboration, The Architecture Center Houston (ArCH)*

Susanne Theis, *FotoFest Collaboration, Discovery Green Conservancy*

FOTOFEST 2010 CURATORIAL FORUMS

Anne Wilkes Tucker, *Curatorial Dialogue, Symposia Panelist and Consultant, Museum of Fine Arts, Houston*

Clint Willour, *Curatorial Dialogue, Symposia Panelist and Consultant, Galveston Arts Center*

Madeline Yale, *Curatorial Dialogue, Houston Center for Photography*

Fernando Castro, *Curatorial Dialogue, Independent Curator*

Charlotte Cotton, *Symposia Panelist*

Gilbert Vicario, *Symposia Panelist, Curatorial Dialogue*

Daniel Joseph Martinez, *Symposia Panelist and Exhibiting Artist*

Aaron Schuman, *Curatorial Dialogue*

Edward Robinson, *Curatorial Dialogue*

Natasha Egan, *Curatorial Dialogue*

Margaret Mims, *Symposium Support, Museum of Fine Arts, Houston*

FOTOFEST 2010 BIENNIAL WORKSHOPS

Mary Virginia Swanson, *Co-coordinator, Beyond Print, M.V. Swanson & Associates, AZ*

Katrina D'Autremont, *Associate Coordinator, Beyond Print, Artist*

Brian Storm, *Director, Multimedia Storytelling, MediaStorm, NY*

Lisa Robinson, *Artist, Multimedia Storytelling, Artist*

Susan Carr, *Presenter, Beyond Print, American Society of Media Photographers (ASMP), NY*

Richard Kelly, *Presenter, Beyond Print, (ASMP), NY*

David Bram, *Presenter, Presenter, Beyond Print, Fraction Magazine, NM*

Aaron Schuman, *Panelist, Beyond Print*

Darren Ching, *Panelist, Beyond Print, KLOMPCHING Gallery, NY*

Darius Himes, *Panelist, Beyond Print, Radius Books, NM*

Katherine Ware, *Panelist, Beyond Print, New Mexico Museum of Art*

Nadji Masri, *Panelist, Beyond Print, GEO Magazine, NY*

Jenni Rebecca Stephenson, *Promotional Support, Spacetaker, Houston*

FOTOFEST 2010 BIENNIAL FILM PROGRAM

Marian Luntz, Curator, *Director, Museum of Fine Arts, Houston Film Department*

Tracy Stephenson, *Associate, Museum of Fine Arts, Houston Film Department*

Mary Lampe, *Director, Southwest Alternate Media Program (SWAMP), Houston*

FOTOFEST 2010 BIENNIAL FINE PRINT AUCTION

Wendy Watriss, *Creative Director, FotoFest*

Blakely Bering and Austin James, *Co-Chairs, Live Auction Fundraiser, Bering & James Inc.*

ROMA, Tony Gareri, *2010 Auction Frames*

Denise Bethel, *Auctioneer, 2010 Auction, Senior Vice President and Director of Photographs, Sotheby's Inc., NY*

Rocio Carlon, *Coordinator, 2010 Auction, FotoFest*

Marta Sánchez Philippe, *Co-coordinator, 2010 Auction Catalogue and Live Auction Fundraiser*

Vera Misteau Mitchell, *Special Events and Live Auction Fundraiser*

Masterpiece Litho, *2010 Auction Catalogue Printing, Houston*

Doubletree Hotel Houston Downtown, *2010 Auction Sponsor and Caterer*

Jim Johnson, *Events Manager, Doubletree Hotel Houston Downtown, Houston*

Ron Gremillion, *2010 Auction Preview Exhibition, Gremillion & Co. Fine Art Inc., Houston*

W. Harwood Taylor, *2010 Auction Preview Exhibition, Gremillion & Co. Fine Art Inc., Houston*

Trish McClanahan, *2010 Auction Preview Exhibition, Gremillion & Co. Fine Art Inc., Houston*

Kristina Larson, *2010 Auction Preview Exhibition, Decorative Center Houston*

Justin Matthais, Artists' Framing Resource, *Matting/Framing, Houston*

Annick Dekiouk, *Auction Support, FotoFest*

George Neykov, *Matting/Framing, FotoFest*

FOTOFEST 2010 BIENNIAL MEETING PLACE AND EVENINGS WITH THE ARTISTS

Marta Sánchez Philippe, *Coordinator, International Meeting Place*

Sarah Craig, *Associate, International Meeting Place*

Francesca Bontempi, *Biennial Meeting Place Assistant*

Sebah Chaudry, *International Meeting Place Assistant*

Jake Mooney, *Reviews Schedule Coordinator*

Jim Johnson, *Events Manager, Doubletree Hotel Houston Downtown*

FOTOFEST 2010 BIENNIAL PHOTOGRAPHY BOOKSTORE

Rixon Reed, *PhotoEye, Santa Fe, NM*

Bernard Bonnet, *Museum of Fine Arts, Houston Bookstore*

FIRST LOOK FOTOFEST COLLECTORS GROUP

Kath Blanco, *Co-Chair*

Krista Dumas, *Co-Chair*

Laura Nolden, *Co-Chair*

Sarah Craig, *FotoFest Staff Coordinator*

Wendy Watriss, *Advisor*

SPECIAL PROGRAMS

HexaGroup (Arnaud Dasprez, Cory Jensen, Jutas Arthasarnprasit), *FotoFest Website Design, Houston*

Vera Misteau Mitchell, *2010 Biennial Opening Party and Special Biennial Events, Paricutin, Houston*

Doubletree Hotel Houston Downtown (Susan Lewis), *Biennial Hotel and Catering*

Greater Houston Convention and Visitors Bureau, (Jorge Franz, Lindsey Brown, Cherry Eno, Mark Ellis, Celia Morales, Nathan Tollett), *Promotional Support*

Dr. William V. Flores, *University of Houston Downtown*

Robin Davidson, *University of Houston Downtown*

Christine Jelson West, *Lawndale Art Center, Houston*

Bernard Bonnet, *Museum of Fine Arts, Houston Bookstore*

Meg Poissant, *Poissant Gallery, Houston*

Maria Ines Sicardi, *Sicardi Gallery, Houston*

Deborah Colton, *Colton & Farb Gallery, Houston*

Matt Adams, *Artist, Houston*

Thomas J. Hawkins, *2010 Website Assistant, FotoFest*

Claudia Hernandez, *Administrative Support, FotoFest*

Ernest Thompson, *Gallery Supervision, Vine Street Studios Building Manager*

Ventura Saldña, *Gallery Maintenance, Vine Street Studios*

SIERRA STAGE COACHES, INC., (Sandra P. Reid), *Houston Event Transportation*

LITERACY THROUGH PHOTOGRAPHY (LTP) FOTOFEST 2010 BIENNIAL STUDENT EDUCATION PROGRAMS

Kristin Skarbovig, *Education Program Manager, Student Education Tours*

Julie Knutson, *Curriculum Coordinator, Literacy Through Photography Special Projects*

Sarah Reavis Sokolowski, *Assistant, Literacy Through Photography*

Robin Reagler, *LTP Program Partner, Writers in the Schools*

Susan Davis, *LTP Program Partner and Teacher, Chinquapin School*

Shirley Lyons, *LTP Program Partner and Teacher, East Early College High School*

Pam Karter, *LTP Program Partner and Teacher, Spring Woods High School*

George Ramirez, *LTP Support, Houston Museum of Fine Arts, Houston*

Wendy Watriss, *LTP Curriculum Development*

Emily Neal, *LTP Program Teacher; Former LTP Director*

Anthony Winkler, *LTP Curriculum Development*

Kem Kemp, *LTP Curriculum Development*

Marianne Fives, *LTP Assistant, 2008-2009*

Chuy Benitez, *LTP Program Partner and Teacher*

LTP COHORT TEACHERS

Julie Brook Alexander

Emily Neal

Kathleen Pellicer

Kymberly Keeton

Howard Sherman

LTP COMMUNITY PARTNERS

Houston Grand Opera Company

Project GRAD

Project Row Houses

Writers in the Schools (WITS)

Young Audiences of Houston

FOTOFUN 2010 – A VALENTINE FOR THE EARTH

Sophie Girard, *Co-Chair*

Margaret Hill, *Co-Chair*

FOTOFUN 2009 – FOTO SYNTHESIS: SEE AND BE GREEN

Annie Criner, *Co-Chair*

Lucy Chambers, *Co-Chair*

Vera Misteau Mitchell, *Co-Chair*

FOTOFEST ORGANIZATIONAL SUPPORT

James "Brock" Kobayashi, *Technical Consultant*

Richard Duncan & Assocs., *Accounting*

Stephanie Atwood, *Bookkeeping*

2009-2010 INTERNS

Jessi Bowman, *University of Houston, Texas*

Adele Avivi, *University of Texas at Austin, Texas*

Marianne Fives, *American University, Washington DC*

Stephanie Gobea, *University of Houston, Texas*

Thomas J. Hawkins, *Davenport University, Grand Rapids, Michigan*

Sarah Jamison, *Texas Tech University, Lubbock, Texas*

Michael Luong, *University of Houston, Texas*

Citalli Martinez, *University of Houston, Texas*

Irene Mendez-Cruz, *École Estienne, Paris, France*

Leah Shugart, *The Emery/Weiner School, Houston, Texas*

Tala Vahabzadeh, *University of Houston, Texas*

"Joy" Theepwong Yarwpa, *Chulalongkorn University, Thailand*

FOTOFEST 2010 BIENNIAL VOLUNTEERS

Carolina Alaniz	Mickey Marvins
Cyndy Allard	Mike Marvins
Fae Marie Anicete	Patty Millspaugh Meador
Keefe Borden	Betty Mooney
Susan Brubaker	Nathan Munier
Linda Foot	Julian Ong
Trish Fowler	Beverly Parker
Arnold Franco	Marie Pince
Alexandra Gaisbauer	Juan Rivera
Santos Gaitan III	Ginny Romero
Stephanie Gobea	Vero Schlumberger
Amira Góngora	Tencha Shoemaker
Steffanie Halley	Martha Skow
Claudia Hernandez	Heidi Straube
Carola Herrin	Megan Smith
Frazier King	Eryn Vaughn
Edward Lara	Eliane Thweatt
Irinia Lingard	Dave Wilson
Sharon Lynn	Alexandra Yoder
Citlalli Martinez	

MEETING PLACE VOLUNTEERS

Carolina Alaniz	Citalli Martinez
Francesca Bontempi	Jake Mooney
Mary Daly	Betty Mooney
Steffanie Halley	Royce Ann Sline
Carola Herrin	Dave Wilson
Frazier King	

FINE PRINT AUCTION VOLUNTEERS

Carolina Alaniz	Citalli Martinez
Maria Ciepiel	Ginny Romero
Susan Davis	Fernando Sabira
Linda Foot	Diana Sampayo
Stephanie Gobea	Cameron Sands
Claudia Hernandez	Vero Schlumberger
Candace Jaggard	Tala Vahabzadeh
Geoffrey Koslon	Alexandra Yoder